Rembrandt

The Complete Etchings

K. G. Boon

Rembrandt

The Complete Etchings

Thames and Hudson · London

Translated from the Dutch by Elizabeth Willems-Treeman
Book design by Wim Crouwel Gkf-AGI (TD association)

First published in Great Britain 1963
Thames and Hudson, London
Printed and bound in the Netherlands

Throughout the history of the graphic arts a technique has seldom been identified so completely with one artist of a particular period as etching in the seventeenth century is identified with Rembrandt. When the origins of etching are considered, almost invariably it is he who comes to mind. Yet from the beginning of the century many other artists worked in this medium, producing portraits, innumerable broadsheets and reproductive prints after paintings, and even works of art original in concept. Painters were particularly attracted to etching because it permitted rapid execution and a great measure of freedom. They were able to note ideas on an etching plate as quickly as in their sketchbooks. For most of them, however, such notations remained hasty scribbles, a play of lines going not much beyond drawing with a pen. To penetrate the technique further required great imagination, and especially perseverance.

For still another reason the world of the Baroque was slow to accept etching as its graphic medium. Grand display was the keynote of the times, and experimentation for its own sake was held suspect. The explorations of Hercules Seghers were rejected, therefore, and little attention was paid even to the attempts of Adam Elsheimer and Claude Lorrain, who endeavored to free themselves from superficial flourishes by using controlled short strokes and stippling. Only through the etching of Rembrandt, which went much deeper than the poetic evocations of Elsheimer and Claude, were minds shaken awake. In the prints by this northern artist could be perceived a spirituality and an expressive power rarely encountered before in the graphic arts. Arnold Houbraken, a Dutch painter and biographer of painters of the early eighteenth century, declared that Rembrandt excelled in the "expression of the soul's passions," and the French critic Roger de Piles summed up Rembrandt's art in 1699 by ascribing to it "a character of life and of truth."

Except for Albrecht Dürer, European art knows no artist so extensively occupied with graphic activity as was Rembrandt. Many hours of his crowded existence were filled not only with drawing and etching on the copper but also with printing his plates. Again and again he tried to introduce modulations by varying his printing techniques, and he experimented constantly with different kinds and qualities of paper—in his later years he preferred fine Oriental papers. For Rembrandt the process of graphic creativity was crowned only by the completion of the printing.

There is no continuity to his graphic work. It does not consist of carefully planned series illustrating great cycles from the life of Christ, as in Dürer's woodcuts and engravings, or from mythology, as in the work of Jean Duvet. Aside from a few portraits and illustrations, each of Rembrandt's etchings originated in an inner impulse, in the deeply felt need to make that particular print. For this reason his prints to this day impress one as being spontaneous sketches which contain no more and no less than the essentials necessary to an understanding of their subject.

The circumstances of Rembrandt's life give some insight into the shifts and turns of his thoughts as reflected in his work, but the biographical facts do little to elucidate the intent behind the works of art. Rembrandt committed to writing almost nothing that might provide a key to his intellectual life. A glimpse into his mind is given by a single sentence in a letter of 1639 to Constantijn Huygens, secretary to the Stadholder Frederick Henry. The letter concerned the group of paintings, as yet unfinished, that Rembrandt had been commissioned by Huygens to make for the prince. As explanation for his failure to deliver the works at the appointed time, the artist wrote that he had had to search long to attain expression of "the greatest inward emotion." Another glimpse is provided by a line written above a drawing (now in the Print Room of the Rijksmuseum at Amsterdam) in which he had sketched the Virgin as the Mother of Sorrows. Having drawn an arrow to the figure of Mary standing at the foot of the cross, he wrote, in the year 1637 when he was working on the paintings for Frederick Henry, "A devout treasure that is preserved in His heart to the consolation of her compassionate soul." Brief as they are, these two holograph phrases epitomize Rembrandt's lifelong quest for reality as it is revealed in human emotion.

Rembrandt never advocated any particular artistic theory. At least, there are no traces of such advocacy in his work, nor are there any annotations for or studies of proportion. He made no attempt to conform to an absolute canon of beauty, although he often made drawings after the work of his predecessors. He collected eagerly and was open to everything, to the artistic heritage of his own country as well as to the masterpieces of the Italian Renaissance. His interest indeed went out to the art of lands beyond Europe, as may be seen from his copies after Indian miniatures of the Moghul period. He was probably the first European to recognize their unique beauty.

Evidence of his aversion to preconceived theories of art that have nothing to do with the creative process itself comes from a conversation he had with his pupil Samuel van Hoogstraten, who recorded the anecdote in his *Inleyding tot de Hooge Schoole der Schilder-Konst* (Introduction to the Academy of Painting) of 1678. When Hoogstraten was arguing about the virtue of following fixed rules, Rembrandt settled the dispute with the words: "Take it as a rule to use properly what you know already; then you will come to learn soon enough the hidden things about which you asked."

Here speaks the artist who knew that inspiration can be guided by individual insight alone, and that the study of the art of the past must not lead to theory but be the source for new inspiration. Rembrandt adopted an old motif only when he found its equivalent in his own language and could insert it into his own world. In this world everything had a place. The ugly and the pedestrian, the solemn and the sacred—he transformed it all into beauty, not by costuming it for effect, as did the Baroque artists of his country, but by rendering it in the simplest possible form. For that reason the true Baroque,

as it found expression in the work of Rubens or of the Roman artists Pietro da Cortona and Gianlorenzo Bernini, always remained alien to him, even though he was for a time under the spell of Rubens' art. He also remained largely unaffected by the classicism of his century, which was expressed most purely in the paintings of Nicolas Poussin. Theories did not impress him. He was content, as one of his contemporaries remarked, to follow what life offered.

This does not mean that Rembrandt was ever a realist and nothing more, or that the currents of his time left him unperturbed. Certain aspects of the Baroque and of classicism as well are to be traced in his work during successive periods, but never to the extent that his work in the long run can be categorized as Baroque or as classical. His entirely human approach, evident in his youthful work, makes it impossible to identify him as a representative of either of these styles. His art forms a separate chapter in the history of seventeenth-century art—that of his own country and of all Europe.

There is, furthermore, not much point in attempting to make Rembrandt's art derive from the background from which he sprang, and certainly not from the provincial town that Leiden was at the beginning of the seventeenth century. In the blighted years after the Spanish siege of 1574—at the outset of the Eighty Years' War—art had declined there to a relatively primitive level. How much Rembrandt's first teacher, Jacob Izaaksz Swanenburch, contributed to his development has never been clarified. So far as is known, Swanenburch was an insignificant architectural painter who adhered to the Mannerist style of the late sixteenth century. Rembrandt, who was born in Leiden on July 15, 1606, the son of the miller Harmen Gerritsz van Rijn and the baker's daughter Neeltgen Willemsdochter van Zuytbrouck, was fourteen years old when he came to Swanenburch, shortly after matriculating at the University of Leiden in 1620. The budding artist was probably set to work on exercises in the flourishing pen-strokes at which all the Mannerists were so proficient. Presumably it was in the studio of his second teacher, Joris van Schooten, that Rembrandt encountered another young Leiden student, Jan Lievens, his junior by a year. Then and for some time after, Lievens was considered to surpass him in talent.

Sometime in the early 1620's, probably in 1624, Rembrandt went to Amsterdam for about six months to study under Pieter Lastman and Jacob Pynas. Whatever he had learned from Swanenburch he no doubt quickly forgot in their studio. He must have worked there more with chalk than with the pen, and Lastman cannot have failed to give him insight into the principles of composition and figure study from models.

Rembrandt's sojourn in Amsterdam, a city bustling with a vitality unknown to the quiet university town of Leiden, made positive contributions to his earliest artistic endeavors. He became acquainted

with the work of artists who had emigrated from Spanish-occupied Flanders to settle in the capital of the northern Netherlands—landscape artists, such as Gillis van Coninxloo and his pupil Hercules Seghers, and various portrait painters. There, too, he discovered the nuances assimilated from the art of the German-Italian artist Elsheimer and brought to the north by Dutch painters, of whom Lastman was one.

It is difficult to gauge the impression made by Italian art on the young Rembrandt. When Constantijn Huygens advised him and Lievens to go to Italy to study, they rejected his advice on the ground that enough Italian art could be seen in Holland. From this reply it would appear that Rembrandt had already gained some knowledge of Italian painting during his early years in Leiden. Whether he then had any real understanding of the work of the Carracci, whose prints he later used, or whether he was then able to form an opinion about Caravaggio's art must be strongly doubted. But he had certainly been introduced to the pictorial ideas of the *tenebrosi*, who used chiaroscuro in their art, through his contact with the works of Hendrick Terbrugghen and Gerard van Honthorst.

All these experiences and impressions formed the components out of which the young artist, back in Leiden after 1625, began to build up his art. In Amsterdam he had learned a great deal, not only about painting but also about the new art of etching, which in those years was becoming popular, especially with landscape artists. Before 1600 etching had not been widely practiced. The burin, instrument of the engraver, was employed almost exclusively, binding its users to certain limited linear patterns. Methods of etching at first deviated only slightly from those of engraving, and in both the artist closely followed a previously established design. There was thus little spontaneity in the etchings produced at the end of the sixteenth century, and, in its restricted role of translating drawing onto plate, the technique remained of subordinate importance.

During the first decade of the seventeenth century various artists attempted to free themselves from the engraving style. They no longer wanted to use flowing lines to render figure and landscape, and they quickly discovered that the etching needle offered greater possibilities for variation than the burin. Such Haarlem artists as Esaias van de Velde and Willem Buytewech in particular, as well as David Vinckeboons in Amsterdam, sought greater diversity through zigzag lines and dots, which enabled them to bring out contrasts between foreground and background. The engraving line was not adaptable to this play of contrasts for making space appear lighter and opener. Another path toward strengthening the illusion of depth and space was followed by Hercules Seghers. He printed on colored paper and introduced tints into his etchings; at the same time he reduced the etched line itself to dots and short strokes, bringing the surface of the print more strongly into motion.

It goes almost without saying that Rembrandt, sensitive as he was and at a most impressionable age,

must have been fascinated by these experiments, which were carried out over a short period of time in his immediate surroundings. Even though their effect on his work is not at once apparent, they opened his eyes to the rich possibilities of etching.

During the years just after his return to Leiden, while he was engrossed in imitating the realistic historical painting of Lastman, Rembrandt was probably not particularly attracted to etching, which does not lend itself to strongly charged compositions. He did try twice in these years to attain with the etching needle what he had already mastered with chalk and brush: a confident delineation of figures, modeled with a dynamic light and dark. He failed to achieve what he wished in both attempts—the one a *Circumcision*, in which the heavy figures are tightly packed together in a composition wholly in the style of Lastman; and the other a *Rest on the Flight to Egypt*, drawn in a freer manner, it is true, yet still bound by his teacher's vocabulary of forms.

Some time must have passed before he again turned to etching, although the large print *St. Jerome Kneeling*, preserved in a single copy at Amsterdam, is possibly one of the early experiments. This phase apparently lay behind him when he placed upon the copper, in a completely new manner, his first truly monumental etching: *Peter and John at the Temple Gate*.

Rembrandt's horizon must have widened rapidly. Perhaps even at Leiden he was laying the basis for his collection of the art of his precursors which later, in the years of his prosperity in Amsterdam, he would broaden to include all eras and lands. Among his early acquisitions certainly belonged the work of Jacques Callot, which must have excited him by its powerful and spirited linear technique. Above all in Callot's series *Les Gueux* (The Beggars) Rembrandt found inspiration for his first experiments with "figures after Life," as Pieter Bruegel the Elder used to call them.

It is not entirely clear whether Rembrandt's early figure studies, seven in number, were done from various models or from only one. The impression arises that these figures of beggars (there is just one woman among them), their bulky, ragged cloaks hanging like great bell-jars upon their limbs, were all drawn from the same model. The technique is spontaneous and free, displaying an ability to capture the entire figure with a few defining lines and modeling shadows. A sensitive, truth-seeking hand is already at work, adding accents here and there to bring as much variety as possible to the modeling. These studies hold much promise of the future richness of Rembrandt's ingenious spirit.

At about the same time that these early figures of beggars were created (some are dated 1631 by a later hand, probably that of a pupil who reworked the plates), the *Peter and John at the Temple Gate* must have come into being. This is the first etching Rembrandt constructed from individual studies, and in it the division into light and dark reveals the influence of the chiaroscuro of the Caravaggio

school of painting. Like the beggars, the three figures beside the temple gate are seen in large, simple contours, set off against adjacent areas of light and shade. Evidently Rembrandt had not yet mastered the technique of biting, for the soft ground he must have used has regrettably been bitten irregularly by the etching acid. From this time on he no longer worked a plate with a broad point but turned more and more to a fine and complex etching line, which he incised on a hard etching ground. His attempt to achieve an etched double line by using a double-pointed needle, which almost equaled the brush, was restricted to one experiment: a self-portrait with long curly hair. Nonetheless this print illustrates Rembrandt's desire at the very beginning of his career as an independent artist, when he was just over twenty years old, to free himself from conventional restraint.

At the outset Jan Lievens, who had also been a fellow pupil under Lastman, apparently pointed the way, for Rembrandt in his etchings of beggars followed Lievens' lead. But he must soon have realized that the young art of etching offered countless other possibilities.

The method of etching on a hard ground generally practiced in the sixteenth century was abandoned by Callot in Florence for etching on a soft ground, which permitted greater variety of line. In addition, Dutch landscape etchers began to use the etching needle along with the burin to obtain even more pronounced linear variation. Preliminary drawings were no longer so narrowly followed; elements were introduced into etchings that the drawings had barely suggested. Thus Jan van de Velde achieved deep blacks for his night scenes by working with both etching needle and burin, and Moses van Wttenbrouck brought greater cohesion into his prints by using the burin. Etching was no longer a simple transferral of lines to a plate; instead, both the biting in varying stages and the retouching with the burin led to a complicated network of lines. Set at various depths in the plate, these lines at last performed the same function as layers of paint placed one on top of another in painting.

None of the artists of the seventeenth century pursued the farthest potentialities of this complex technique so completely as did Rembrandt. None succeeded in achieving so much variation in black and white. As Rembrandt advanced in skill he was able, through ever more systematic use of the burin, to place the deepest blacks next to the unbroken white of the paper. And he never limited himself. He continually struck out along new paths, some of which he had reconnoitered earlier. Thus time and again he could return to the roughly sketched etching, as found in the beggars' pieces, long after he had begun to use a finer etching needle.

Leiden was home ground to Rembrandt. He had grown up there and been educated at the Latin School, where the foundation was laid for his knowledge of the ancient world. There too, in 1620, when he was fourteen, his name was entered on the registers of the university. How long he attended

classes is not known; that he was not a studious man is attested by the small collection of books he later owned. After his return from Amsterdam he probably lived quietly within an intimate family circle. Often his mother and his father, his eldest brother Adriaen, and his younger sister Liesbeth sat as models for him, and from his earliest etchings it is apparent how affectionately he viewed his familiar surroundings. In his portraits of his mother, with her warm, inward-turning gaze, the tenderest thoughts suffuse her face. He recorded her every wrinkle with incomparable delicacy. In 1628 he made *6* two etchings of her, one in a fine diffused light as if sketched with a silverpoint, the other with her *7* careworn face dramatically shadowed under a hood.

The model that he studied most during the Leiden years from 1628 to 1631 was, however, himself. *5, 11, 13, 14, 15* The first sketches were hasty scribbles, primarily meant to capture a certain fall of light; then the eye penetrates more deeply, and in 1630 the young Rembrandt attempts to record all sorts of expressions: *48, 41, 47, 39* anger, hatred, surprise, laughter, all of which he had already portrayed in his paintings. The beggars *27, 34, 35, 36* are also now studied with greater attention to character. Moving indeed is the expression of a seated *61* outcast, sheathed in rags, who with implacable, burning eyes seems to be extorting alms. From this *54* same year, 1630, date two small, minutely executed religious etchings, *The Presentation in the Temple* *40* and *Christ Disputing with the Doctors*, in which light has become the binding factor. In both etchings the shadows are vigorously worked out, and in *The Presentation* the burin has been used at various points to lend an extra touch. The left side of this print is filled with a vivid light. The light is intercepted by a pillar, beyond which it subsides into the dimness of the temple interior. Rembrandt left to the imagination of the viewer the composition of this inner space. For him there was no border between imagination and reality. He built his world from his memories of the work of others and from his observations of his own surroundings.

Late in the same year he again took up a religious subject, once more from the infancy of Jesus: *55* *The Circumcision*. For the first time in this little etching he concentrates the light strongly upon the central group. The foreground and background are enveloped in darkness, out of which the bystanders dimly emerge. From this etching it appears that Rembrandt had already become attracted to the art of the Baroque. Still missing are the propelling motion and the breaking open of space which, in the first years after his return to Amsterdam, were to bring him closer to Rubens. In Leiden the young Rembrandt continued to waver when confronted by southern *brio*. He apparently felt more at home in a deliberate, finely wrought style of drawing than in the impetuous execution of the Flemish Baroque. What is lacking is the great exhalation that seemed to break through in *Peter and John at the Temple Gate*. A typical specimen of his Leidenish taste, which was sometimes a bit ornate, is the dandy-like *76* self-portrait with soft, cocked hat and embroidered cloak, on which Rembrandt bestowed almost

endless refinement. This print, in all its various impressions, must be considered a practice piece.

72

74

The enduring monuments from this Leiden period are the portraits of his mother. After etching the careful studies of her head, he created two portraits in half-figure—one in profile with an "Oriental" veil hanging from the back of the head; the other seated at a table, the face in thoughtful repose. Each etching in its own way is a moving witness to Rembrandt's veneration for his mother. More than the profile, perhaps, the subdued portrait of the woman at the table symbolizes old age reconciled.

After July, 1631, Rembrandt left for Amsterdam. Before returning there he had been in touch with the art dealer Hendrick van Uylenburch, who in 1633 would become the publisher of two of his prints. In all probability Rembrandt had completed portrait commissions in Amsterdam before he finally settled there himself. The attractions of the great city must have been too strong to withstand. In addition to a large circle of interested art-lovers, Amsterdam offered Rembrandt the advantages that René Descartes summed up in a letter of 1631 to his friend, the Seigneur Jean Louis Guez de Balzac: "If there is pleasure in seeing the fruits of our orchard grow, don't you think there will be just as much in seeing ships arriving here, bringing us in abundance all that the Indies produce and all that is rare in Europe? What other country could one choose where all the conveniences of life and all the exotic things one could desire are to be found as easily? Where else could one enjoy a freedom so complete?"

The freedom essential to Descartes appealed no less to Rembrandt. The narrow-minded Calvinists of Leiden, where the pedantic erudition of theologians set the overtone of the milieu, must eventually have proved too much for a freebooter like him. His religious attitude inclined strongly toward that of the Mennonites, a sect that permitted lay preachers and paid more attention to practical, humble piety than to dogma. Moreover, Rembrandt did not reject the traditions of the Catholic church, at that time discredited if not banned in the Protestant Dutch Republic; later he was able upon more than one occasion to depict ideas from the realm of Catholicism.

Again, therefore, Amsterdam widened his horizon. It brought him new contacts and made it possible for him to veer away from genre art and the close observation of detail upon which he had become more and more dependent. And just because he was seeking new paths, his encounters with the art of Rubens, the Carracci, Antonio Tempesta, and the early Dutch painters (with whose work he now became better acquainted through the medium of prints) must have affected him more forcibly than ever before.

These impressions influenced him in two directions. In some of the prints created during or shortly after the year 1632, the figures are placed in environments more precise than earlier settings; but in other works his imagination is given even freer play. Everything that had inclined to genre or narrative

86 is now handled with realistic minuteness. The rat-killer and his little helper appear at a house door,
84 where an old man rejects their services; St. Jerome kneels in nearly desperate prayer within a particu-
90 larized landscape of rocks; the Good Samaritan brings the injured man he has found to an inn, whose
entrance courtyard is rendered with great exactitude.

This emphatic realism, which tends to locate everything precisely, assumes an almost panoptic aura
91 in the large *Descent from the Cross*, a print that Rembrandt executed with the help of his pupils after
one of his paintings for the Stadholder Frederick Henry. Judging from this minutely finished, detail-
laden piece, it would seem that Rembrandt's art allows itself to be translated from one medium into
another only with difficulty. Rembrandt himself felt this. Whereas in the painting the central group is
brought forward by color contrasts, with lighter and darker accents to give forceful expression to the
dramatic event depicted, in the print the action is unclear because of the multitude of details, all ren-
dered in just one tint. Only by adding obliquely falling shafts of light was it possible to free the figures
about the cross from the background. Rembrandt borrowed this substantial depiction of light from
Rubens, and similar invasions of light are often encountered in prints reproducing works of the
Flemish master. By adopting an element of true Baroque art, Rembrandt attempted to avoid the
impasse into which the over-detailed technique was driving him.

85 In his print *The Raising of Lazarus*, whose pathos prevents it from being one of his more felicitous
creations, he found a better solution by giving light a more active and pervasive role. Light streams
with a nebulous glow into the grotto-like space, as if it manifested God's presence therein. In other,
less detailed works he also was able to maintain the evocative power of light. Its beneficent presence
82 can be traced throughout the simplest productions. In the little *Holy Family* of 1632, which was in-
spired by Annibale Carracci's print, the shifting play of light creates an aura of cheerful intimacy that
suggests an interior full of warmth and comfort.

During the years 1633 and 1634 Rembrandt enriched the world of his black-and-white art in an un-
precedented way. He created an alternation of tints between gray and black such as his contemporaries
had never dreamed of. Painting had taught him to profit as much as possible from contrasts; now in his
etchings he attempted to put this lesson into practice. Five etchings, all dating from 1634, most
distinctly reveal his new approach.

107 He used these contrasts in *Joseph and Potiphar's Wife*, where the woman is trying to draw Joseph
away from the brightly lighted room into the dimness of the canopied bed; in the little etching
108 *St. Jerome Reading*, the saintly scholar withdrawn into the shadow of a tree and dense undergrowth;
105 and in *Christ and the Woman of Samaria*, where Jesus sits conversing with the woman at the well, his

back turned to the cavern-like gloom of a building in ruins. But the richest and deepest black and the most brilliant light he saved for those prints that were to render the supernatural events of the life of Christ. In the small *Christ at Emmaus*, a theme to which Rembrandt returned throughout his life and in which he continually discovered deeper meaning, there is a blinding light around the head of Christ. Even more radiant is the light that breaks from heaven in *The Angel Appearing to the Shepherds*, the most mature work of these years, comparable in its rich contrasts to his most successful paintings from the same period.

109

106

This print was prepared with the greatest care; it was etched in various stages and thereafter re-touched with the burin. The darkest part, the valley landscape, in which the last light of evening hangs and the glow of a fire is dimly reflected in the water, was the first to be etched powerfully into the plate. Going out from these deepest blacks, he tempered the lighter sections in the foreground and in the sky until all that remained was the patch of light on the ground where the shepherds cower and the deep funnel of sky from which the cherubic choir tumbles toward the earth. Here and there light touches the lush vegetation with great beauty. It trembles through the treetops, which look as though they have been stirred into motion by a little gust of wind preceding a storm. The dusky twilight is laden with tension. Rembrandt is the first to make nature an active participant in a supernatural spectacle.

In the angel's appearance and in the panicky terror of the animals and human beings, there is some-thing theatrical, suggestive of Baroque drama, but the figures remain so subordinate to what is happening in nature that they actually do not disturb the greater design of the print. The evocative night mood emanating from the deep black, through which light plays ever and again—particularly in the early impressions of this plate, in which all the lines retain their power—was unknown to the art of print-making in Europe before Rembrandt. Only much later was his tremendous enrichment of graphic art fully understood. Strictly speaking, Goya was the first to realize the magical working of this night-like black. To the degree that Rembrandt's feeling for drama intensified, his world of night grew ever more overpowering and at the same time possessed of almost inexhaustible variety. In this print the twilight still has something benevolent, working as antipode to the blinding light of heaven; later his darknesses become ominous, especially when he takes as subjects the episodes from the Passion.

The years 1633 and 1634 brought domestic happiness to Rembrandt. On July 5, 1633, he became betrothed to, and in June, 1634, he married, Saskia van Uylenborgh, the daughter of a burgomaster of Leeuwarden, who had been brought up in Amsterdam as the ward of her kinsman Jan Cornelisz Sylvius, a Calvinist preacher. In his self-portraits from these years Rembrandt is a confident young

96, 102

man who gazes at the viewer with challenging eyes. He sketched and painted his Saskia over and over

100
101
again. He saw her, as in the small etching *Saskia with Pearls*, as a fashionable young lady clad in exquisite garments, the jewel of his house. At the same time he etched a portrait of himself, an Indian sword in his hand, as an exotic potentate.

94

78

But Rembrandt would not have been Rembrandt had he not also been able to see himself in a light other than that of worldly and vain display. In the studio he remained as always his own model, trying out new ideas in front of the mirror. Thus originated an attempt to render a figure in counter-light—the Caravaggesque self-portrait with the face in shadow, entirely constructed from a play of small modeling planes that avoid line and contour as much as possible. Perhaps this sketch was a sequel to his earlier attempt to model a head with shadows alone, even though that slightly developed self-portrait, which Rembrandt in 1632 etched as a dark accent beside light jottings of beggars, cannot with certainty be identified as a conscious effort in this direction. The drawing on the early plate of studies appears more a whim of the moment—but sketches like this among later etched studies have afforded magnificent, spontaneous discoveries, to the delight of recent students of Rembrandt. In 1632 the artist had not yet attained the freedom he later displayed. The portrait with the shadowed face is actually more than an attempt to imitate in etching what Terbrugghen had done earlier in painting. Here is the beginning of that dialogue with himself which Rembrandt was to continue up to his very last moments. Here for the first time is the glance, turned inward and directed at that unknown other, whom he watches and questions.

89
120

100
102

If, in addition to examining the portraits of Rembrandt's family circle and the highly varied likenesses he made of himself, one looks at other of his portraits from this period—that of Jan Cornelisz Sylvius of 1633, or that of the Remonstrant preacher Jan Uytenbogaert of 1635—one is struck that Rembrandt here permitted himself less freedom. He now tried with the etching needle to achieve pictorial effects, which he had not needed in the little portrait of Saskia or in his own portrait with soft cap of 1634. In both the Sylvius and the Uytenbogaert portraits, it is primarily the shadowy parts (borrowed from his paintings) on the arm directed at the spectator, and the strong contrast between the light on the face and the dark background (introduced in the later stage of the portrait of Uytenbogaert), that do violence to the fine open work of the etching. Why did Rembrandt sacrifice the blond effect of the first state of Uytenbogaert's portrait, in which a few touches of the needle sufficed to establish so lovely a counterbalance between the still life of books and the curtain? For whatever reason, he gained but little plasticity by his introduction of the alcove-like darkness behind the head in the second state.

Much was still contradictory in Rembrandt in these years. He had not yet given up his ambition to make large prints, and it appears from the painted grisaille sketch of the *Ecce Homo*, which must have

been set up as a preliminary study for the print, that he also continued to regard etching as a reproduc-

124 tive technique. The large *Ecce Homo* of 1635 (also known as *Christ Before Pilate*) came into being with difficulty—an etching uneven in execution, with some beautifully characterized heads next to work of considerable roughness. It has been assumed that the greater part of this print was a studio piece in which Rembrandt himself executed only the figure of Christ and a few of the heads directly below. In one state of the print this central section has not yet been introduced. Therefore, it is argued, the master laid no more than the last hand to a piece wrought almost wholly by pupils. However, no matter how much one may wish to believe this, it appears from other prints of this time that Rembrandt's work still bore ready resemblance to the *Ecce Homo*. One need only compare it with *St.*

119, 110, 95 *Jerome Kneeling in Prayer*, with the little etching *The Tribute Money*, and with *The Strolling Musicians*. These prints contain the same monotonous black, a result of too methodical work. It is also pointless to ascribe *The Strolling Musicians* to a pupil; this etching has merit enough to have been done by Rembrandt, if one notices how directly and spontaneously the figures have been set down.

In these years Rembrandt's power lay especially in his response to reality. This direct response makes

121, 125 the prints of *The Pancake Woman* and *The Great Jewish Bride* his masterpieces of 1635. They remain
114 more compelling than the cleverly executed religious prints, such as *Christ Driving the Money-Changers*
112 *from the Temple* and *The Stoning of St. Stephen*, in which he used techniques borrowed from Dürer and Rubens. His interest in children, which arose during these years and which is attested by his many drawings of mothers with children, is first to be seen among his etchings in *The Pancake Woman*. Perhaps he was inspired in this case by Adriaen Brouwer's hastily scribbled sketches. Only Brouwer knew how to note down various interrelated movements so quickly and accurately. In Rembrandt's print the sole resting-point is the old woman, who focuses her attention imperturbably upon her frying-pan. Round about her, in a seemingly arbitrary dance of lines, he has sketched a mobile circle of children, capturing their eager expectancy with extraordinary effectiveness.

The Great Jewish Bride, so called because the print was once thought to portray a daughter of Ephraim Bueno, was created with far greater solicitude than was *The Pancake Woman*. Rembrandt probably had Saskia sit as his model when, after drawing his young wife in the hands of her hairdresser, he thought to make an etching of her as an allegorical figure. Before this idea occurred to him, he must already have drawn the head on the plate with an etching needle and made several impressions of it. In the first state of this print the hair is considerably shorter than in the completed sheet. The shorter hair style also occurs in a sketch at the National Gallery in Stockholm of a monumental figure with scroll in hand, from which it is no easier to judge than from the print whether Rembrandt intended to represent a Minerva or a Sibyl.

In the further development of the first design the hair is spread out copiously to cover the whole light bodice, and on the plate the heavy, fur-trimmed robe is even more broadly draped than in the drawing. It is possible to trace these changes very clearly, as well as smaller ones that were introduced in later states—more clearly, certainly, than alterations in *The Pancake Woman,* which was apparently drawn on the plate directly from life. Yet there was in the latter just as much precedent deliberation and perhaps also modification—evident divergencies from the first sketch, which is in the Print Room at Amsterdam, occur in the later states, which also include additions taken over from other sketches. Notwithstanding all these changes, both prints retain an indefinable contact with reality. Not without reason was *The Great Jewish Bride* for so long a time thought to be a portrait.

The growth of an artist comes in sudden spurts as he discovers new horizons. To be sure, these leaps and bounds alternate with moments of standstill or of apparent backsliding into earlier styles, making it almost impossible to indicate the precise year in which a truly new turn in the creative process begins to manifest itself. Only by noticing the changes in an artist's handling of subject matter can a process of maturation be observed. An unmistakable ripening in Rembrandt's graphic art is evident in 1636. He is no longer attracted to the *grivoiseries* of 1631, the urinating man and woman; and attracted as little to his earlier, strongly charged scrawls of beggars, which, unlike the acutely observed *Quacksalver* of 1635, had served special purposes or had been inspired by other artists. His increasing maturity can be read in his confrontation of Saskia and in his far more human approach to the Bible. Rembrandt now evaluates and understands with an adult mind.

66, 67

123

In this year he also freed himself of the idea that graphic art should be able to profit by imitating the technique of painting. His etching line more and more adapts itself to the subject, following a course wholly different from that prescribed by the great opposition of light and dark in the paintings. In *The Return of the Prodigal Son,* this line is raw and unruly; it is tender, velvety, and melting in the transitions that occur in *Abraham Caressing Isaac* of 1637. The moods in which the prints originated now dictate the line.

129

134

Rembrandt's maturing insight can be perceived most plainly in *The Return of the Prodigal Son.* For his interpretation of this ancient subject he started out from a woodcut by Maerten van Heemskerck. Apparently he did not greatly change the composition of the Haarlem master; even the gestures of the two principal figures correspond. And yet, everything is different. Like Shakespeare with his Julius Caesar, so Rembrandt animated the traditional subject with a completely new spirit. Heemskerck helped him only to find the theme. Rembrandt projected the Bible story into his own time—for him the drama itself was timeless. With a few strokes he captured the gist of the story's epilogue: the

intense emotional release of the wastrel son, and the all-forgiving embrace of the father. This duality forms the chief accent of the print. The subordinate figures look on with sympathy or turn shyly away from such raw emotion. Our attention is also strongly attracted to the stone steps, drawn in acute detail, and to the staff that has fallen from the hand of the wanderer; both tell us that the Prodigal Son again has firm ground under his feet. The landscape in this print plays scarcely any role; it is but vaguely indicated—a distant looming of hills and trees, and some people with a herd. It is as though the past of the Prodigal Son were fading away in the haze.

100 Rembrandt's art also appears more mature in the two portraits of Saskia from this year, and particularly so if they are compared with the little 1634 etching *Saskia with Pearls* and with the exuberantly painted self-portrait with Saskia on his lap (now in the Dresden Gallery). In one, the etched double
127 portrait of 1636 showing Rembrandt at his work table with drawing pen in hand, Saskia is a pensive
128 companion who has laid aside all festivity. But in the other, the sheet of studies of six heads, we see for the first time who Saskia actually was. With all the tenderness that was in him, Rembrandt has placed her there amidst other heads of women. She may also have served as model for the other jottings, but in them Rembrandt paid no attention to resemblance, because the form of a cheek, the shadow cast by a broad-brimmed hat, were more essential to him. These details give to the three lower portraits a powerful relief that of necessity forms a contrast to the portrait in the middle. Thus around the center portrait grew a frame of spontaneously recorded sketches, which counterpose the scintillating dialogue of the soul with the charming play of light and dark, of picturesque attitude and attire. Yet the whole is at once and indissolubly fitted together in a completely natural way by the broadly spaced lines, which fill the sheet and bind the sketches one to the other.

This combination of so much freedom with so much certainty, comparable in its way to the creation of a new verse form, places Rembrandt far above anything achieved in the graphic arts by his contemporaries. Not until the nineteenth century were these *griffonnements* fully appreciated. Even the eighteenth century, ever ready for beguiling experiments, did not follow up this instantaneous recording of the fleeting idea. Was Rembrandt himself able to continue at so high a level? Not in his
131 sketch the following year of three heads of women, including one asleep; nor on the sheet containing
132 three studies, one of Saskia leaning her face on her right hand. In the latter etching (reproduced here only in the first state), the head of a shawled woman, drawn in heavy relief, does definite damage to the first design—the sketch of Saskia alone. This is the same Saskia, somewhat whimsically expressed, of the sheet with six heads, and the perfect design occupies the space so magnificently that no intrusion can be tolerated. In his penetration of the art of the portrait, Rembrandt again has reached the same
6 high level of the small portrait of his mother from 1628. He achieved something of this same simplicity

in the 1636 portrait of his neighbor, Samuel Menasseh ben Israel, which is executed so plainly and tautly.

This perfect balancing of separate elements in sketches re-emerges only in his later genre prints. Two other plates of studies date from 1638, but Rembrandt was too preoccupied with other things at that time to bring himself to weigh one small notation against another. After 1639 he shifts the balancing of elements entirely to his larger compositions, applying in them the lessons learned from his free sketching.

The differences in etching line determined by subject matter, mentioned above, are readily observ-
able if the rough, little-differentiated lines in *The Return of the Prodigal Son* are compared with those of the print of the old father caressing his son. The subject of the latter print is explained at some variance. There is question whether it represents Abraham and the young Isaac, following the 1679 inventory list of the collection of Clement de Jonghe, or Jacob and Benjamin. The second interpretation rests on a drawing of Joseph relating his dreams to Jacob, who appears with Benjamin in a pose similar to that of the print. In both of the etchings Rembrandt expresses the feelings between father and son. Yet his mode of drawing in the two prints is altogether different. None of the spontaneity of the *Prodigal Son* remains in *Abraham Caressing Isaac*. The tenderness with which the old man touches the child is conveyed by cobwebby lines, carefully drawn as though with a silverpoint, and this cautious style establishes a whole relationship between father and child difficult to reconcile with the relationship between Jacob and the happy-go-lucky Benjamin. Rembrandt also used the same fine, tender line in
the small 1638 print of St. Catherine, for which Saskia served as model. In this etching, however, his hand moved more playfully upon the plate, as if recording a passing fancy.

The years between 1636 and 1640 were perhaps the most carefree that Rembrandt ever knew. The only shadow over his existence was the frailty of the children Saskia bore him. Of her four babies the only one to survive infancy was the last, Titus, born a few months before her own death in 1642.

Earlier in this period Rembrandt's light-heartedness is manifest in the enthusiasm with which he collected works of art and "curiosities." Time after time his name appears among the buyers at auction sales. His large expenditures indeed aroused the envy of some of Saskia's relatives, who accused the young couple of extravagance and display. Rembrandt was nevertheless not to be frightened into for-going any expense, and in 1639, when he bought the house on the Breestraat, he recklessly loaded him-self with the heavy burden that eventually proved his undoing.

Of his art purchases, prints and drawings formed a large part. Rembrandt's universality of interest, his openness to every trend in art, is most clearly evident in his collection. In having such interest he is

also a phenomenon among his contemporaries, for they assembled little more than examples bearing out their own artistic ideas. Compared to Rembrandt, even the artists of the eighteenth century collected in a traditional and conservative manner.

The impressions aroused in him by his collection enriched Rembrandt's imagination ever more powerfully. As he handled and studied his new possessions, his creative power was excited and his picture of the world greatly enlarged. Many writers have attempted to ascertain Rembrandt's borrowings from other artists in the expectation that, by identifying more or less concrete transcriptions, they would be able to establish his relationship to the art of his older countrymen and to that of the Italians and Germans. This is looking at the matter too narrowly, however. Rembrandt's constant preoccupation with the art of former centuries was not limited to borrowing motifs; it also served to heighten his imaginative faculty to the utmost degree. His world, so hermetically sealed to his contemporaries, was the world of the imagination, nourished by impressions from older art. Thus he created his own domain, to be entered only if one maintains sufficient distance from reality.

This is not to say that Rembrandt now lost sight of reality. Realistic elements emerge time and again in his drawings and in his rapidly scribbled etchings, but no longer with the detail of his earlier years. By 1638 he had virtually outgrown the Baroque realism of the years from 1630 to 1636. More than once, however, a seeming hesitation may be noticed between his tendency toward excessive detail and his rapid recording of a first inspiration. For example, *Adam and Eve*, with its dragon-like serpent borrowed from Dürer's engraving, is not yet free of descriptive elements; and in the small print *Joseph Telling His Dreams*, despite the effectiveness of the characterization, Rembrandt also has not broken loose from his preliminary grisaille sketch, which he followed quite faithfully here.

He gave his imagination free rein in *The Death of the Virgin*, his first print in large format in which he no longer attempted to emulate engraved reproductions. Sketched in rapid strokes, this sheet must be judged by early impressions, in which the darker accents—the reader on the left, the armchair in the right foreground, and the curtain on the right-hand side—retain the powerful burr of the dry point. In these early impressions, too, the light around the bed and around the angels poised above it emerges clearly. The room itself, barely defined by ceiling rafters and the wall at the left behind the bed, can be made out only with difficulty in this radiant light. The effect is just what Rembrandt wanted—the illusion of a space that has lost its boundaries. This light is entirely different from the streaming light that breaks through walls in Rubens' pictures.

In his recent book, *Rembrandt's Etchings*, Ludwig Münz has justifiably suggested that the idea for this print probably came from Dürer's *The Birth of the Virgin*. A year earlier Rembrandt had purchased Dürer's series of prints on the life of the Virgin, to which this woodcut belongs. From *The*

140

139

147

Death of the Virgin, also one of this series, he borrowed the motif of the boy who holds the long staff. Yet everything in Rembrandt's print differs from Dürer's. For example, he introduced a group of women, even though the old story suggests the presence only of the apostles. Rembrandt thus ignored the traditional version and in place of it set up his own interpretation, perhaps influenced by his memory of the stained-glass window by Dirck Crabeth in the Old Church at Amsterdam. He gave his new interpretation a strong Old Testament stamp, noticeable in the boy's long staff, which here replaces the crozier of Dürer; Rembrandt used a similar staff several times in depicting subjects from the Old Testament. This stamp is even more apparent in the introduction of the reader, a figure Rembrandt borrowed from Jewish rites in his own Amsterdam neighborhood. By this innovation he placed the event in a clear historical setting: that of a richly colored past, compounded of worldly data.

146 The same re-creation of the past is to be seen in the small print of the young couple confronted by Death; here Rembrandt takes up the medieval theme of the Dance of Death without understanding its exact purport. Probably he was acquainted with Holbein's *Dance of Death*; but this encounter with Death, who rises from a tomb with an hourglass in hand, is more likely Rembrandt's paraphrase of Dürer's *Promenade,* where Death with the hourglass hides behind a tree.

152 Even the seemingly realistic delineation of Jan Uytenbogaert, at work as receiver of public revenue, must contain reminiscences of earlier paintings of money-changers, such as those by Quentin Massijs and Marinus van Reymerswaele. Uytenbogaert and his young servant are indeed clad in sixteenth-century costumes, making this portrayal of the man who helped Rembrandt obtain payment from Frederick Henry for his commission into a genre picture rather than a portrait. If the interior were not so realistically depicted, one could point to a parallel between this print and analogous Romantic pieces from the nineteenth century.

 Rembrandt's feeling for the historical was commented upon as early as 1641 by the painter and writer Philips Angel in his *Lof der Schilderkunst* (Praise of Painting). Rembrandt treated himself to such
149 a setting in his self-portrait of 1639, borrowing the ceremonious pose from Raphael's *Baldassare Castiglione.* Yet despite his fondness for trappings of the past, his glance at the world round about him remained spontaneous and unrestricted. In recording each new impression he made good use of the dry-point technique, by which the line could be engraved directly on the copper, eliminating the minute attention to detail required by biting with acid. One rapidly drawn impression is the little
144 *Skater,* a favorite subject in Dutch art, which attracted Rembrandt primarily because of the figure in action. He used the dry point also in making the first design of certain prints, a procedure that may
148 easily be studied in the sketch *Old Man Shading His Eyes with His Hand*—only the head, arm, and beret
151 are fully worked out—and in the unfinished plate, *The Artist Drawing from a Model.* In the latter print

the dry-point lines follow in general the pattern of the original pen sketch, yet they are so lightly drawn on the plate that no definite contours may be perceived. Only by the further development of the heavily bitten etched parts were these contours finally determined. It has often been remarked that Rembrandt was so busy searching for expressiveness that he paid scant attention to recording a contour exactly.

Anyone wishing to understand Rembrandt's development as an etcher must pay particular attention to his increasing use of the dry point. It is not always easy to perceive where he used this instrument, because techniques overlap more and more in his later work.

155 The initial design for *The Beheading of John the Baptist* of 1640 was certainly done with the dry point. In early impressions of this plate, which are extremely rare, the sharply drawn contours are fairly distinct. However, Rembrandt re-bit some of the contour lines during the etching process. He must have worked on this etching very cautiously, so that the fine first design was not altogether lost. As a result of careful biting, the lines in the background remained shallow, and this part came out gray rather than black in the printing, providing too little contrast with the figures in the foreground. A re-working with the dry point was necessary to bring out the darker contours, and the modeling of John's body was strengthened with very fine hatching.

It seems to me that Rembrandt must have come to this painstaking technique after he had first in-vestigated to its furthest limits the process of pure etching. He conducted this experiment, if it may be

154 so called, with the larger *Presentation in the Temple*, which also dates from 1640. In this print he at-tempted to achieve a rich differentiation of fine tints solely by means of the etching process, and in many respects he succeeded. But, exacting as he always was of himself, he later subjected the etching to a revision with the dry point, because the special meaning he wished to convey had not yet received full expression. He strengthened the contours of the kneeling Mary and, by powerful hatching, darkened the robe of Simeon, who holds the child. The swarming light that glides over both of these figures in the first state (here reproduced) is lost through this reworking. In the later state these figures do come out more clearly, and the fine gray tonality of the first version is not destroyed. The prophet-ess Anna, who served in the temple day and night, has become the center of the print in this second state. She stands in the full light, and it is clear that Rembrandt, who let the Holy Spirit hover over her, saw in her the main figure of the print.

In Rembrandt's work various subjects that he had handled earlier frequently return. Their inter-pretation is usually changed, having evolved along with the circumstances of his life. With him, fuller experience led to a deepening of the subject. Certain themes can be pointed out—the visit of God or of

an angel to human beings, the revelation of the divinity of Christ, the solitary meditation of a recluse or philosopher—the treatment of which over the course of the years bears witness to an ever more profound understanding of the world. In 1640 Rembrandt lost his mother, whom he so often had portrayed with love. Her death and his poignant memories of her, the central figure of his youth, may well have led him to focus his attention upon the aged prophetess Anna in *The Presentation in the Temple*. Far more than in his *Presentation* print of 1630, the old woman has become the principal figure in the composition. It is possible that his frequent delineation of the Tobias story had its origin also in the relationship between son and parents. This theme comes up again and again in his sketches during the 1640's. Is it a sign that Rembrandt now looked at his own bond with his parents in a new and different light?

During the same period landscapes also begin to appear in his etchings. Attempts have been made to ascribe Rembrandt's suddenly aroused love for nature to his anxiety about Saskia's ill health, which may have driven him to seek consolation in the loneliness of nature. This explanation is surely superficial. It takes no account of the changes that were occurring in his relationship with the outside world. In the decade 1630–1640 Rembrandt composed landscapes around particular motifs—sunlight abruptly streaming or a threatening storm, scenes with an obelisk or with ruins—that very often contain an allusion to the past, and arise from the same disposition that led him to fill his figure paintings and etchings with historical allusions. The high point of all such work is *The Night Watch*, completed in 1642. In his recently published book, *Rembrandt Fecit 1642* (Amsterdam, 1956), W. G. Hellinga contends that this painting is an allusion to Joost van den Vondel's drama of 1638, *Gijsbrecht van Aemstel*. Even if one does not agree with this opinion, one must nevertheless see in *The Night Watch* a glorification of Amsterdam and of the power of the Dutch Republic.

Before 1640, therefore, Rembrandt's view of landscape was decidedly romantic. Soon after that date, however, he turned away from this view in his drawings and etchings. The early landscape etching *House and Trees beside a Pool*, which was probably inspired by Elsheimer's drawings, remains at the boundary between fantasy and reality, but in the landscape *Cottage with a Large Tree*, reality approaches much nearer. However, upon closer examination of the blending of the foliage masses, the thatched roof of the cottage, and the tumble-down haystack, there appears to be a good deal of similarity to the early small etching. In the development of Rembrandt's landscape prints, *Cottage with a Large Tree* forms a turning point, as does the large *Presentation in the Temple* among the figure compositions.

Like the religious print, this landscape is wholly etched. Rembrandt employed a style of drawing that can be compared to calligraphy. Something of this style is also to be found in the etched *View of*

159 *Amsterdam* and in the landscape drawings of this period. The foreground of the Amsterdam print is drawn with long strokes, lines that swing from the foreground to the background; they create the connective link along which the eye covers the distance to the horizon. One glance at the landscape

164 *Cottage and Hay-Barn*, etched beside the Amstel River, is enough to show that Rembrandt gave up the calligraphic manner in 1641. It is as if he now let his eye travel more thoughtfully over the scene, submitting himself more deeply to the spell of nature's mood.

 Nonetheless, this change in approach to the landscape does not come from a suddenly awakened feeling for nature. Rembrandt never knew the out-of-door life so uniquely represented in the art of Claude Lorrain and Elsheimer. For him nature remained "motif," a setting in which light and shade alternate more subtly than within an interior. It brought him a new treasury of forms, which he began to explore with new means. This above all was significant for Rembrandt. There are limitless possibilities for contrast between the minutely etched, gossamer-like background and the plump, shadow-bound forms of the cottage and hay-barn. And how much livelier than in the *View of Amsterdam* is the drawing of the grass and plants along river and path, now that they serve as foil to the fine background

175 details. A year later Rembrandt repeated this scheme even more subtly in *Cottage with a White Paling*; it is both simpler and opener in the background, and more exhilarating in the play of light and dark that results from the potent opposition of the wooden fence and the darker roof of the farmhouse.

160 Only once, in *The Windmill*, did Rembrandt let himself go in more detailed description. It was not the landscape that delighted him here, but the contrast between city and country. The mill that he etched stood at the edge of Amsterdam; just beyond the bulwark upon which it was built began the flat countryside. What attracted him was the rarefied emptiness of the polder land, against which the verticality of the windmill thrust up with prodigious force. To counterbalance the almost ethereal expanse of space, he had to develop the rich details of this structure so typical of the Dutch lowlands. Contrast thus rules this aspect of the print also, but its major interest remains the realistic depiction of a piece of architecture. Such realism diminishes steadily in his later landscapes.

166 During 1641 and 1642 Rembrandt wrestled with the problems of *The Night Watch*. It is possible to see the repercussions of this struggle in various prints. If one looks at *The Triumph of Mordecai*, which is enacted before an archway resembling to some degree that of *The Night Watch*, one is immediately struck by the similarity of the groupings in both print and painting. Haman here takes the place of Banning Cocq. The gesture with which he turns to the spectator as if he were an actor is not unlike that of the captain of the civic guard. So, too, the curious crowd, armed with lances indicating its movement, surges forward through the portal. In order to isolate Haman more tellingly, the modeling

of his head is powerfully worked out, and the figures to the left of him are plunged into half-shadows. Rembrandt himself, with Saskia, takes part in the occasion: from a sort of balcony between two pillars, a setting perhaps inspired by the interior of the new Amsterdam Theater, he displays himself as Ahasuerus beside Esther. The print gives the impression of having originated from a rapid design with the dry point. Thereafter the framework was strengthened and the etching further embellished by touches of the dry point, so that a brilliant play of light and dark was created.

216 Many of the preliminary drawings for *The Hundred Guilder Print* are also related in various ways to Rembrandt's etchings of this period. In some, echoes are found of the figures that grace the teeming 168 *Triumph of Mordecai*; others recall *The Baptism of the Eunuch* of the same year (1641), the *Three Oriental* 174 *Figures* (perhaps an illustration of the dispute between Jacob and Laban), or the small print called *Man* 180 *in an Arbor*. Rembrandt wavered in these years, as indeed he would for so long, between the loose, purely suggestive style of *The Baptism of the Eunuch* and the elaborate, almost engraving-like style of 178 *The Flute-Player*, in which acute attention is paid to each detail. *The Triumph of Mordecai* was wrought without a single change, and only a small modification was made to *The Baptism of the Eunuch*. *The Flute-Player*, however, went through five states, in each of which every detail was subjected to revision.

The difference can be explained only by the fact that the first prints mentioned were closely connected with Rembrandt's other work, whereas in *The Flute-Player* he attacked a completely new problem. His prints were sometimes in advance, sometimes in retard, of his paintings. In both, paintings as well as etchings, the lyric alternates with the heroic. The heroic finds its supreme expression in *The* 82 *Night Watch*; the lyric, which was evident as early as the small print *The Holy Family* of about 1632 and which came out with greater maturity in the depictions of Saskia, received a melancholy accent in 172 1641 and 1642. From the oval *Christ Crucified between the Two Thieves* emanates a grief-stricken dismay, conveyed by the darker areas under the cross, where the mourning women are crouching. In *St.* 182 *Jerome in a Dark Chamber*, an intensified darkness spreads itself over the whole print. Here the mood is oppressive, as if weighed down by the approach of night, which brings melancholy and despair.

171 Sadness also pervades the non-religious prints: the tender *Portrait of a Boy in Profile*, in which some see a likeness of the young prince William II of Orange; and especially the mysterious little portrait of 161 a young nobleman clad in sixteenth-century costume—a recollection of a portrait by Lucas van Leyden. One wonders who this contemplative young man can be as he sits staring into infinity, a cross hanging from a chain around his neck, and a pen in his right hand. Is he a historical figure, or did Rembrandt use this disguise only to indicate that worlds lie between the life of this daydreamer and that of his 162 alter ego, the card-playing scalawag depicted in the smaller, roughly etched print? The same sort of melancholy possessing this somber young aristocrat envelops the Aristotle which Rembrandt was

commissioned to paint years later for the Sicilian nobleman Don Antonio Ruffo; and to his *Aristotle Contemplating the Bust of Homer* Rembrandt in 1661 added a vigorous, active Alexander.

Between 1643 and 1649, during which time *The Hundred Guilder Print* was completed, Rembrandt returned again and again to compositions in which light and dark alternate. The darks, however, are filled with fine half-lights. They no longer breathe the oppressive gloom of the chamber in which St. Jerome sits sunk in melancholy meditation. Sometimes warm lamplight twinkles through branches, as in the small *Rest on the Flight to Egypt* of 1644; sometimes a glimmer of foliage is mirrored in darker water, as in the print called *The Boat-House*. More and more often these blacks are worked with the burin until they take on a velvety tone approaching that of a mezzotint. They bear the same Rembrandtesque stamp as the chiaroscuro of his paintings, out of which colors emerge in subdued half-tints as from a golden twilight.

188

198

In landscape, also, Rembrandt opposed light and dark in their full power, yet only once: in *The Three Trees*. The theme of this print—the retreat of a summer thunderstorm—lent itself admirably to this contrast. At the left lowering cloud masses still hang above the city and gusts of rain stream down over the land, while at the right above the dike and behind the trees the sky is already clear and light, so bright that it casts the foreground into shadow. On the dark slope of the dike a courting couple sits concealed in the bushes, and at a little pool stands a fisherman, whose wife beside him barely catches the light. The print is a Dutch Arcadia, composed with great deliberation and full of allusions to the pleasures of the out-of-doors. To the right, on top of the dike, the seated artist looks out over the countryside newly bathed in sunlight. A wagon loaded with market-goers rattles past. Between the city on the horizon and the water at the foot of the dike stretch canal-crossed pasture lands dotted with grazing herds. The high wind breaks the sky open and drives the clouds scudding away, and in its lower reaches plays with the tops of the trees.

185

No preliminary study for this print has been preserved. A drawing that Rembrandt made a decade later of the Diemer dike, which leads east from Amsterdam to the village of Diemen, permits a conjecture that he was inspired for the etching at the same spot. The German art historian Jaro Springer suggests, in his catalogue of the etchings of Hercules Seghers, that *The Three Trees* may have originated from a reworking of one of Seghers' unfinished plates. Rembrandt perhaps introduced the streams of rain at the left to cover up sections of Seghers' work. It has also been thought that Rembrandt simply made changes on one of his own plates, started with a different idea. He may have superimposed the piled-up clouds upon figures of angels and cherubim originally on this plate. Both theories are beyond proof. Most probably, however, the obvious changes in this plate were necessitated by a completely different conception of the left side of the print. The fisherman and his wife give an impression of

having been introduced later, and the somewhat uncertain lines at the left point to a thorough revision of this area. It is certain that the print must have existed in various states. Presumably the dike with a single tree and a few houses formed the initial subject, and during the emendations Rembrandt was moved to include the more tempestuous natural events, combining them with the motif of bucolic placidity. This was the first and only time Rembrandt gave dramatic content to a landscape etching.

195 In the view called *The Omval*, the name of a spit of land along the river Amstel, Rembrandt in 1645 once more cunningly inserted the arcadian motif of a love-making couple concealed in shrubbery. Here the lightly sketched background is only a supplement to the study of the old willow tree in the foreground. The strength of the contrasts between light and shade is almost effaced by the fierce midday glow that shimmers over the river and filters into the shadowy places. This play of light is so ephemeral, so tremulous, that the impression of a summer day becomes almost palpable.

If one examines Rembrandt's use of deep black in these years, it appears that, with the exception of *The Hundred Guilder Print,* he employed it only in his etched portraits. In 1646 he placed the posthu-
205 mous likeness of Saskia's kinsman, the minister Jan Cornelisz Sylvius, who had died in 1638, in an oval frame, out of which the old man leans as if to address an imaginary congregation. His parchment-like face comes into the full light, while his body melts into the background shadows. For this portrait Rembrandt used a compositional medium that Frans Hals had introduced in the 1620's. Unlike Hals, however, he does not use it only for illusionistic effect, but with the symbolic by-purpose of permitting a dead person to appear in the light of the living.

206 The portrait of Ephraim Bueno of 1647 shows the physician descending a staircase in a dark vesti-bule. In the dimness the light from the street, reflected from the tile floor, spreads a sheen across the solemn black of the man's garments. Like Sylvius, Bueno is represented in his professional capacity. So much black lends a solemnity to this print, emphasizing the earnest and thoughtful expression of this sympathetic man.

208 Rembrandt chose yet another way in 1647 to portray his young friend Jan Six in his study. The dusky room suggests intimate comfort, an atmosphere of peaceful meditation and poetic contempla-tion. The objects lying about, just touched by the light, attest to the literary and worldly activities of the young patrician. Each detail of the print is elaborated almost undefinably with etching and en-graving needles, and a dry point has been used for some of the finishing touches. In spite of such profuse detail, the harmony of space and figure is so transcendent that one is arrested primarily by the poetry of the whole. Later one realizes that this poetry is most lucidly expressed in the counte-nance of the young man absorbed in his reading, although his features are blurred by the strong light.

212, 213 A fourth portrait is linked directly with the other three. In it Rembrandt has sketched himself by

the window of his studio. The surroundings are indistinct; there is only the white light from the window and the darkness of the room behind. These strong contrasts combine to shut the artist off from contact with the world. Rembrandt has followed with full concentration the play of light and dark upon his own face. His ability to develop its every nuance is readily apparent if one compares the first and second states of this print. This is Rembrandt, the man who, according to Filippo Baldinucci, would receive no monarch if he were engrossed in his work. Each fractional part—the hand, the eyes, the compressed mouth—bespeaks an inflexible will.

As Rembrandt worked out the problems posed by these prints, he was consciously or unconsciously preparing himself for the completion in 1649 of the great work that must have occupied him for *216* several years: *The Hundred Guilder Print*. The dark areas of this masterpiece have the velvety sheen of the interior in the portrait of Jan Six, but at the same time the subtle transitions into chiaroscuro are imbued with all the finesse of the self-portrait. The delicately etched parts at the left, where the Pharisees turn their backs on Christ, preserve the thin, silverpoint touch of such finely etched studies from *190, 193, 192* 1645 as *The Rest on the Flight to Egypt*, *St. Peter in Penitence*, and *Old Man in Meditation* (can he be Archimedes?). Yet juxtaposed with this section are the figures of the rich young man and the disciples gathered near Christ, portrayed with the same adroit alternations of light and dark that throw Abra-*196* ham and Isaac into relief against a lightly shaded background in the print of 1645, or that silhouette *204* against the white of the paper the little beggar woman of 1646—that gem of meticulous etching.

Preoccupied though he was with the complexities of *The Hundred Guilder Print*, Rembrandt was nonetheless able to turn his thoughts to other things. And how different, even contradictory—the term comes from Frederik Schmidt Degener, late director-general of the Rijksmuseum—these thoughts proved to be: they embrace the trivial, in the etching which the Dutch somewhat abashedly *201, 210* call *Het Ledekant* (The Bedstead), and the comic, in the bespectacled St. Jerome under a willow tree. Is the scene of *Het Ledekant* really trivial, however? In depictions of Leda with the swan is there not actually more vulgar triviality than in this celebration of true sensuality? *Het Ledekant* offers strong evidence that Rembrandt was the most unconventional artist produced by the seventeenth century. How people have scorned his nude studies for diverging from idealized beauty of form! The eighteenth century could only respond to this magnificent portrayal of the act of love by giving it the piquant title *Le Lit à la française*, and the prudish nineteenth century often ignored the etching altogether.

The intention behind such prints will always remain conjectural. One can only presume that Rembrandt's lively spirit found it necessary now and then to shake free from the hard discipline enforced by his great paintings or etchings. A hint in support of this hypothesis may be supplied by *St. Jerome*

210

beside a Pollard Willow, in which the holy man and his faithful lion were gaily added to the highly finished study of the tree. Further evidence may perhaps be seen in the setting provided for the two

202

male nudes in the studio. This print must have grown like Topsy, following no particular plan. After completing the nude studies, the artist rounded off the picture by sketching a domestic scene in the background: his housekeeper playing with the infant Titus in a curiously modern wheeled walker.

194

One religious etching only, *Christ Carried to the Tomb* of 1645, conveys a Bible-inspired atmosphere similar to that of *The Hundred Guilder Print*. Just as he had done before, Rembrandt adapted a traditional theme to his own thoughts and purposes. Customarily the theme of Christ borne to the grave was combined with that of the entombment. Rembrandt, however, isolates the first from the more general theme, representing the progress of the mourners from the cross to the tomb. Four disciples carry Christ's mortal remains with measured tread, as if they were bearing a prince to his sepulchre. Each figure is immersed in its own deep grief. There is nothing external about this tragedy: Rembrandt is here far removed from the Baroque.

216

In certain respects *The Hundred Guilder Print* more nearly represents the spirit of the age. The light and dark that divide the sheet spoke positively to the imaginations of Rembrandt's contemporaries. Perhaps, in the contrast of the dazzling white in which the arguing scribes are placed and the comfort-giving half-dark out of which the lame and halt make their way to Christ, they saw a symbol of reason measured against the inscrutability of the love of Christ, which is beyond reason. On one impression of this print the seventeenth-century poet H. F. Waterloos wrote: "The Scribes scorn the Faith of the saints, but Christ's divine glory transcends it all."

At first Rembrandt must have come slowly to the antithesis of light and dark in this print; at least, everything points to the fact that the background, especially in the darkest parts, was drastically revised. From the stylistic differences between the subordinate figures it may also be concluded that some of them, such as the woman and child in front of Christ, were added later. A change in the subject of the print must have brought the artist to these emendations. The grouping of the scribes and the arrangement of the sick recall a much earlier period, and probably the original plan comprised only the benediction of the children or the healing of the sick. Over the years, however, Rembrandt's vision of the subject broadened. He drew Peter nearer to Christ, his head raised in anxious inquiry. And at last, after including the rich young man seated in dejection at Jesus' feet, he felt compelled to add the camel to complete the parable. To do so he had to alter the whole right side of the print.

Such a revision of subject matter led to combining in one representation the whole nineteenth chapter of the Gospel of St. Matthew, wherein the essence of Christ's ministry is set forth. This, above all, is the significance of *The Hundred Guilder Print*. For Rembrandt the scriptural texts were not, as

such, an incentive to good works. The blessing of the children had too often suffered pictorial abuse in the name of doubtful charities. In his print Rembrandt glorified the message of Christ in its most universal meaning. Perhaps, therefore, it may be correct to accept the idea of the Dutch art historian Cornelis Hofstede de Groot, who found the features of the two disciples to the left of Jesus reminiscent of Socrates and Erasmus. In contrast to the hopeful skepticism of the Peter-Socrates and the hesitant caution of the tall-hatted disciple with the features of Erasmus, Christ's all-embracing gesture of welcome and benediction appears that much more triumphant.

When the rich content of this masterpiece is considered, one comprehends why the etching has come down to us with the noncommittal title of *The Hundred Guilder Print*. The whole world cannot be summed up in a descriptive title. However it may have received its name—the eighteenth-century art dealer and collector Pierre Jean Mariette records in his *Abecedario* that Rembrandt repurchased the sheet at a sale for the price of a hundred guilders—this print is its creator's confession of faith.

Of Rembrandt's life throughout the ten years after Saskia's death in June, 1642, not much is known beyond the little that can be read in his work and in the few deeds and legal documents having to do with the trumpeter's widow Geertje Dircx. Rembrandt had taken this woman into service for the care of his son Titus, who was born in September, 1641. She became very attached to the child, remembering him with affection in her will; but symptoms of a mental deterioration, to which she succumbed about 1656, gradually became so evident that her continuation in the artist's household was impossible.

The name of Hendrickje Stoffels, daughter of a soldier, first appears as that of a witness in one of the documents relating to the dispute that arose when Rembrandt dismissed Geertje Dircx in 1649. Hendrickje was apparently employed by Rembrandt in that year as replacement for Geertje, and until her death in 1663 she remained the devoted caretaker of the little family. She was about twenty-six years old when she entered the house on the Breestraat; in 1652 she bore Rembrandt a daughter, Cornelia. This child and Titus' daughter, born in 1669, were to be the only direct family members to survive the painter.

A renewed interest in the life of women and children is traceable in Rembrandt's work during these years. In his etchings of 1651 and 1652 the child plays an important role, for Rembrandt transposed his thoughts into prints that dealt with the infant Jesus. The "night pieces," *The Flight into Egypt* and *The Adoration of the Shepherds*, were created in those years, and from 1654 dates a group of prints that is wholly concentrated on the life of the Christ Child.

Hendrickje herself does not appear in these etchings. Rembrandt painted and drew her repeatedly,

225
234

but did not depict her in his graphic work. Perhaps it is not unreasonable to assume, however, that her tender love for her baby inspired the artist's depiction of the Virgin and Child in a room with a playful cat. If this be accepted, then the watch that Joseph keeps by the window may take on added significance. When Rembrandt created this print after Mantegna's *Madonna and Child*, he must have thought about himself and his relationship to the miracle of new life in his little family. Because of his advanced years, did he perhaps also feel that he was something of a spectator of this young happiness? In any event, it is remarkable that in all his religious works created after 1650, Rembrandt seems to avoid personal involvement. Instead, he gives a central place to revelations of the miraculous and of Christ's divinity.

How deeply he was concerned with the revelation of the divine appears from the etching *Faust in His Study*, which must have been made about 1652. This print has always been difficult to explain, although a short time ago it was discovered that Rembrandt had taken the cabalistic anagram on the luminous disk from an amulet to which magic power was ascribed. Moreover, in the practice of magic, the mirror at which Faust is looking signifies the hidden side of the world. This mirror is pointed out to Faust by an apparition emanating from but concealed by the radiant disk. What meaning did Rembrandt attach to the words of the anagram? Had he learned its secret from his neighbor, Samuel Menasseh ben Israel, who was deeply interested in the occult? In any event, he used the magic formula to suggest unknown powers and thereby to point to the errors of Faust. The First Epistle to the Corinthians says: "For now we see through a glass, darkly; but then face to face." It is as if Rembrandt, pondering this line, wished to make clear that Faust did not share in the divine revelation.

Thus there are strong signs to indicate that Rembrandt's attitude toward life and religion was beginning to change after 1650. His work was more and more governed by a few themes. And this concentration can be observed not only in his religious prints; it also breaks through in the landscapes.

Rembrandt's landscapes etched from 1640 to 1645 were constructed of many planes, often enriched with alternation of light and dark. The landscapes in etching and dry point of 1650, 1651, and 1652, however, are much simpler. They usually consist of only one plane, bounded and enclosed by trees or buildings. Their contours are sketched with a few large lines, and in the main the buildings are grouped in such a way as to form a single complex. The simplicity suggests peacefulness and rest. The light is high, and the heavy shadows are reminiscent of a summer day.

In the landscape *Trees, Farm Buildings, and a Tower* the theme of the withdrawing storm, from *The Three Trees* of 1643, is again taken up, but with no dramatic play of light and dark. The vegetation surrounding the farm and the tower is freshly luminous with new light, which has been conjured up with the simplest of strokes and shading; it is as if Bruegel's pen were here employed by Rembrandt.

Only from the shadow on the cluster of trees farthest to the left do we become aware that the dark clouds are moving away. Rembrandt draws with equal subtlety—this time with the dry point alone—the open, water-reflected summer light in which the Diemer dike and the farms at its foot lie dozing,

219 in the little etching of the milkman (recently more accurately identified as a fisherman) with his dog.
221 In a few of these etchings, particularly *Landscape with a Square Tower*, the compacted forms resemble those of a modern draftsman.

Despite all simplification, Rembrandt's resources remained endless in variety. At times his technique
228 approximates that of an Impressionist (in *The Bathers*); again, he turns to Venetian examples (in two
222, 223 romanticized little landscapes, one with an angler and swans, the other with a boat and bridge, which
220 were etched originally on one plate). In *Landscape with an Obelisk* he maintained the open shading of the stone boundary marker because it formed a happy contrast with the finely meshed lines he had used for the farmhouses and trees. This variation, however, was not enough for him. The leap into depth must be more powerful, and therefore he added the dry-point scratches in the foreground.

In 1651 and 1652, working with the simplest possible means—the dry point alone—he created two
242, 231 masterful landscapes: *Clump of Trees with a Vista* and the distant view of Haarlem from Saxenburg, the country estate of Rembrandt's landlord Christoffel Tijsz (because the scene depicted was long thought to be Jan Uytenbogaert's estate near Naarden, this print was formerly called *The Goldweigher's Field*). In these etchings the accidental is completely subordinate to the essential lines of which the print is constructed. At first sight one is pulled into the infinite space that surrounds these landscapes. Only on further viewing do the details speak out.

217 Two years earlier the little etching *The Shell* was created, the only print of that year not a landscape. In it the artist forced himself to the greatest possible accuracy, as if he wished to go back once more to nature's school. Why was he touched just now by the sight of a shell? Perhaps he found epitomized in this fastidious masterpiece the one thing he had so long sought to discover in nature: the simplicity of a perfect form.

The succession of landscape etchings makes clear that Rembrandt's way led to ever greater concentration. His manner of achieving this was through simplification. By omitting all distracting details in the 1654 series of the life of the Christ Child, which has already been mentioned, he gave a concreteness to the various episodes of the story that was lacking in his first renderings of it in 1630. In
253 *The Flight into Egypt: Crossing a Brook*, the black of night impenetrably encircles the fleeing couple;
250 and the lamp in the stall at Bethlehem, in *The Adoration of the Shepherds*, sheds a warm, intimate glow that holds at bay every trace of the world outside. Where the heavenly light pierces through to the
251 interior, as in *The Circumcision in the Stable*, its rays have an almost tangible quality. Rembrandt relived

every phase of the story with a pervading sensitivity to the reality of the events. This is revealed

255 brilliantly in *Christ between His Parents, Returning from the Temple*, in which Rembrandt gave sublime expression to the physical and spiritual communion between parents and child. The earnestness with which the mother ponders the words Jesus has just spoken, and the ecstatic face of the young son, have remained unforgettable through the centuries.

In every etching Rembrandt made after 1650, the essential is said with the most economical means.
232 The old blind Tobit, who has risen upon hearing his son and upset the spinning-wheel in his agitation, and who now gropes his way to the door, has never been portrayed with greater compassion. Even when one knows that Rembrandt here followed a print after Raphael's *The Blinding of Elymas*, one cannot but admit that this is a most poignant representation of a blind man, whose life is inescapably turned in upon itself. Nothing could be more striking than the tension-drawn face or the figure's
236 halting movement, which fills the whole humble room. The depiction of David in prayer is soberer. The head is sketched with a few telling hatch strokes. Since all attention is directed to the figure abandoned to prayer, Rembrandt had no need to work out details.

When, in 1652, Rembrandt returned to the theme of Christ's ministry he forsook symbolism almost entirely, even though three years earlier, in *The Hundred Guilder Print*, he had found this an indispen-
237 sable element. The new trend is apparent in the etching with the misleading title *La Petite Tombe*, a corruption of a Dutch descriptive phrase that was wrongly interpreted. In the 1679 inventory of Clement de Jonghe's collection this print is called "Latombisch prentje" (La Tombe's little print), which probably meant that Rembrandt had made it for his friend the artist and art dealer Pieter de la Tombe. E. F. Gersaint, who compiled the first catalogue of Rembrandt's work in 1751, was under the impression that the phrase alluded to the "espèce de tombe" upon which Christ stands. However, Rembrandt placed Christ not on top of a grave, but upon a small platform, thus separating him from the group of listeners. The idea of the preacher whose word bridges the distance between himself and his congregation is brought forward more strongly here than in *The Hundred Guilder Print*. Everyone listens enthralled: the Pharisees to the left with rapt attention, the poor and the crippled to the right in complete surrender to the message of hope and redemption. Christ, it appears, has spoken the decisive words that reveal him as the Saviour, and Rembrandt portrays him with a halo. The child innocently playing in the foreground makes it probable that the print also contains an allusion to Matthew 18:3: "Except ye be converted and become as little children, ye shall not enter into the kingdom of heaven." But the true content of the scene can be summed up in the words of Matthew 4:17: "Repent, for the kingdom of heaven is at hand."

The Christ that Rembrandt portrayed in *La Petite Tombe* is a figure wholly different from that of his

earlier interpretations. Here Christ is the preacher who dedicates himself to the humble, who brings solace and promises salvation. As his contemporaries have testified, Rembrandt himself felt attracted more and more to lowly people. He preferred their company, and with increasing frequency he pictured them: beggars receiving alms at a door (1648), the peasant family tramping along (1652), and the children who on Twelfth-night go singing from house to house with their illuminated star (1651). In his portrayal of the dark-alley world of insignificant and impoverished city-folk, vagabonds, and beggars, Rembrandt embodies the message of Christ, who speaks from the kingdom of heaven to the consolation of their immortal souls.

211, 233

224

Rembrandt did not hesitate when he drew *La Petite Tombe* on the copper. Every stroke of it is set down with vigor and assurance. After the completion of *The Hundred Guilder Print*, its composition was no doubt fixed firmly in his mind; he even used the design again in the same year, making only a few small alterations, for yet another subject: a drawing of Homer reciting his verses.

244

In 1653, with the same singleness of purpose and even greater spirit, he drew *The Three Crosses* on the plate. The figures in this print are done entirely with the dry point in a sketch-like, almost angular style. With this instrument Rembrandt reacted directly as ideas entered his mind, and because of this the lines become much more expressive. Sometimes, when ink clung to the burred edges, the strokes of the dry point resemble sweeps of a brush; and where lines intersect, these burred strokes form great areas of black. In early impressions of the first state the black spots overlap many lines, forming dense shadows in the print. Rembrandt experimented continually with these shadow strokes. In every impression they are different. Probably he was seeking a tempered light that would concentrate all the luminosity in shafts streaming from heaven to earth. Outside the circle of the three crosses everything had to be in darkness. His intention is evident from additions made in the two succeeding states, in which he used heavy shading to blot out the areas lying outside the circle of crosses. The impression is thus created that light has abruptly slashed open the dark. Rembrandt has indeed portrayed the last moments of the drama at Golgotha, in which the sun was darkened, the veil of the temple was rent in twain, and Jesus cried out, "Father, into thy hands I commend my spirit." And the centurion, wondering greatly, glorified God. In the early states, the centurion has dismounted from his horse to kneel before the crucified Christ.

The sudden and awesome intensity of the shafts of light strikes terror among the unbelievers, who are banished into darkness. A single ray touches the face of Simon of Cyrene, who had borne the cross for Jesus and is now being led away, disconsolate. Within the circle of light remain those who have faithfully followed Christ: John casting up his hands in despair to heaven, and the women clustered round Mary, who at Christ's last words has fallen in a swoon. The light also falls upon the good thief,

and it brushes along the mounted soldiers, who witness the last moments of the drama as though turned to stone.

The plate completed, was Rembrandt not yet satisfied with this visionary scene, risen so entire out of his own imagination, or did his restless spirit see the Crucifixion in still another, more bewildering light? Such a possibility must be considered when the fourth, completely transformed state of the print is attentively examined. The alterations call to mind the words from Matthew's Gospel: "And the earth did quake, and the rocks rent." It is as if all except the faithful under the cross and those aroused to awareness by the awful tragedy had been swallowed up by the cataclysm. Not a single figure is spared in the final revision. The gestures are simpler, the groups are compactly crowded together, and one mounted figure—borrowed from a medallion of Pisanello—is added. This rider in a Renaissance-like costume now dominates the left side of the print. It has been noted that he, like Pilate in representations of Golgotha from the fifteenth century, carries a staff. In this figure Rembrandt presumably wished to indicate the repentance of the cowardly procurator. This unmistakably new idea must have arisen long after the original conception, and it gives new significance to this print. The far more compact figures and the greater unity of composition, particularly now that the horses are facing the center, also point to a later origin. The soldier with raised sword is reminiscent of Julius Civilis in *The Conspiracy in the Schaker Forest*, the large piece for the Amsterdam city hall which occupied Rembrandt in 1661. On the basis of this internal evidence, the conclusion must be reached that the fourth state of *The Three Crosses* was created about 1660. In it each gesture, each pose, has been thought through more thoroughly than in the earlier versions, and the expressiveness of each figure has been emphasized. Rembrandt did not concern himself with contours, which often fall across each other. Everything is in motion. Christ alone, rigid in death, triumphs in the light.

Between these two interpretations of Golgotha lie years of increasing loneliness for Rembrandt, years also of financial adversity, with comfort found only in the solicitude of Hendrickje Stoffels. A break with the ecclesiastical authorities came in 1654, after difficulties had arisen over their unconsecrated marriage. Hendrickje and Rembrandt were repeatedly called to account by the church council, and when Hendrickje at last appeared before this body, she received a serious admonition and was refused participation in the rites of Holy Communion. All attempts to pay off the increasing debt to the landlord Christoffel Tijsz failed. In desperation Rembrandt was forced to part with his cherished art collection. It was appraised in 1655 and, beginning in 1657, sold at auction. In 1658 the house on the Breestraat was sold, and in the same year went Rembrandt's drawings and prints—the last items of his collection to remain in his possession. The scantiness of Rembrandt's household effects may be

read in the inventory of his property: the large house had been filled chiefly with objects of art.

Rembrandt lived in the Breestraat until 1660; thereafter he took up residence in a modest house on the Rozengracht, at the western limits of Amsterdam. It was probably there that Titus and Hendrickje entered into an agreement to establish and operate an art shop "for so long as Rembrandt shall live," as the deed stipulates. Until 1668 Rembrandt's principal, and at times only, sources of income were the proceeds from this shop and what was still left of Saskia's legacy, which had gone to Titus on his reaching legal majority. After 1661 the artist's commissions virtually stopped, but his debts continued. He could not withstand his passion for collecting, and of course he needed a constant replenishment of art supplies. Income from pupils, which had flowed so richly into the studio on the Breestraat, dwindled to that from a single pupil. Hendrickje died in poverty about 1664; Titus survived only until 1668; and Rembrandt was left at the last with little Cornelia and his housekeeper, Rebecca Willems. After his death in October, 1669, Rebecca declared that Rembrandt had often had to make use of Cornelia's small bequest.

A few friends remained true to him. For the most part they were artists and art dealers, such as Abraham Francen and Lodewijk van Ludick; Jeremias de Decker, a poet of abstruse religious verse, was also among them. The portraits that Rembrandt etched after 1650 included members of this circle.

Rembrandt never felt bound to portraiture of a particular type. His etched portraits are small in number but of exceptional variety; only after 1650, however, did he find a completely individual solution for each subject. In the portrait of the painter Jan Asselyn of 1647 he still employed a pose —one arm jutting forward, hand to the waist—that Frans Hals had introduced into the portrait art of the Netherlands. But for his 1651 portrait of the print dealer Clement de Jonghe, who had published prints after Rembrandt's early paintings and who possessed a large collection of his work, he turned away altogether from earlier Dutch portrait art and looked to Venetian examples for a subtler balance. "As beautiful as an antique marble," James McNeill Whistler wrote under a copy of this print. The portrait can indeed bear comparison with an ancient masterpiece. The pose has a classical naturalness in its lack of constraint, and the subject is handled with such animation and matter-of-fact facility that it is hard to realize the technical skill involved. Yet in the last analysis the mastery of form is not the most compelling feature of this portrait, but its re-creation of the man himself. As he sketched him, Rembrandt must have carried on a provocative conversation with this admirer of his. De Jonghe holds his patrician pose impatiently, as if he wished to spring from his chair and stride up and down, expounding his side of the argument.

Of the four portraits made in 1655 and 1656, that of the young solicitor Jacob Thomasz Haaring, son of the warden of the Court of Insolvents, still resembles the figures in a dark interior that Rem-

207

227

266

brandt had made years before. The other portraits, which were created later than that of young Haaring, are undisputed high points in Rembrandt's graphic work. With each one Rembrandt so immersed himself in his subject's pursuits that in addition to a portrait he also created a type of human

270 being. With regard to Jan Lutma, the old goldsmith, Rembrandt's typification of the artist is most pronounced in the head with its mild, brooding—and not a little sardonic—glance. Lutma's head

271 dominates the large areas of black and white. In portraying Arnold Tholinx, inspector of the Collegium Medicum, a brother-in-law of Jan Six, and a man of some authority, Rembrandt combined a probing and appraising look with a thoughtful gesture of the right hand—the gesture and gaze of a

272 scholar who unwillingly lends himself to posing. The elder Haaring was a type more difficult to delineate, for he was the anonymous civil servant, the anxious and conservative little man. However, Rembrandt tells us more: in Haaring's face are recorded not only the frets and worries of a small soul but also the image of old age. The print is more than a portrait; it is a graphic poem unlike any other, in which the atmosphere of the dusky chamber blends with utmost refinement into the passive stillness of an old man in beautiful velvet garb. The portrait of old Haaring is not dated. Probably it was created last of the four portraits just noted. This would have been in the year before Rembrandt's house and collection were sold under the hammer of the Court of Insolvents.

In the preceding years Rembrandt had thrown himself whole-heartedly into depicting the great moments from the life of Christ. It is strange to think that in these very years, shortly after 1650, the art of Carel Fabritius and Jan Vermeer was displaying a totally different image of Holland—one of peace and repose, saturated with sunlight. Rembrandt's tension-charged darknesses contrast strongly with so amiable a view, which allots the same value to people and things. Yet there is one similarity between Vermeer's peaceful, harmoniously balanced compositions and Rembrandt's inwardly seething prints. After the lightning had spent itself in *The Three Crosses*, a calmer light again streamed forth, and in its glow Rembrandt's Amsterdam etchings are as thoughtfully composed as the Delft paintings.

Rembrandt turned frequently in this period to Italian examples. He copied prints after Mantegna's work and Leonardo's *Last Supper*, as well as drawings by Italian masters from the late Renaissance, and

247 memories of these works crop up repeatedly. In the *St. Jerome Reading* of 1653, the Italian model is indeed so clear that "in an Italian Landscape" has become part of the title. The buildings in this print were undoubtedly taken from a drawing by Giulio Campagnola that is now preserved in the Louvre. Although a similar influence is not so directly traceable in other prints, it is implied in Rembrandt's careful weighing of horizontals against verticals and in his manner of binding them together by means of a squared or rounded arch. He seeks in every way to give a more balanced structure to his work. The Renaissance artists, above all, showed him how to achieve this balance.

Still and all, a very great distance separates Rembrandt from the greatly admired world of the Renaissance, even though he borrowed directly from it. Rembrandt never idealized forms: he recreated what he borrowed and gave it almost tangible immediacy.

257, 260 During 1654 Rembrandt made three religious prints which suggest a great deal of space. In two of them, *The Descent from the Cross: By Torchlight* and *The Entombment*, he crowded the figures so closely together that a large amount of space remains in unfathomable darkness. All that breaks through these areas of gloom are a hand outstretched helplessly in *The Descent from the Cross* and two skulls glinting dimly in the darkness of the sepulchre in *The Entombment*. In the former print some torchlight collects on the linen spread out over the bier, but the body of Christ half-sinks away into the dark of the night. In *The Entombment* nearly all the light is extinguished. It was in this way that Rembrandt now saw Christ's dying on the cross, without triumph, without light. Consciously attuning these prints to

259 darkness, the artist goes far beyond the open hatching of the first state of *The Entombment*. This state was simply the first design on the plate, although its powerful shading, like that in Dürer's late drawings, foretells the deep shadows which were added later.

The third print, following the two of the Passion, shows why Rembrandt desired this darkness.

256 Though the body has died, the spirit has risen and, in *Christ at Emmaus*, returned in all its radiant glory. Rembrandt here portrays Christ at the very moment he has broken the bread and revealed his presence to the disciples. The miracle is apparent only to his two followers, who regard him with adoration. The innkeeper stares in surprise at the worshipful attitude of the disciple on the left, but does not break his stride. From a drawing in the Rijksmuseum we know that Rembrandt originally drafted the print with two figures seated, and that the innkeeper then stood to the right just behind Christ and was thus witness to his presence, as Rembrandt permitted the serving couple in the painting at the National Museum in Copenhagen also to be. In the etching he consciously stepped away from his older conception, thereby emphasizing the recognition of Christ by the faithful alone. Continuing with this thought in 1656, two years after *Christ at Emmaus*, Rembrandt depicted the resurrected Saviour anew

268 in a blaze of glory: the light around Christ in *Christ Revealed to the Disciples* is so powerful that it is virtually blinding to those who wish to approach him; their forms all but dissolve in the brilliant glow.

In comparison with this trio of religious prints, all generated by the thought of the ultimate triumph

261, 262 of Christ, the great *Ecce Homo* or *Christ Presented to the People* of 1655 looks like a showpiece. A

244 counterpart to *The Three Crosses*, it is executed wholly in dry point. The large, figure-laden print brings to mind the public administration of justice that obtained in Amsterdam until well into the seventeenth century. The procurator with his long staff, the statues of Justice blindfolded and of

Prudence as an Amazon (to symbolize that she is the guardian of liberty), and the court enclosed on three sides—all this is a graphic echo of the municipal sentencings of criminals, which were carried out with similar appurtenances in a courtyard open only on one side. Here, therefore, Rembrandt followed not only an engraving by Lucas van Leyden but also a living tradition. By so doing he makes the drama of the moment comprehensible to everyone. Seen in historical perspective, as pendant to *The Three Crosses,* this print attains far greater significance. Here are all those who condemned and mocked Christ and, in the last version of *The Three Crosses,* are banished into darkness.

In breadth of design and power of line the *Ecce Homo* appears to go even beyond *The Three Crosses.* It is not so engulfed in darkness as is the etching of the Crucifixion. On each section of the plate Rembrandt attempted with a few lines to break the figures loose from the two-dimensional plane. He did not completely succeed, and he was thus evidently induced to provide deeper shadows and to remove from the foreground the whole center section of the menacing crowd. To replace these figures he introduced two round arches at the base of the tribune. A dark figure resembling a river god, very difficult to discern, originally appeared in the space separating the two archways; in a later state this figure has been burnished away. After eliminating the crowd, Rembrandt provided the plate with date and signature. He considered it finished, therefore, only when the spatial problem had been solved to his satisfaction. Forceful relief was still a necessity for him, but in later years it gradually diminished in importance. In many of his last prints he tended to hint at forms rather than to define their contours, and such figures separate themselves from the background only as patches of light and dimly sketched

outlines (this appears clearly in *The Agony in the Garden* of 1657 and *Peter and John at the Temple Gate* of 1659).

In *The Presentation in the Temple: In the Dark Manner* the forms at first sight appear to melt into the background. It was formerly assumed that this etching dated from 1654, but later evidence seemed to indicate a date in the late 1650's. The evidence consisted primarily of the discovery of a preliminary study sketched with a few vague, tapering brush strokes in a drawing style which, it was thought, had not yet evolved in 1654. The argument appears logical, but it does not hold up under a careful restudy of the etching. In some impressions, the figures seem to merge into the background. But other impressions, in which the lines are printed more clearly, point to a firmer construction that differs little from *The Descent from the Cross* of 1654. Rembrandt simply made much bolder use of a technique which he had applied to only a few figures in *The Descent.* Insofar as it is visible through the darkness, the background space is determined by powerful verticals and horizontals. A later etching, such as *Christ and the Woman of Samaria* of 1656–58, uses an altogether different, more fluid technique.

The dark *Presentation in the Temple* is certainly the high point of the group Rembrandt created in

275, 284

258

257

273

1654 or shortly thereafter. With a scintillating play of black and white, he here juggles the richest effects, from glittering gold to gleaming brocade. Even though an impenetrable black closes down around the figures, the atmosphere of the etching is made festive by the miraculous light radiating from the divine Child.

263 *Abraham's Sacrifice* dates from 1655, the same year in which the *Ecce Homo* was signed. Schmidt Degener felt in this etching "the imposing awesomeness which the Italians call the *terribilità* of Michelangelo." Abraham's agonized determination as the angel lays restraining hands upon him is caught with terrible immediacy. The terse simplicity of this etching is not inferior to the muscular language of the Old Testament. Yet the forms are less firmly delineated than those in the religious prints of the year before. The wings of the angel fade away into the background. Only the hand, ominously holding the knife, is thrown into strong relief. In the same way, severe outlines are dissolved in the

265 little etching *The Goldsmith*, that poignant depiction of an artist who cannot bear to part with the Caritas group he has just created. Probably Rembrandt purposely weakened the contours here. The

269 subject lent itself to such treatment, as did the small portrait of Titus made a year later. The vague indication of the body blends with the fine *sfumato* effect of the curl-encircled head, enhancing the dreaminess of the youth's expression.

284 Rembrandt's last religious print, *Peter and John at the Temple Gate*, etched in 1659, is also fully in this spirit of discreet modeling. Here the shadows had to be reinforced again and again before the transition from foreground to background was acceptable. The long road Rembrandt traveled in his etchings can be measured best by comparing his two representations of this subject. He took it up originally in his Leiden years, treating it in the print that contains, with youthful virtuosity, his first use of light and shade. The same three principal figures appear in the 1659 etching, but are placed in an entirely different light. The temple with its great forecourt was based on a description by the early Jewish historian Flavius Josephus, but the warm Oriental light falling across the court and upon the figures under the portal arch is the light of Rembrandt's late paintings. The artist had long immersed himself in the many-colored world of the Orient. Several Eastern motifs appear as early as the 1641 *Baptism*

168, 267 *of the Eunuch*, and he set up the composition of the central group in *Abraham Entertaining the Angels* of

261 1656 on the model of an Indian miniature he had copied long before. The great *Ecce Homo*, too, is full of Oriental overtones; one figure standing at the right, at the top of the stairs leading into Herod's palace, stems from a similar miniature of the Moghul period.

 In *Peter and John at the Temple Gate*, which derived from a long series of preliminary studies, the borrowings are less conspicuous. Here Rembrandt created the atmosphere of the East by the magic of his light: the light that gives special significance to his last works. Its power is best demonstrated in the

female nudes of 1658 and 1661, especially the *Negress Lying Down*, in which Rembrandt equals the lyricism of Titian's late nudes. Yet Rembrandt's shadows are more mysterious than Titian's, and his light is more evocative as it caressingly seeps through the draperies of the bed. The light which glides

like a touch along Antiope's body in *Jupiter and Antiope*, an etching in which Rembrandt imitates

Annibale Carracci, reaches its greatest intensity in *The Woman with the Arrow*. As this unknown beauty (could she be Cleopatra?) looks down on her lover hidden in the shadows, her whole body is a shimmer of glowing life.

That light is Rembrandt's last triumph. In every print after 1658 it is the constant yet ever-varying source from which inspiration flows. It is lacking only in a few portraits, such as those of the writing

master Lieven Willemsz van Coppenol and the physician Jan Antonides van der Linden. Light rushes

like a splashing waterfall through the print of St. Francis kneeling in prayer beneath a tree; it falls like

golden solar dust in the landscape where Christ meets the Samaritan woman at the well; and it shreds

the clouds in the late print of Gethsemane wherein the angel comforts Christ in his agony. In these sublime etchings, each a world of its own, all is ordered and unified by the light.

In a ferocious, nearly singeing light, Rembrandt also depicts his own genius rising from the grave as a phoenix who triumphs over satanic Envy, represented by the overthrown figure in the foreground. A glory radiates from the legendary fledgling across town and countryside. At least, this is the inter-

pretation that Schmidt Degener gave to *The Phoenix: An Allegory*, a print of 1658. It purportedly represents Rembrandt's answer to the humiliations he had suffered, first through the vilification of his art, and last through the forced sale of his collection and possessions in 1657 and 1658. It was a "challenging gesture" in the midst of the doubts that must have assailed him when he was rejected and scorned.

Such an explanation is still the most acceptable one for this remarkably aggressive print, etched nearly at the end of Rembrandt's graphic career. Nonetheless, observing the sun-disk behind the head of the phoenix, one cannot help thinking of the original version of the story in Herodotus: there the phoenix symbolizes the rebirth of the sun's light. So viewed, the etching proclaims the resurrection of that light which suffuses Rembrandt's art.

The phoenix print is dated 1658. Two prints followed in 1659: *Peter and John at the Temple Gate* and

Jupiter and Antiope. Somewhat later, probably about 1660, Rembrandt completed the fourth and

drastically altered version of *The Three Crosses*, and in 1661 *The Woman with the Arrow* appeared. During the last eight years of his life Rembrandt created no more graphic work except for one print,

an unimportant portrait commission, in 1665. By the time he left off producing prints he had mastered

6, 217

268

106

198

224

and applied every possible nuance in etching, dry point, and engraving. He had begun with fine, sensitive lines, like those in the little 1628 portrait of his mother—lines he later used in *The Shell* and in such prints as *Christ Revealed to the Disciples* of 1656. At an early date he also used forceful strokes to round out the forms of the early beggars. In the late Passion prints these strokes coagulate into shafts which in turn merge with the shadows. The densest shadows first appear in *The Angel Appearing to the Shepherds* of 1634, then return repeatedly, ever varied, as dark areas under trees in *The Boat-House* (1645) or as a night-like black in *The Star of the Kings* (1652). When Rembrandt ceased etching in 1661 it meant that graphic art offered no further possibilities to him. His concern for the "mystère que la plastique comporte," as Odilon Redon in *A soi-même* describes Rembrandt's language of forms, shifted wholly to the canvas painted with palette knife and broad brush. In his paintings he continued to work at the problems he had set himself in his last etchings.

He cannot have turned away completely in 1661 from the work of more than thirty years. He must have printed his plates often. The picturesque effects that are found in many variants, recalling his late canvases, point in that direction. Just as the little goldsmith could not part with his Caritas group, so Rembrandt must not have been able to abandon the thoughts he had recorded on his plates and reworked with infinite care in the many impressions he printed.

These thoughts are often difficult to fathom. The most patient examination does not always yield a satisfactory answer. Moreover, new questions arise for each generation. The ever-fascinating mysteries of Rembrandt are not confined to enigmatic prints such as *Faust* and *The Phoenix*, but also embrace such apparently simple subjects as *Abraham Caressing Isaac* and the little *Goldsmith*. Like Shakespeare's plays and the music of Beethoven, Rembrandt's images emerge from an invisible world that is manifest in the simplest phenomena. For this reason the words written by the nineteenth-century French critic Thoré-Bürger in *Musées de la Hollande* still form the most trenchant summary of Rembrandt's art: *Rembrandt est tout en dedans, mystérieux, profond, insaisissable et vous fait replier sur vous-même; ce n'est jamais ce à quoi on s'attendait; on ne sait dire; on se tait et on réfléchit.*—Rembrandt is wholly internal, mysterious, profound, unseizable, and you must fall back on yourself; he is never predictable; you do not know; you are silent and meditate.

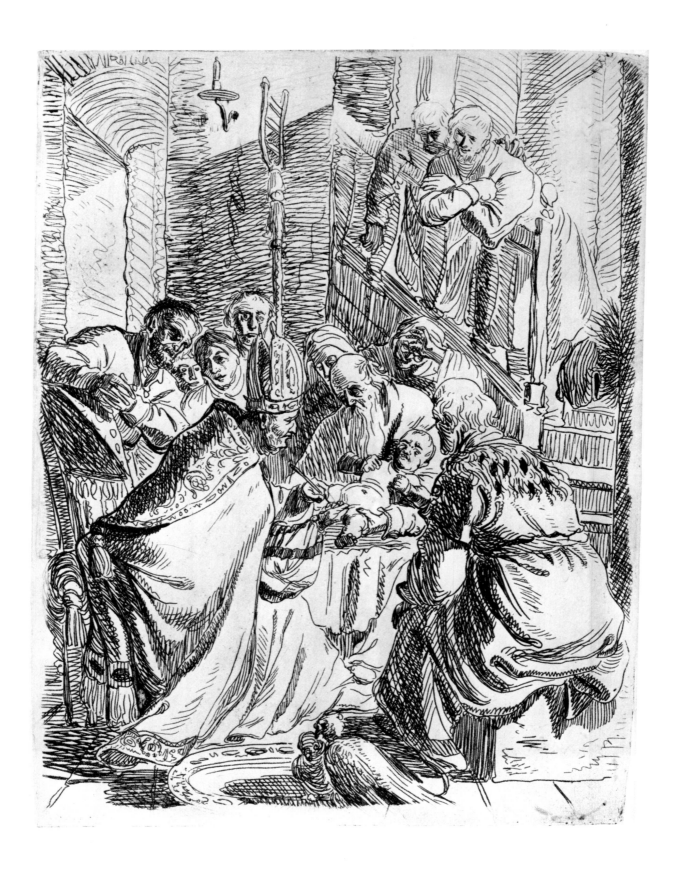

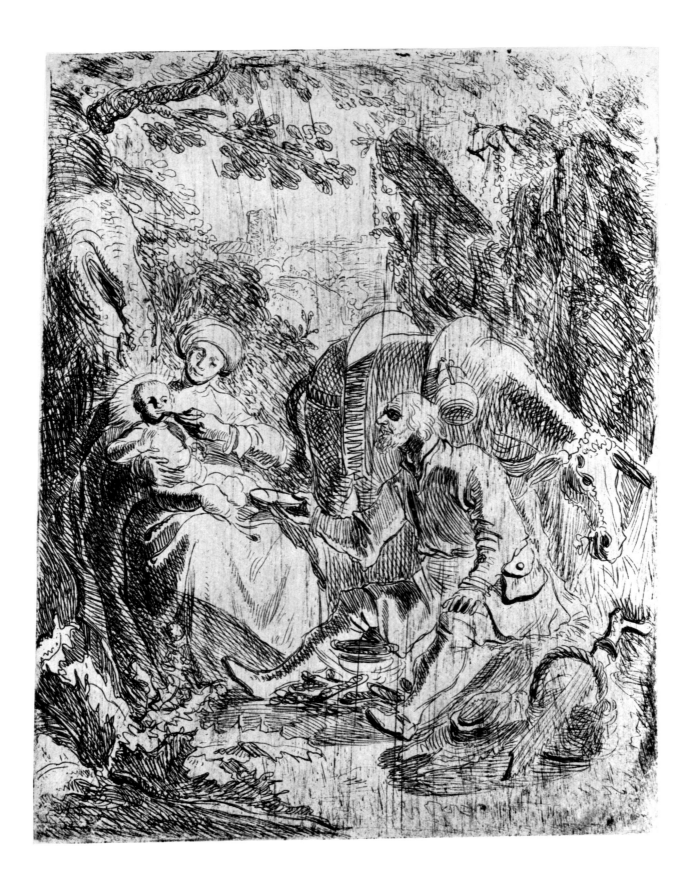

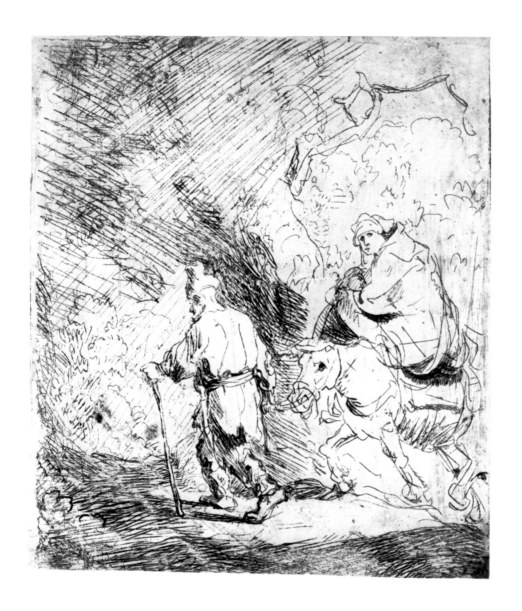

3

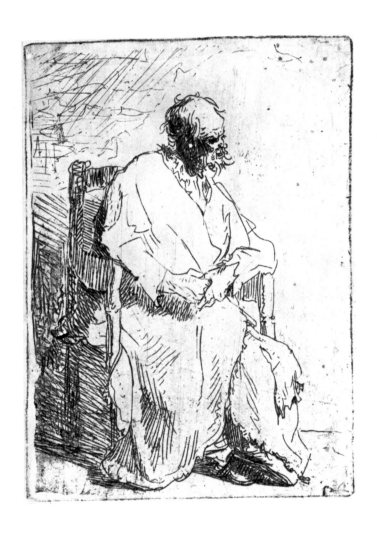

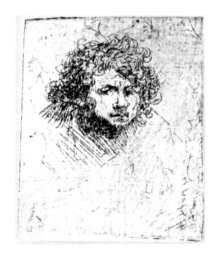

4

5

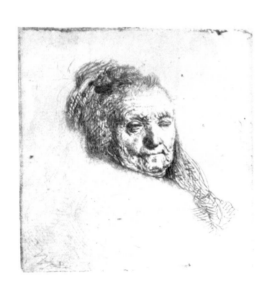

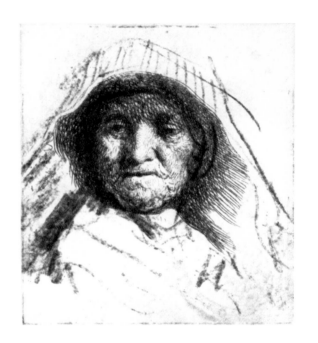

6

7

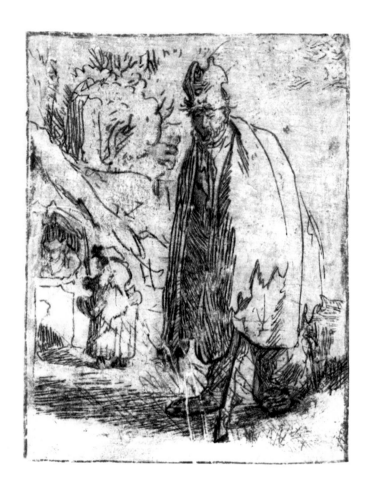

8

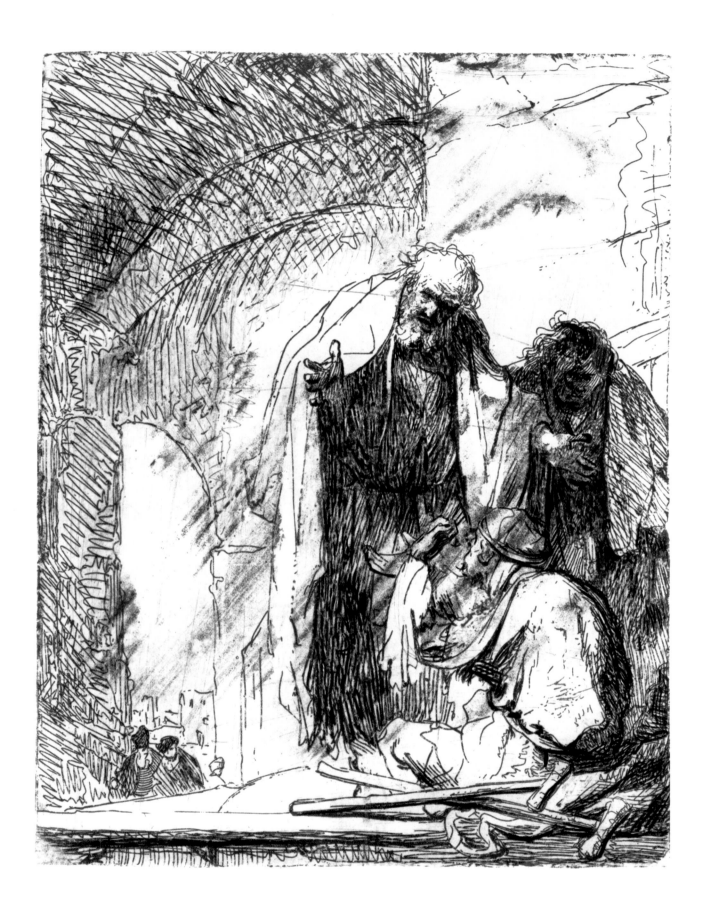

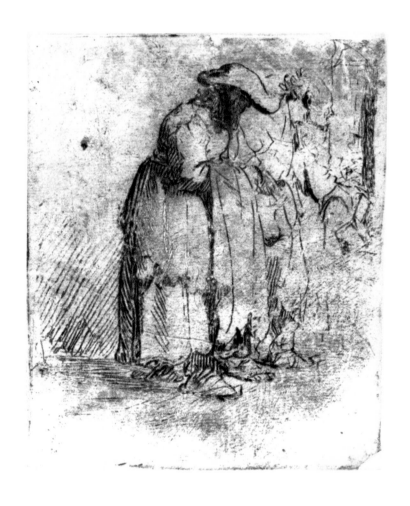

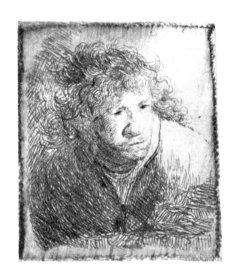

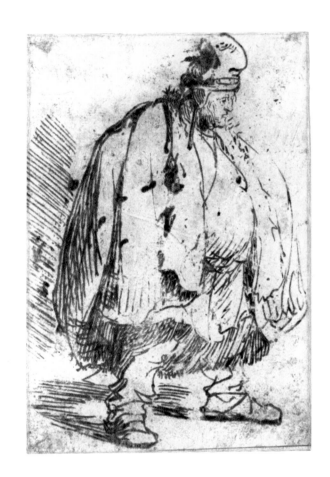

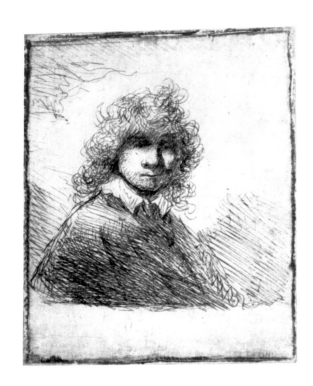

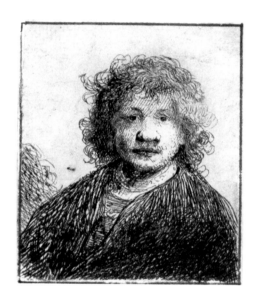

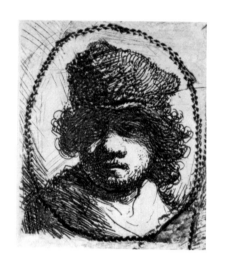

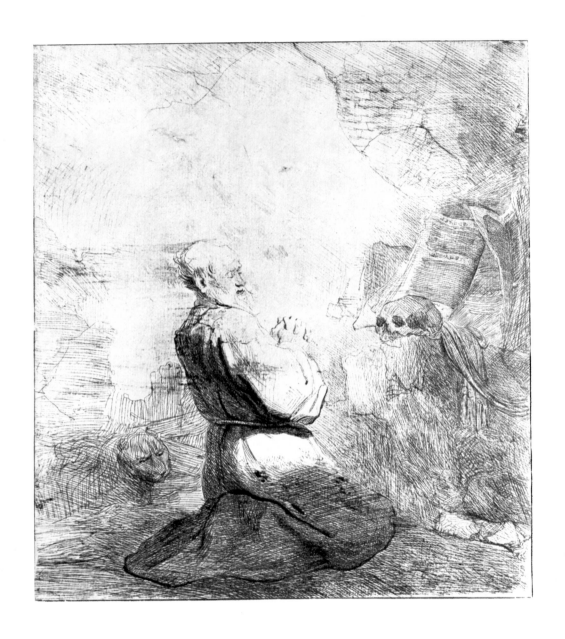

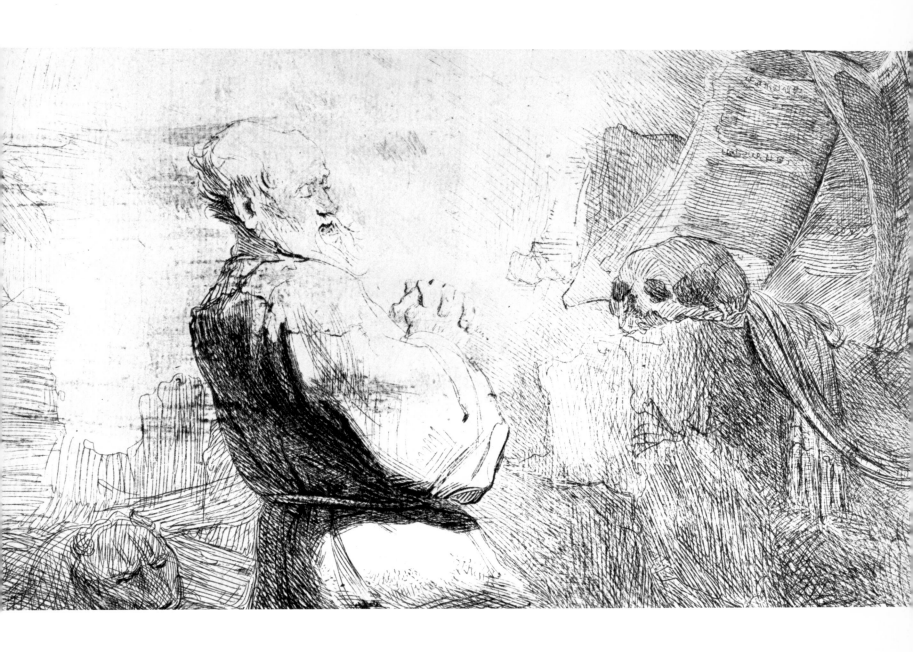

16, detail

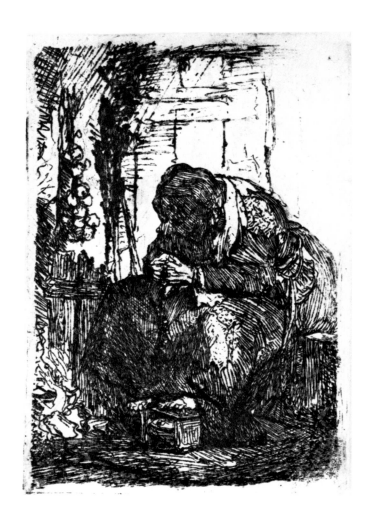

17

18

19

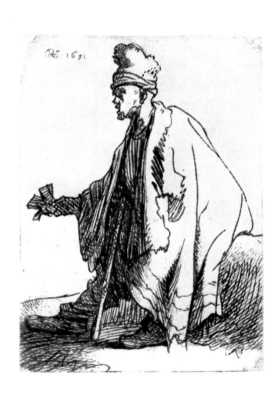

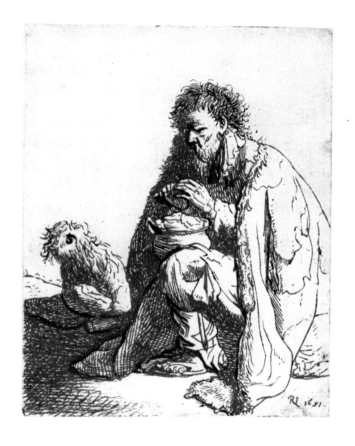

23 24

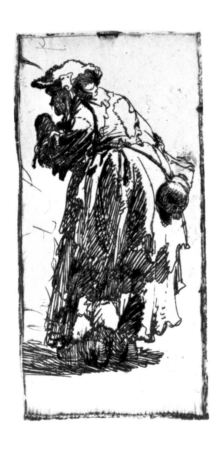

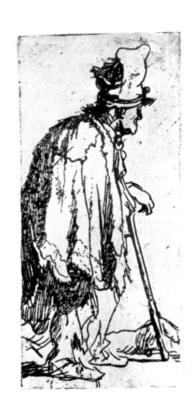

25 26

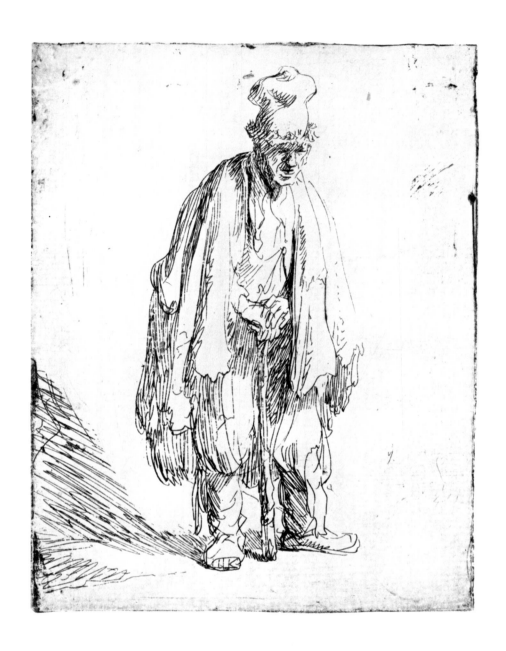

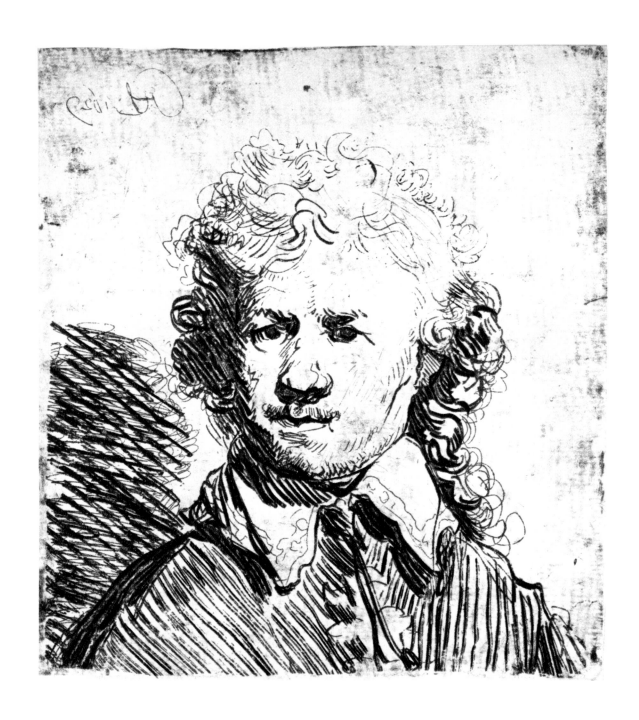

28

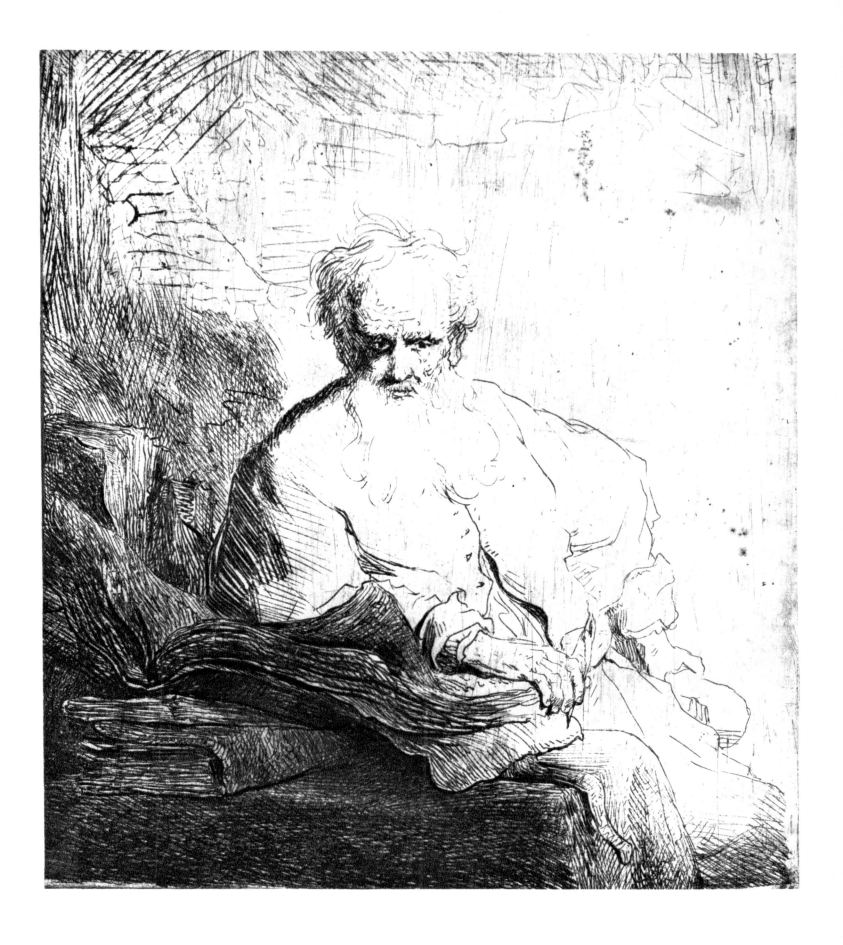

29

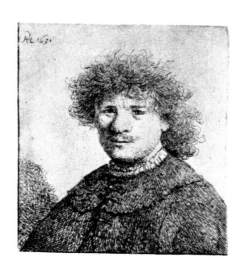

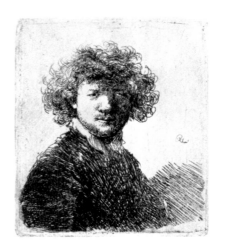

30

31

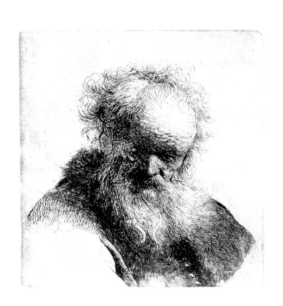

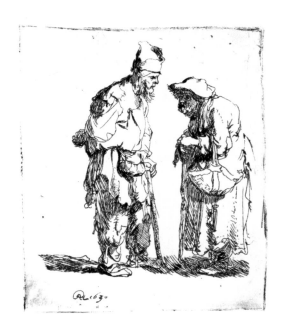

32 33

34 35

36　　　　　　　　　　　　　37

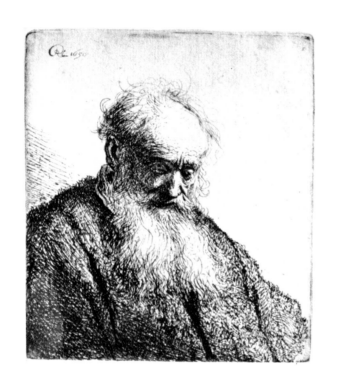

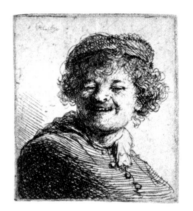

38

39

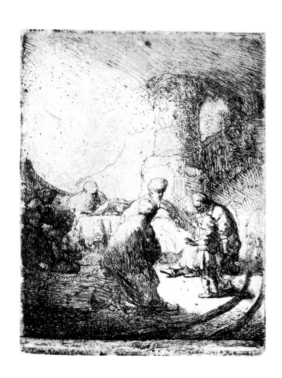

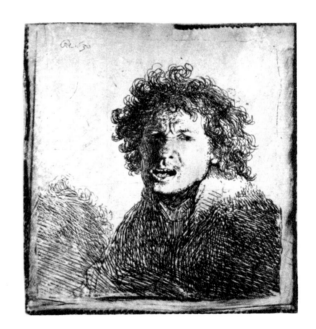

40

41

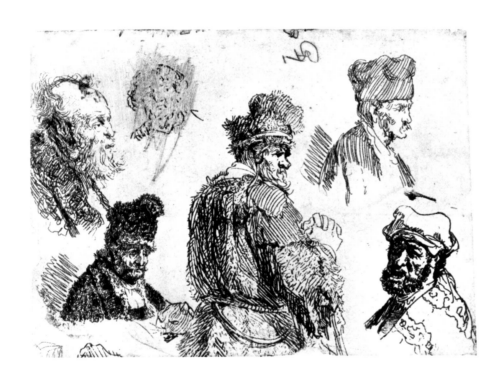

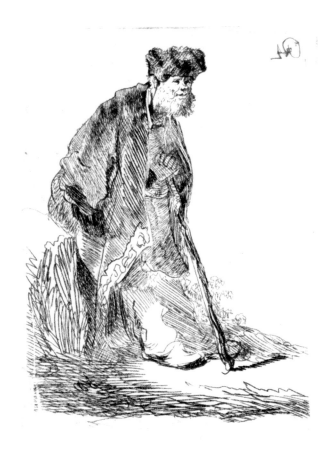

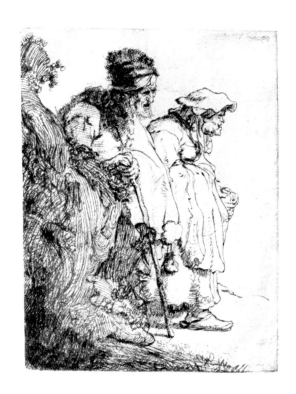

43

44

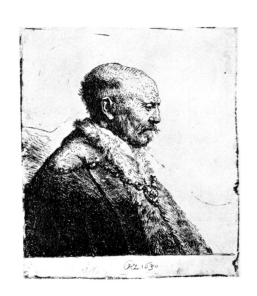

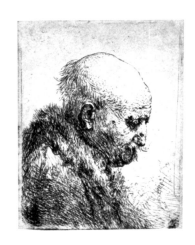

45

46

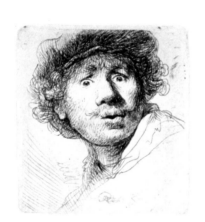

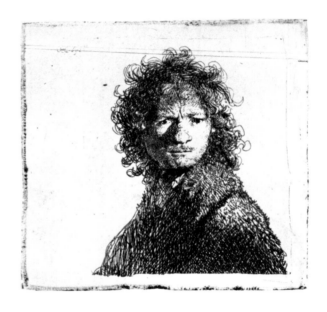

47

48

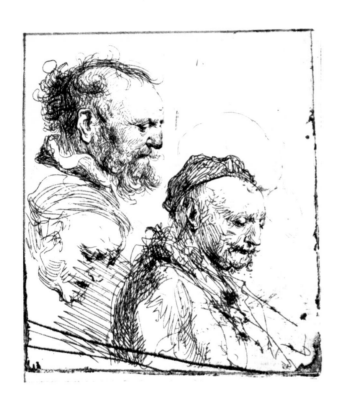

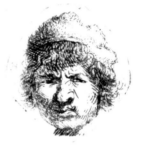

49

50

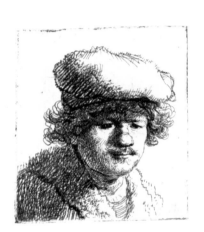

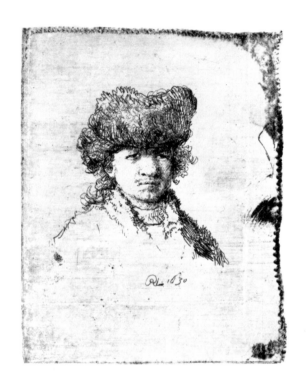

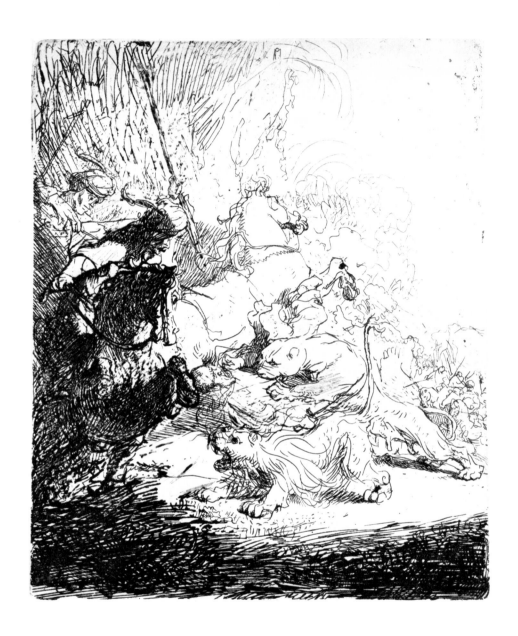

53

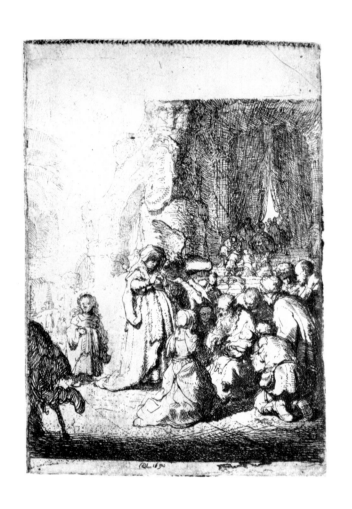

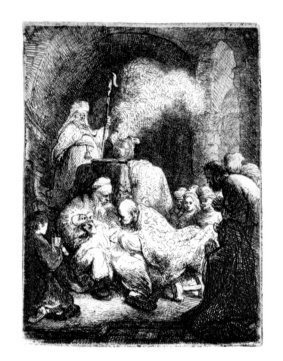

54

55

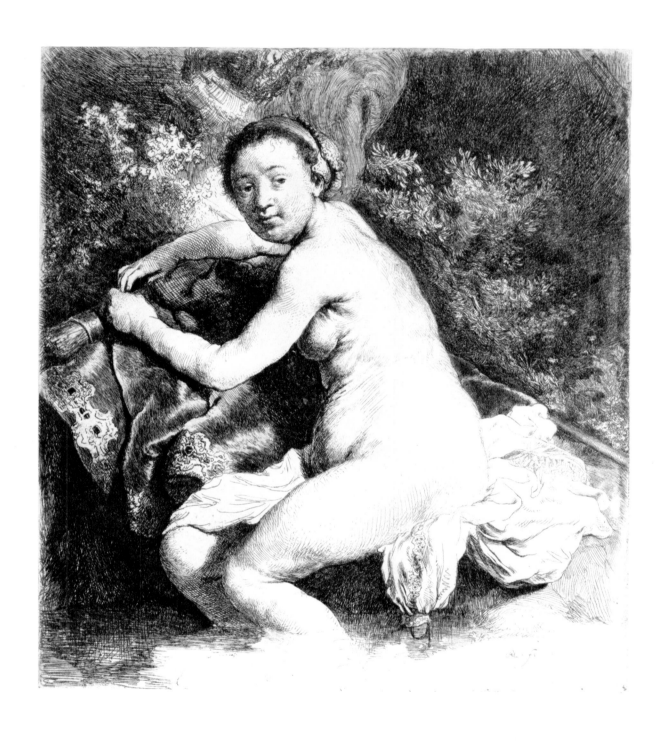

59

60

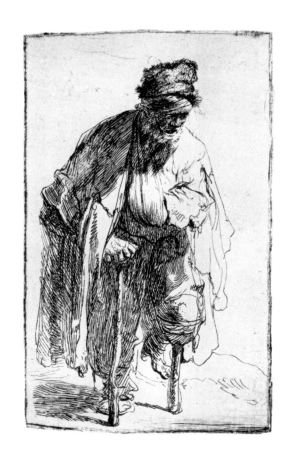

61

62

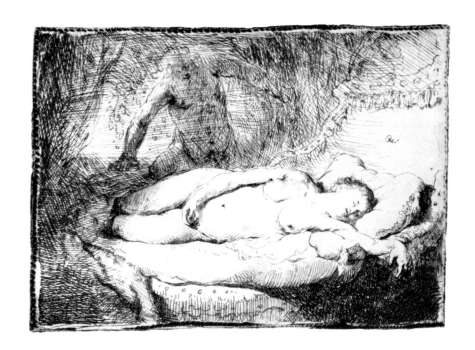

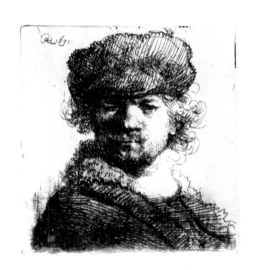

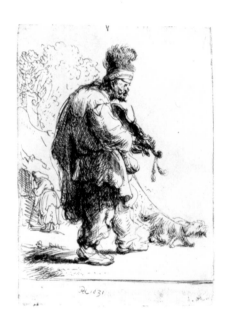

64

65

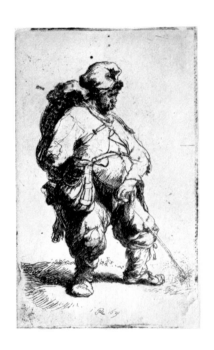

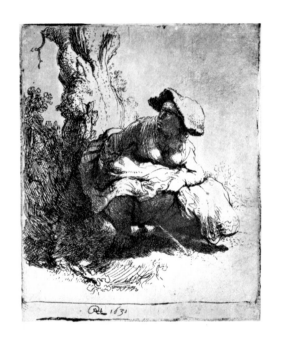

66 67

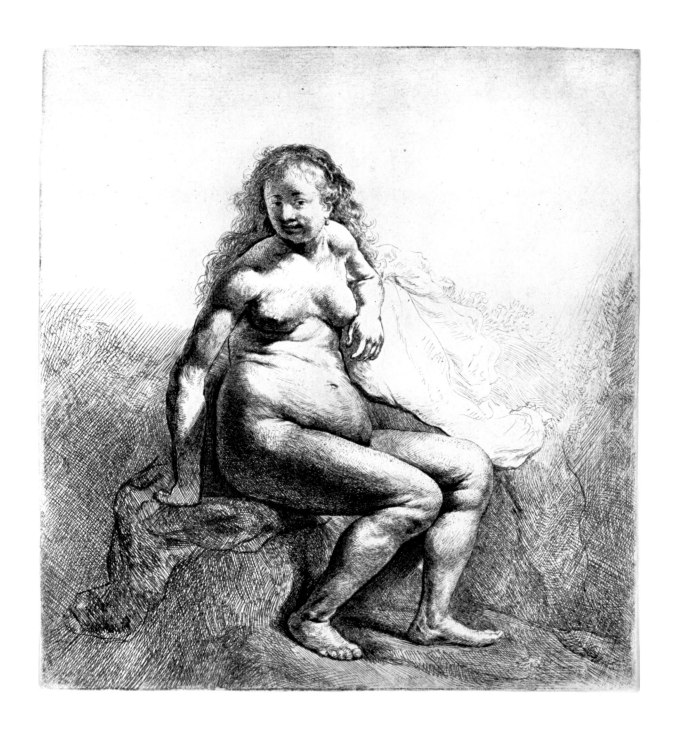

68

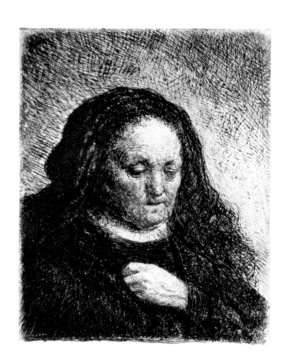

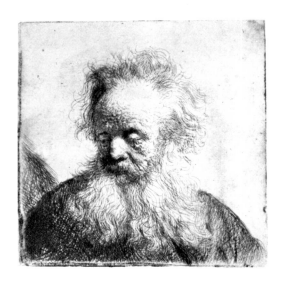

69 70

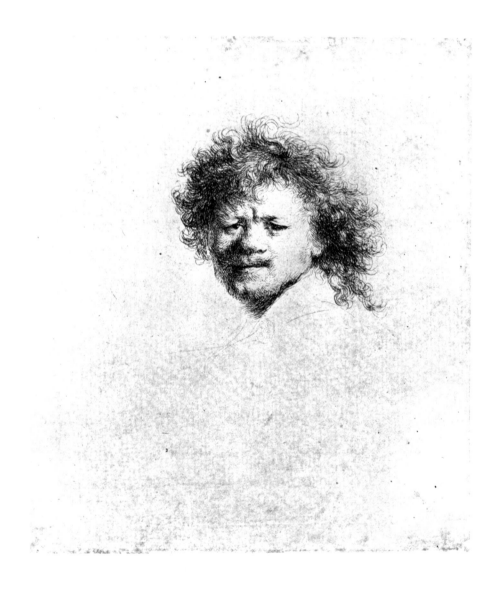

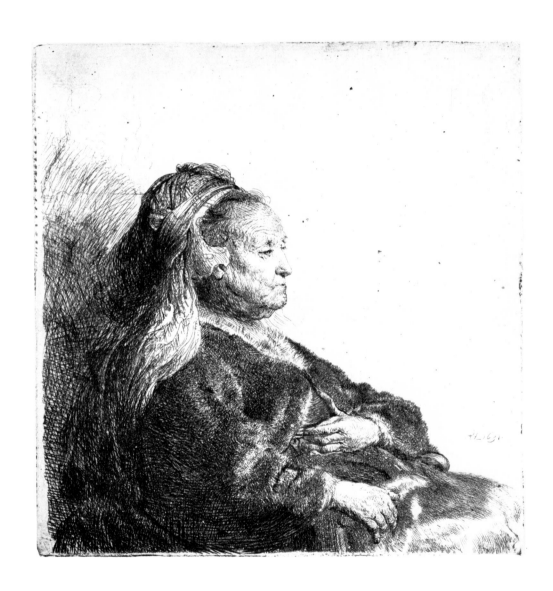

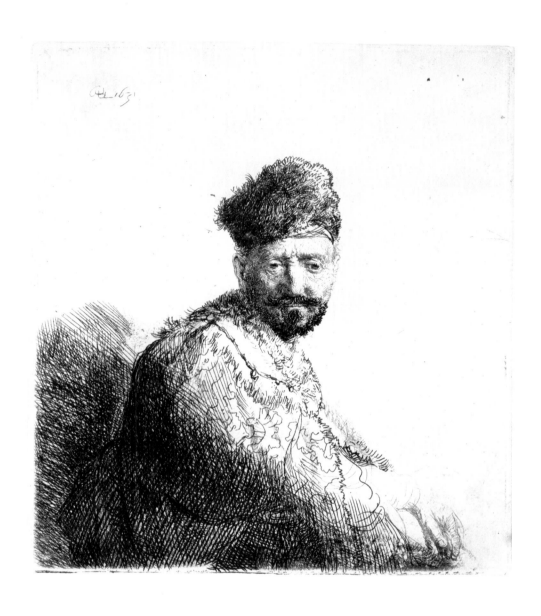

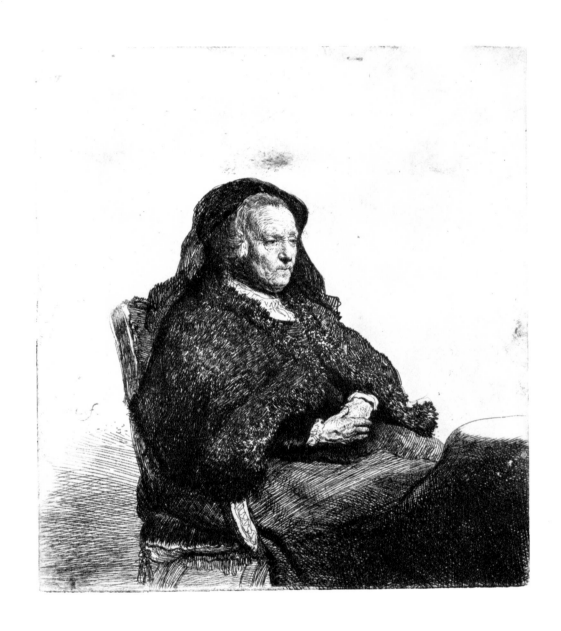

74

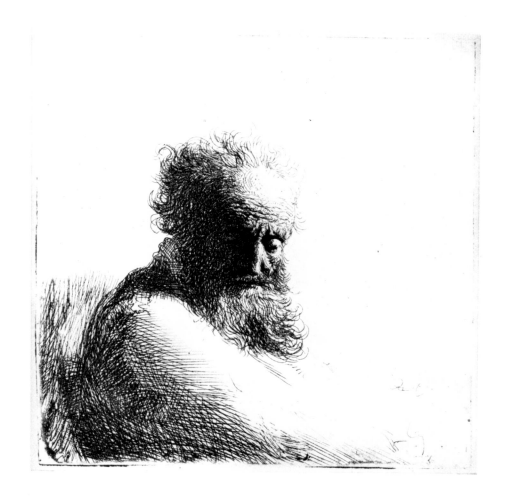

75

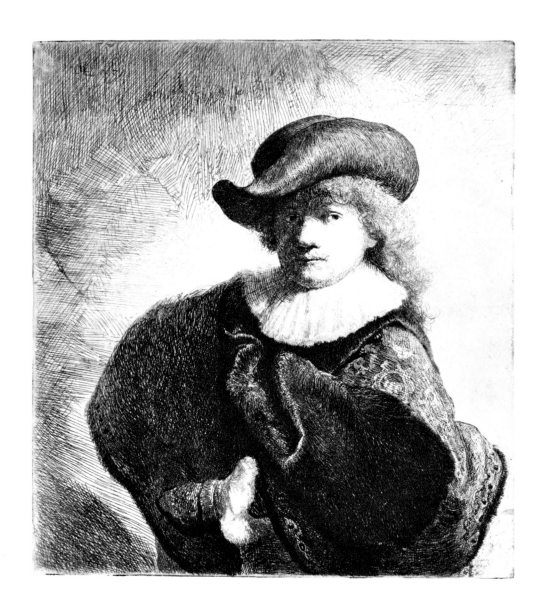

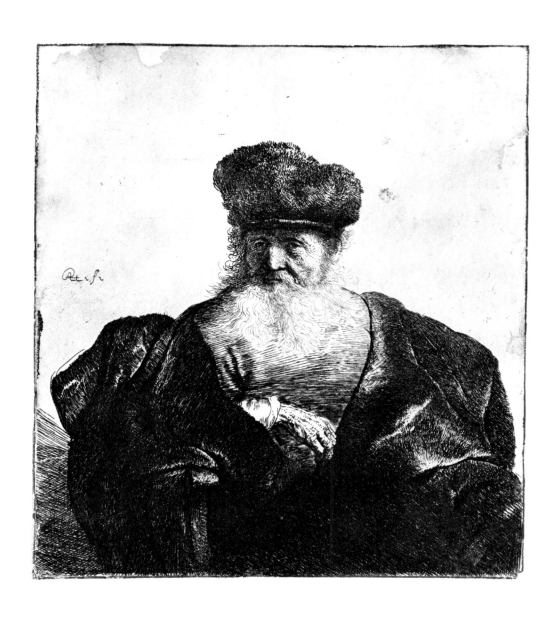

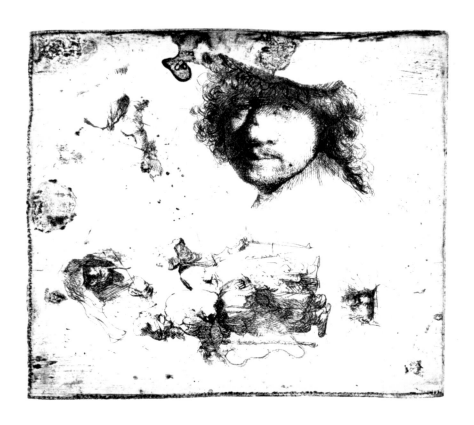

79

80

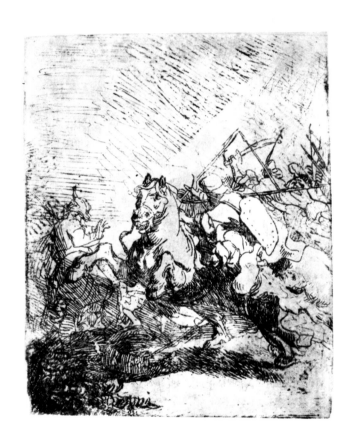

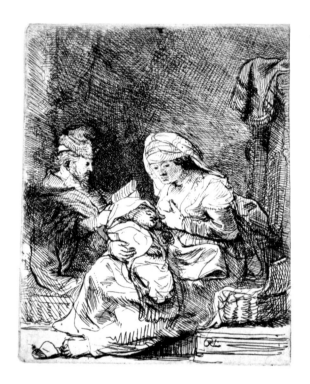

81

82

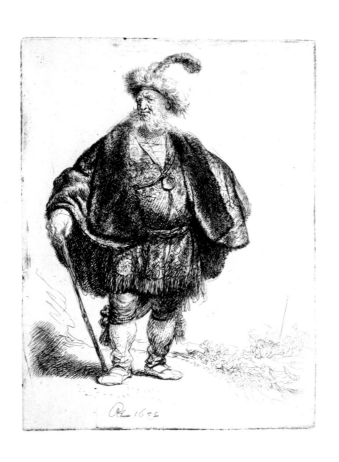

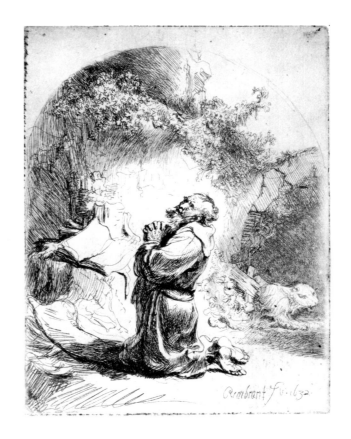

83

84

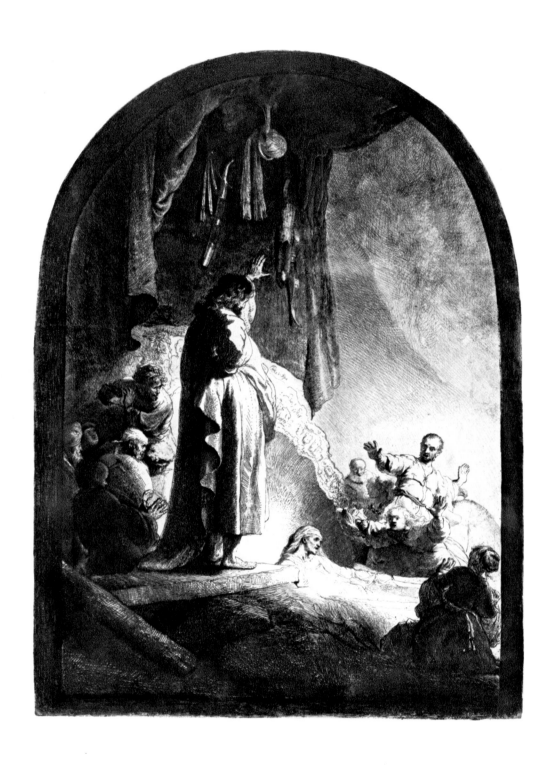

85

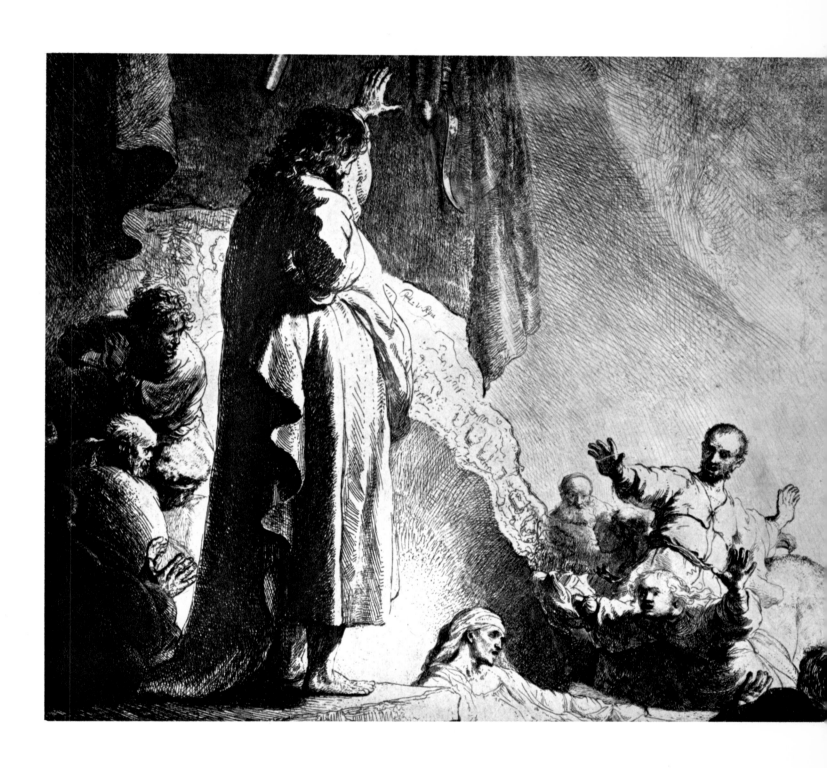

85, detail

87

88

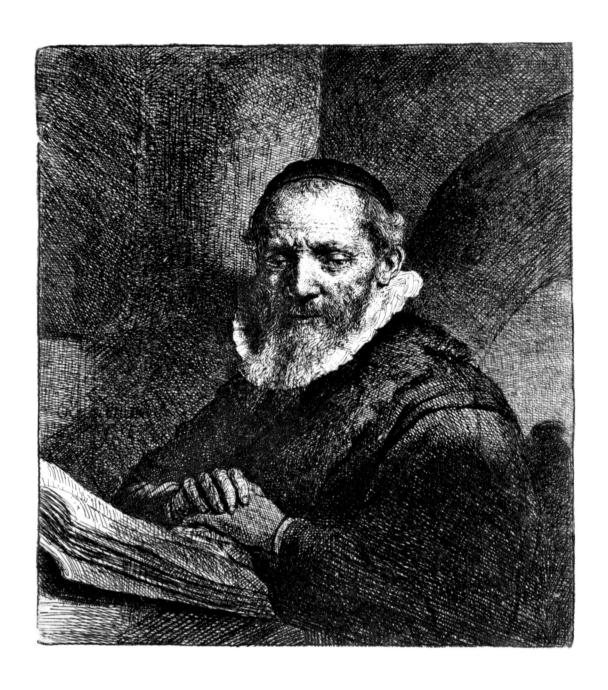

89

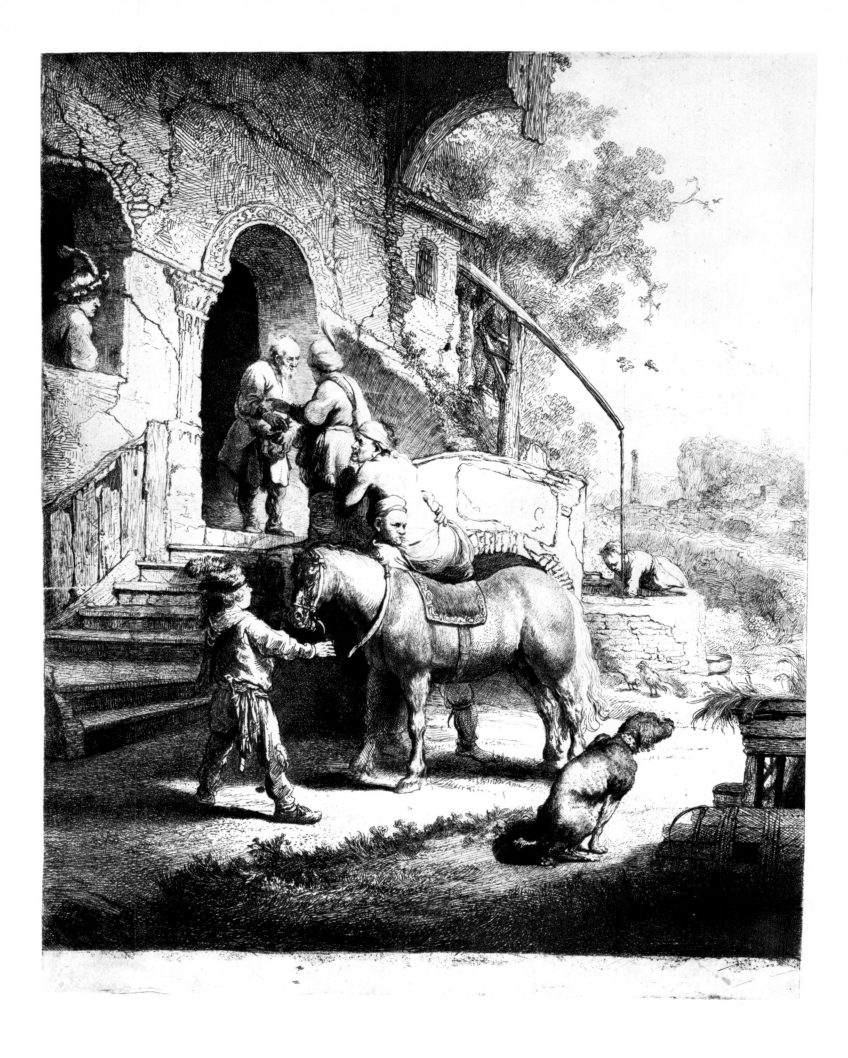

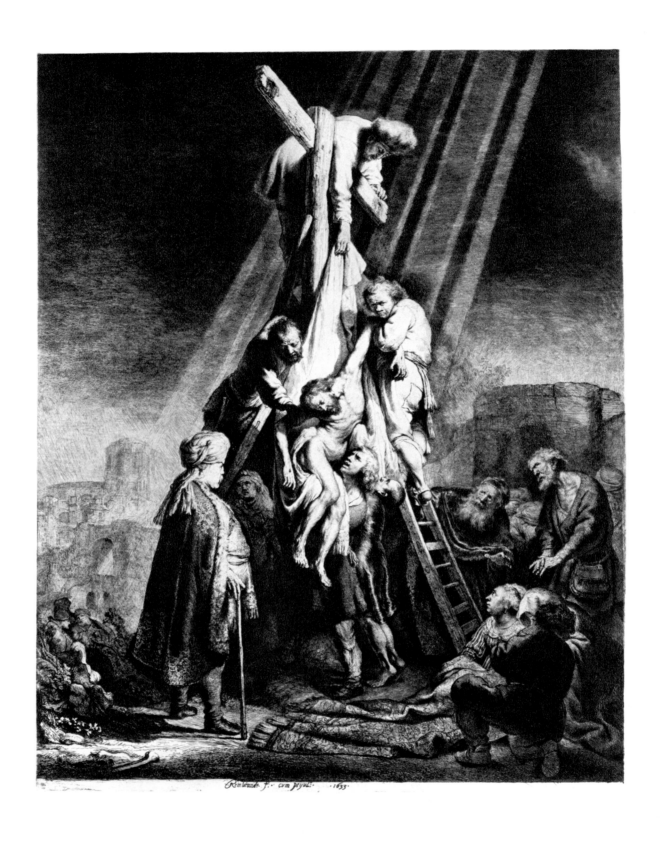

91

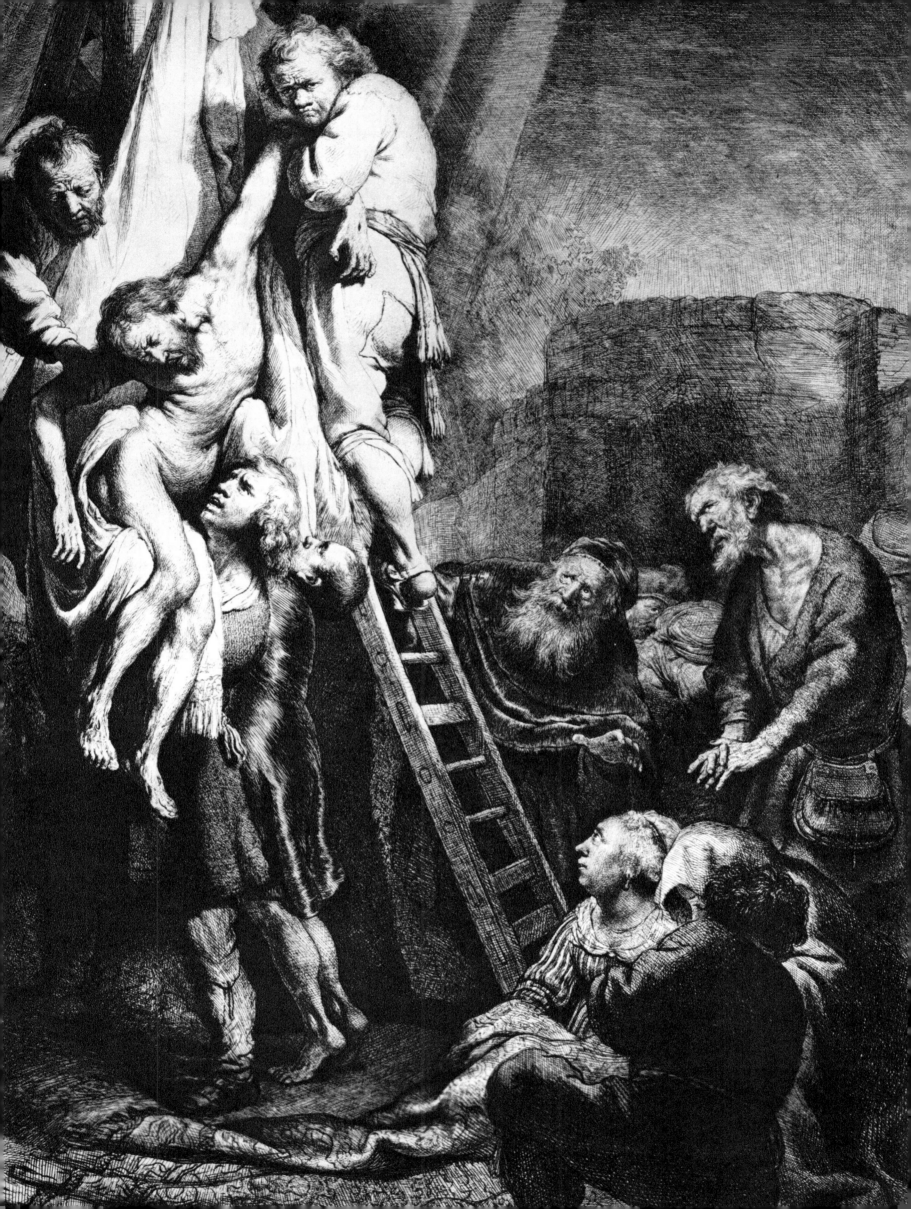

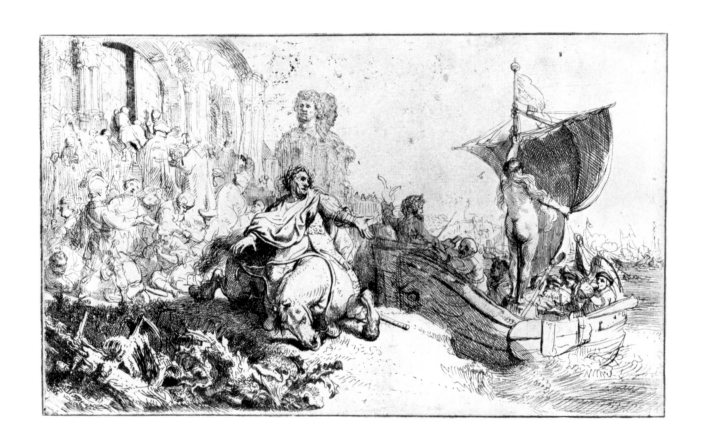

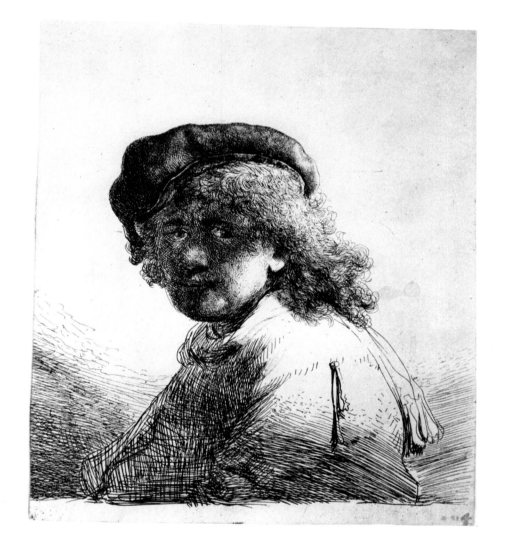

93 94

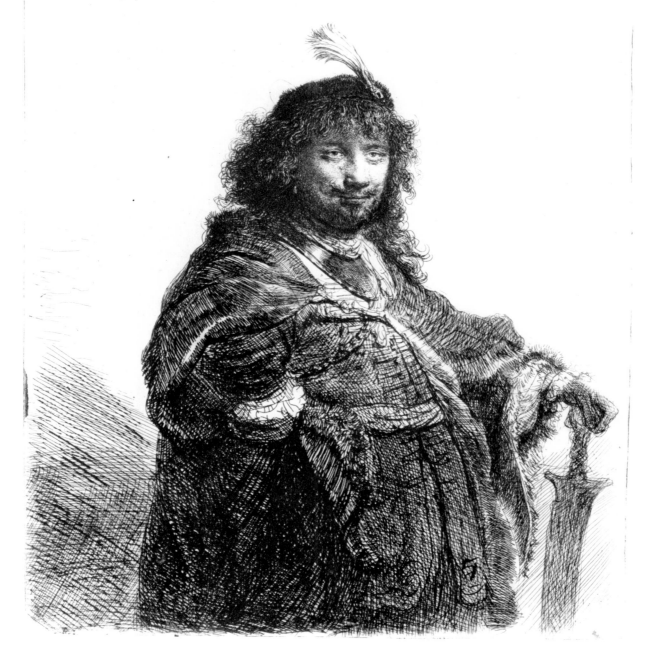

96

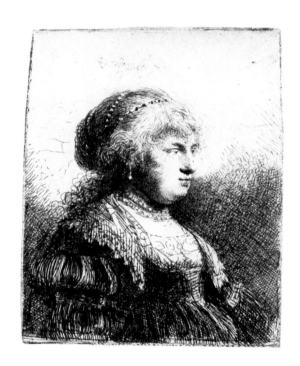

99

100

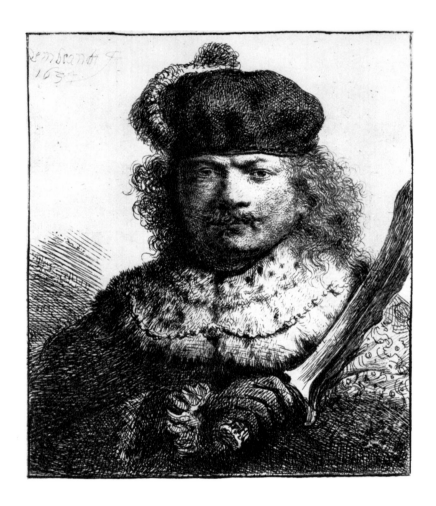

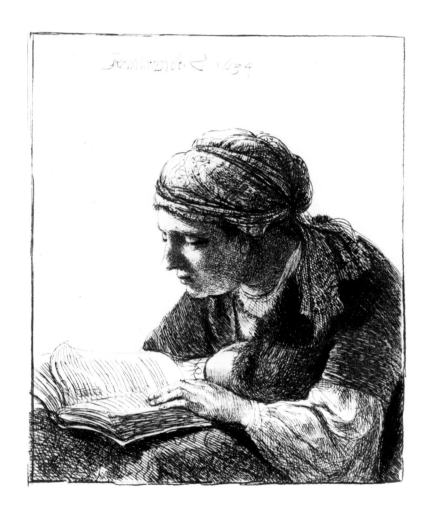

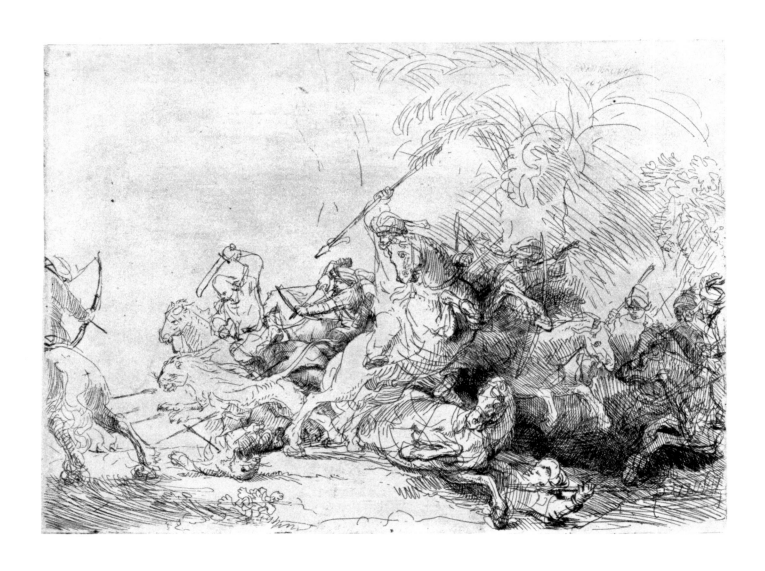

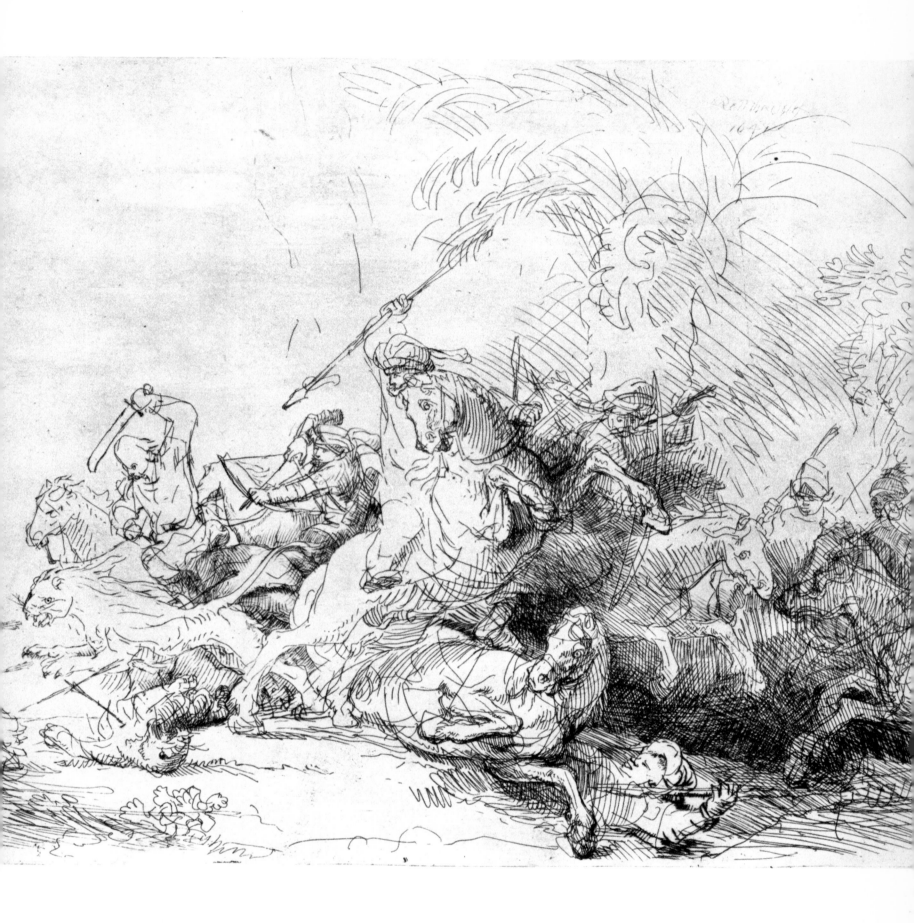

104, detail

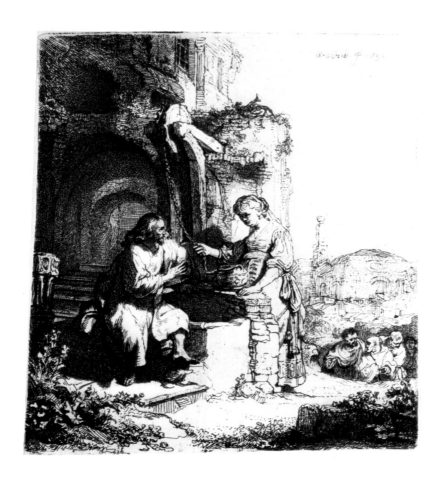

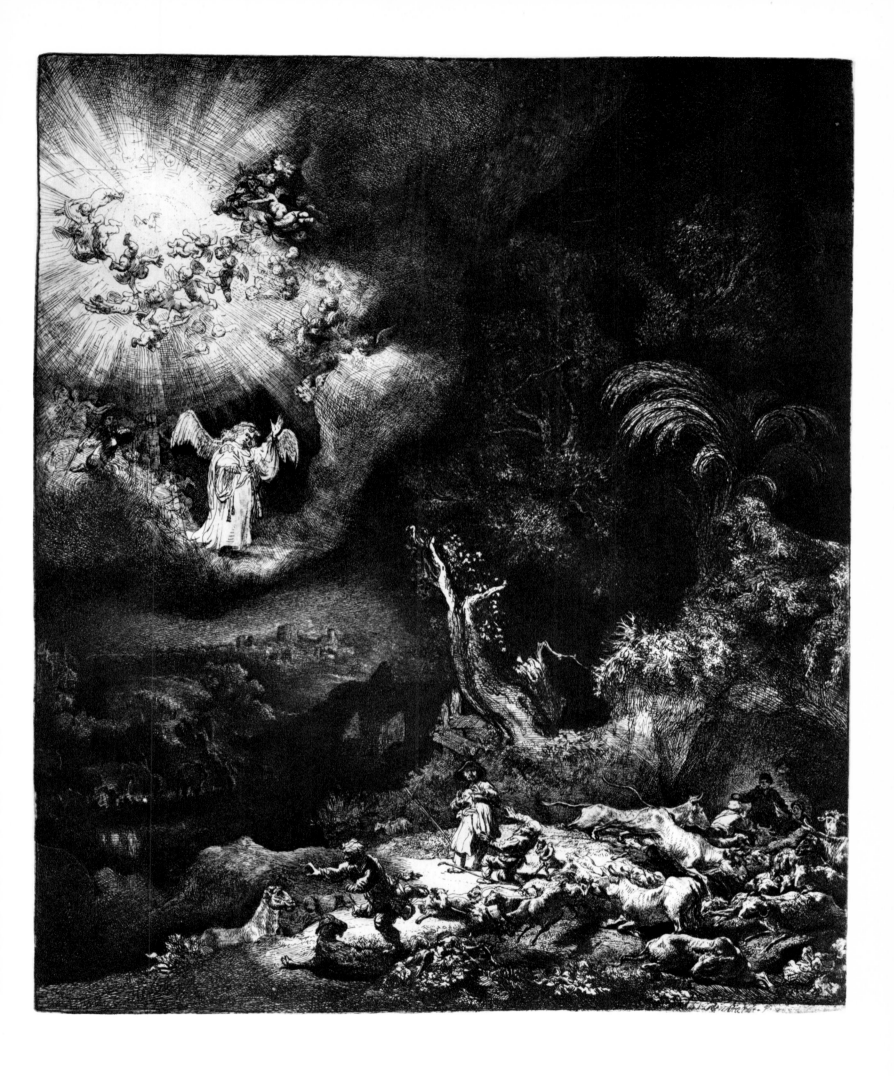

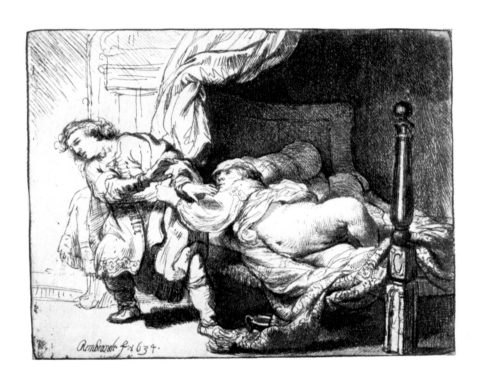

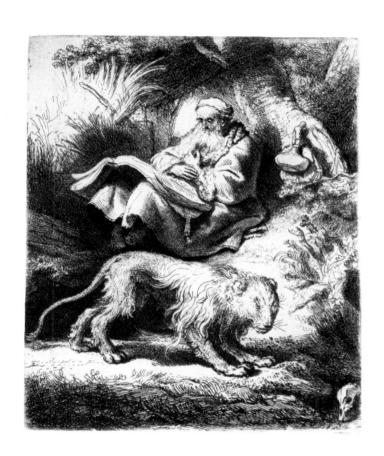

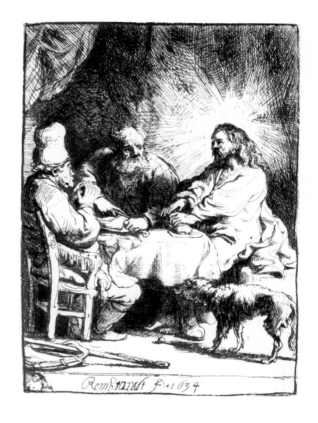

108

109

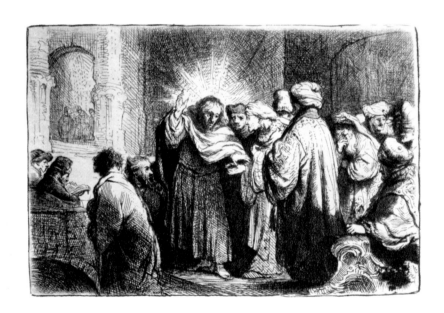

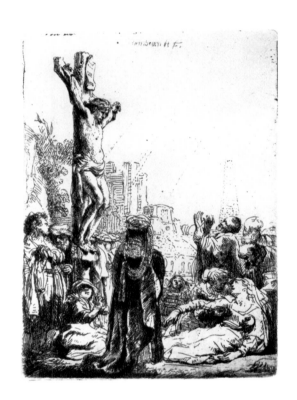

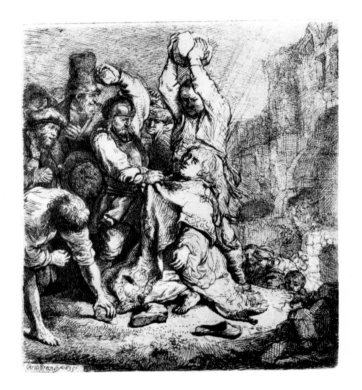

111

112

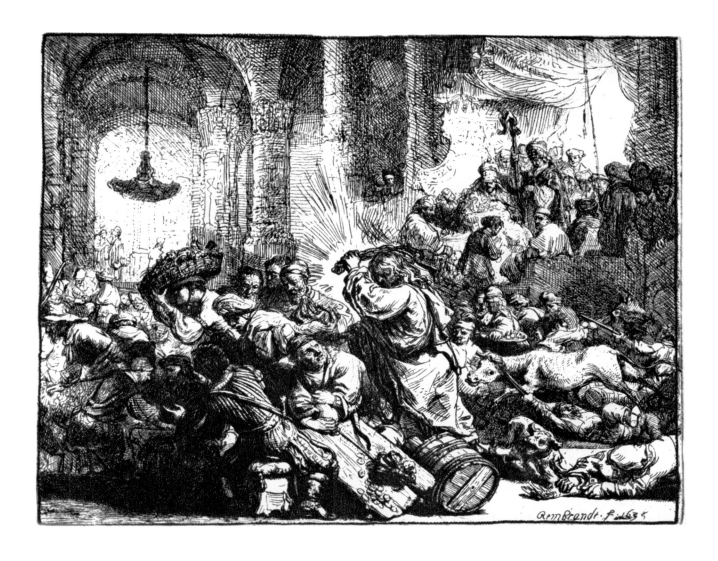

114

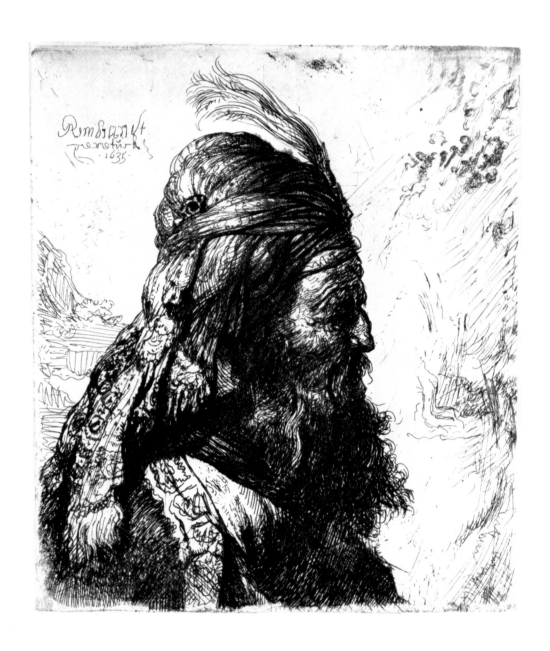

115

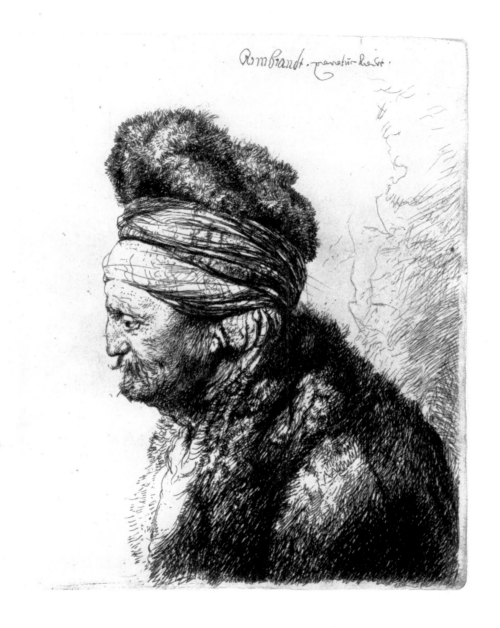

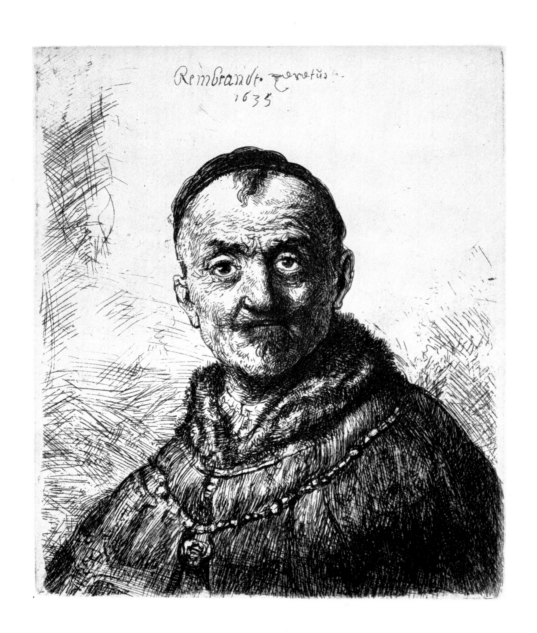

117

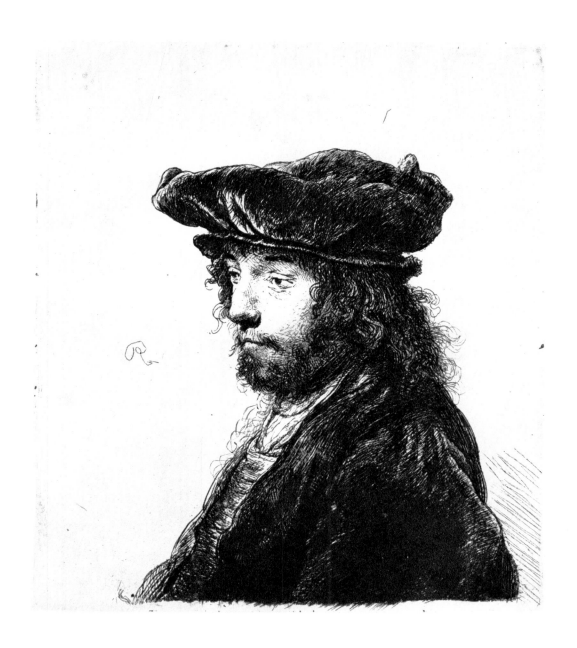

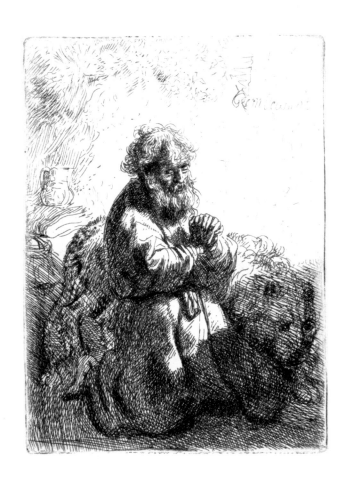

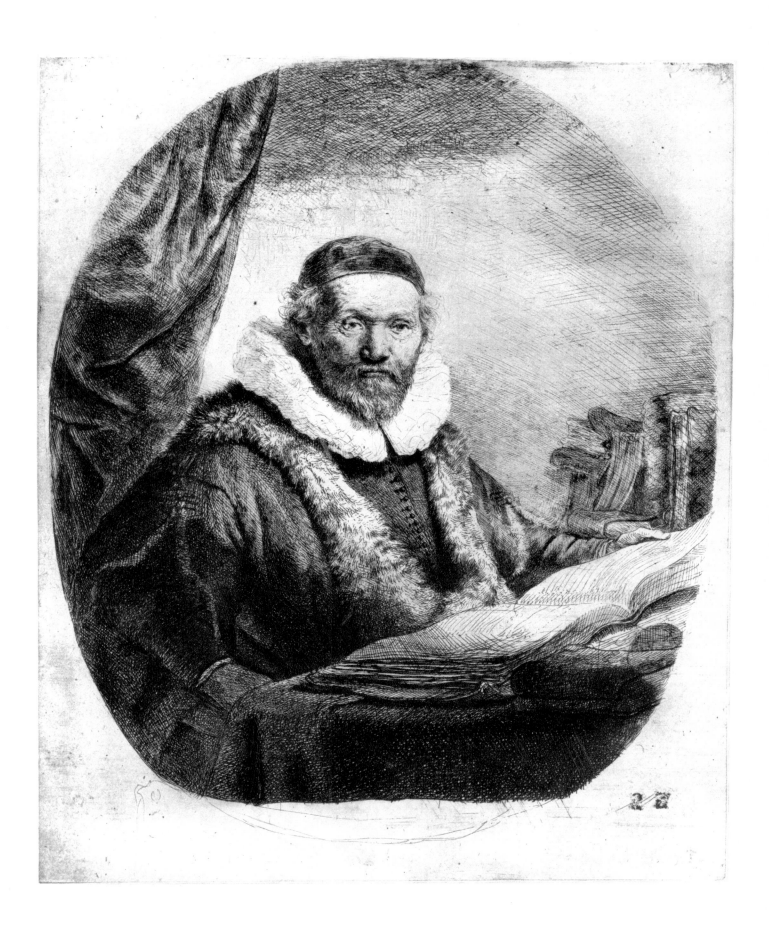

120

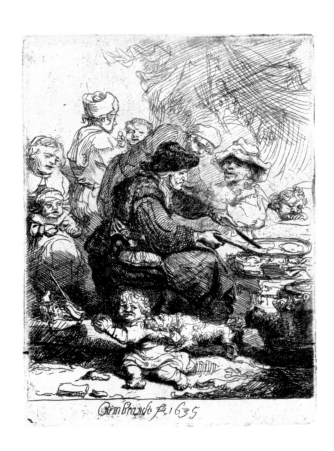

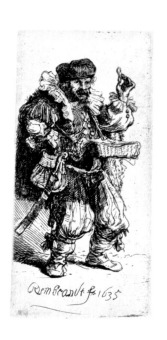

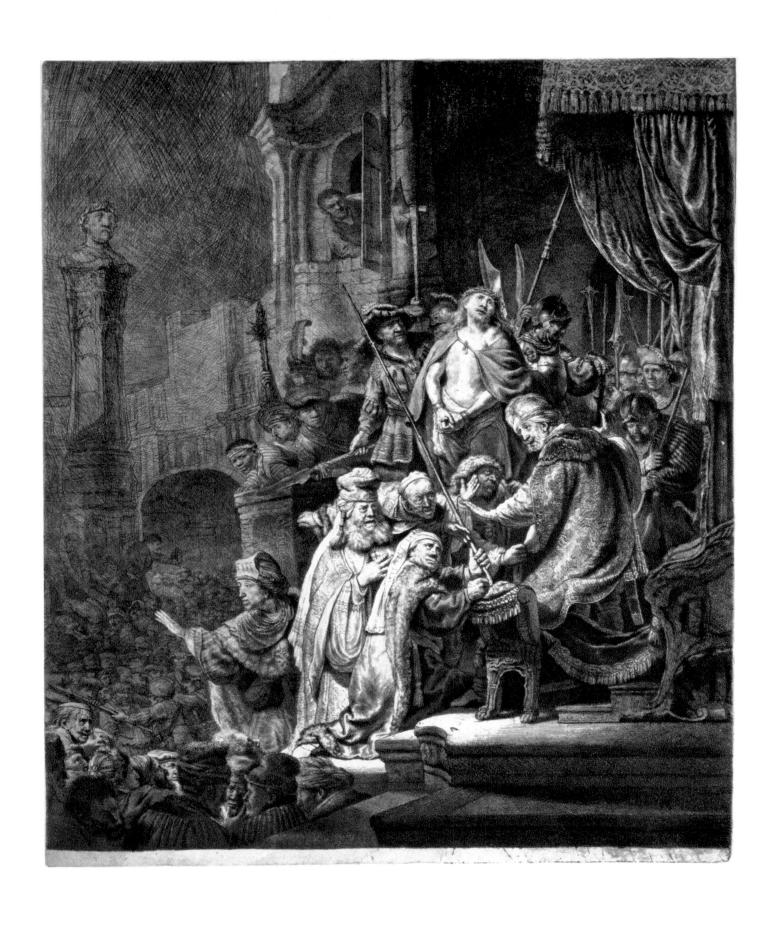

124

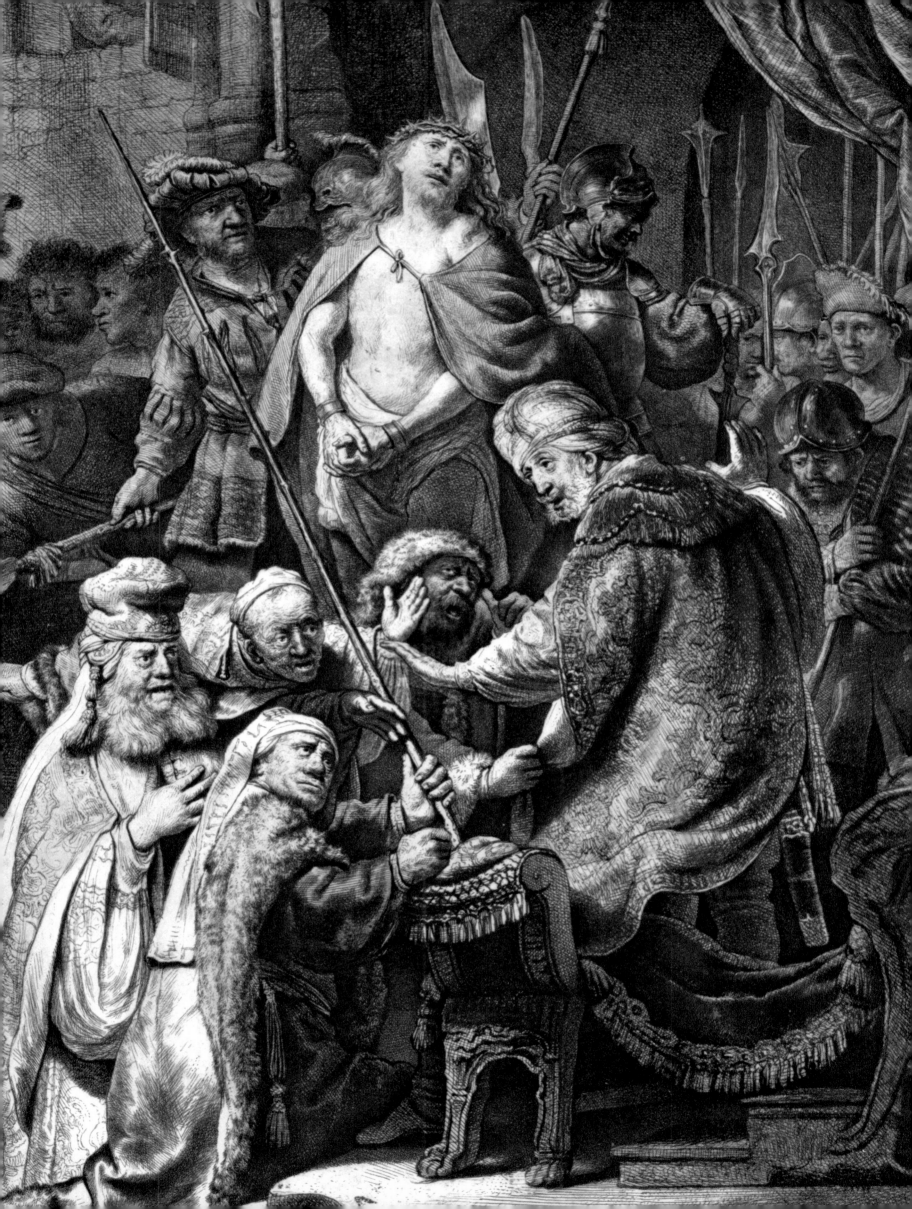

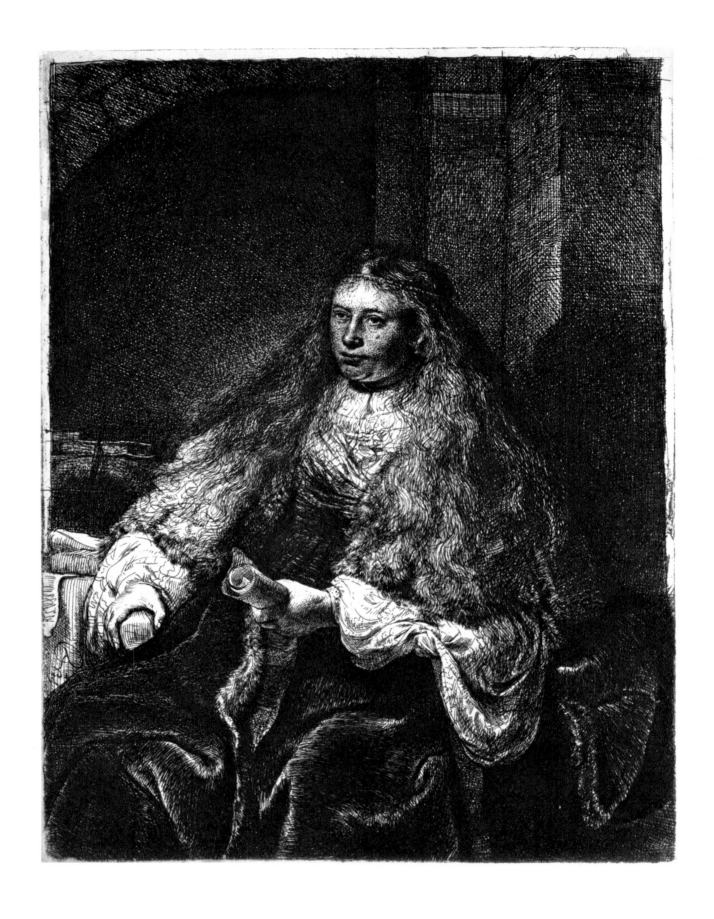

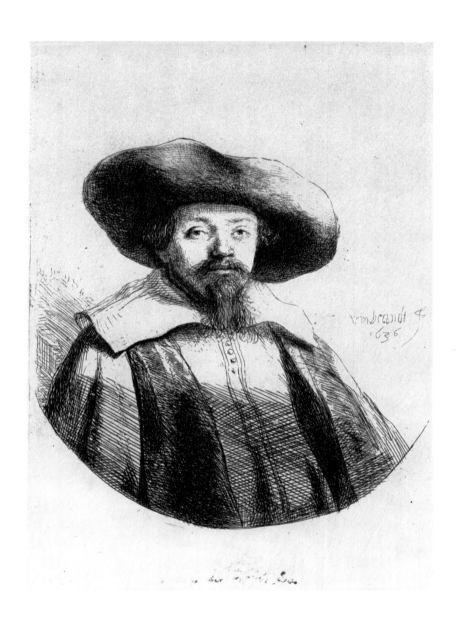

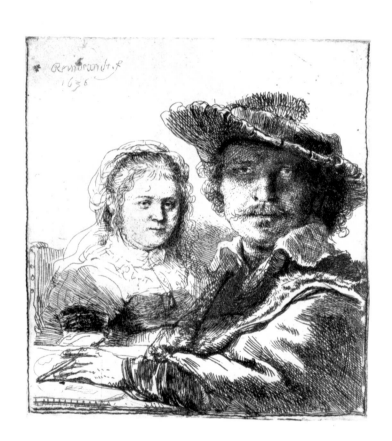

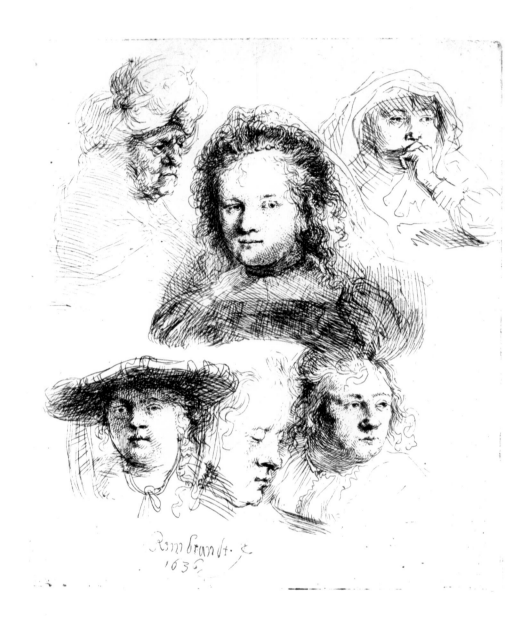

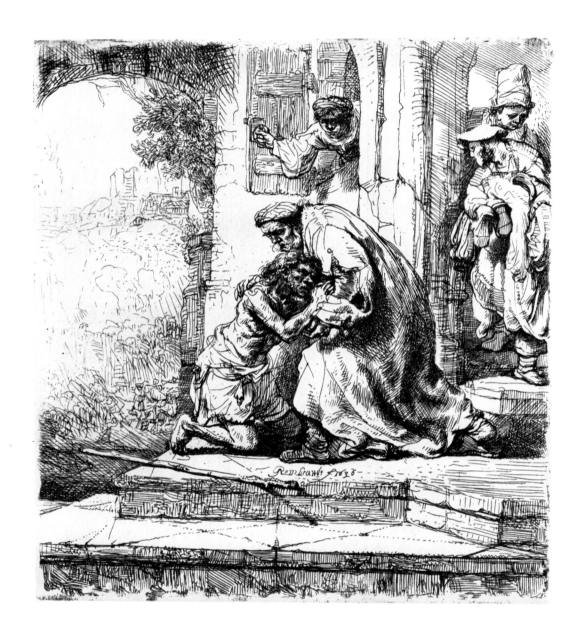

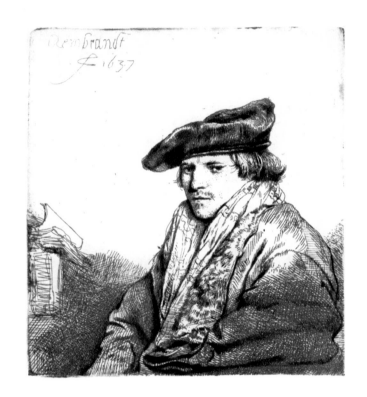

130

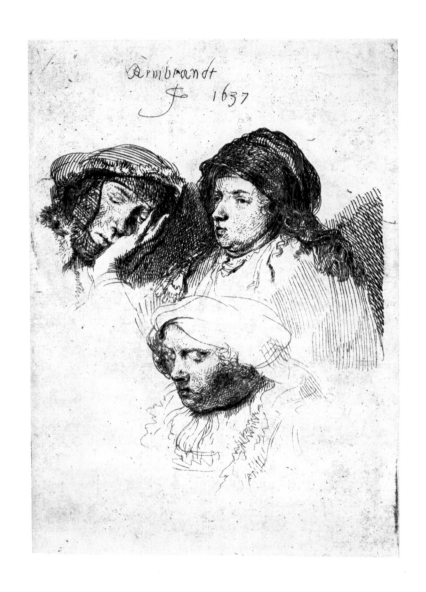

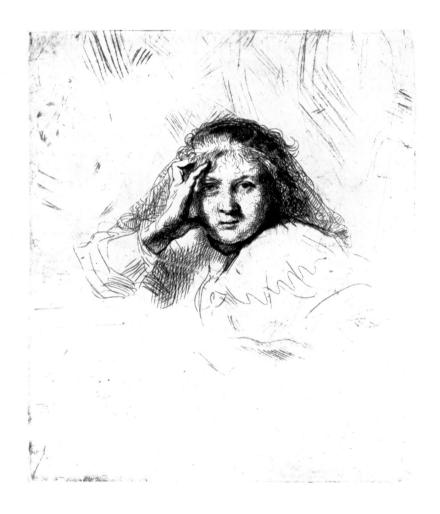

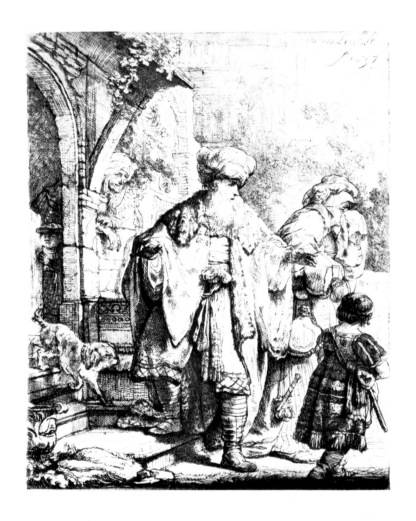

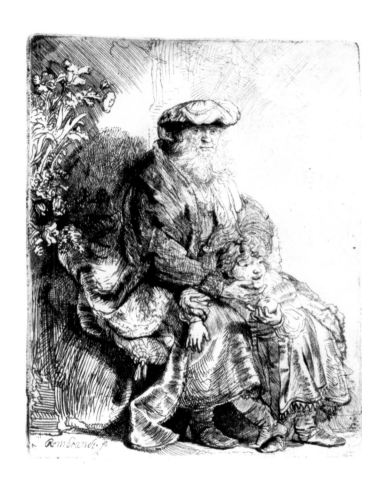

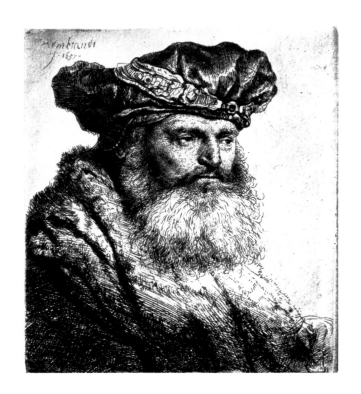

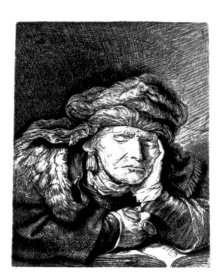

135

136

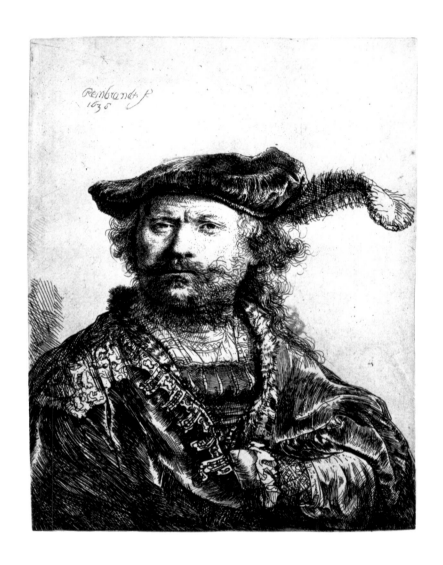

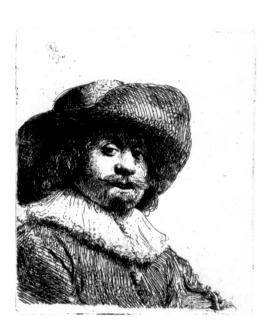

137 138

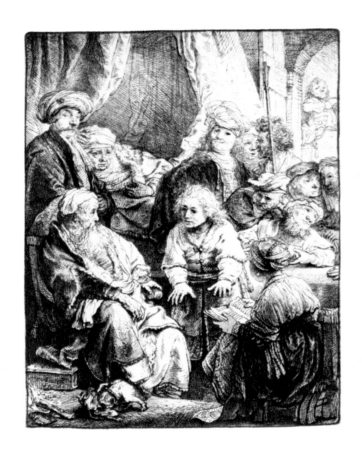

139

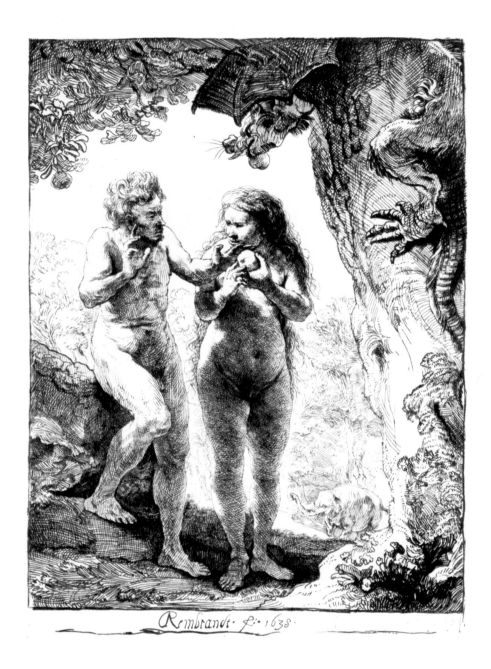

Rembrandt. f. 1638.

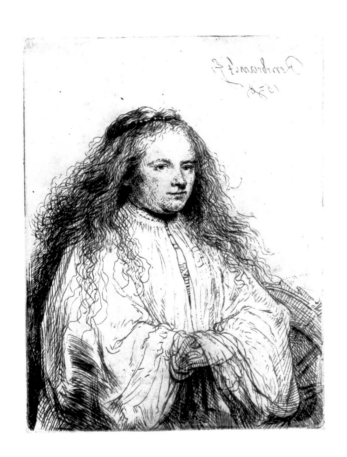

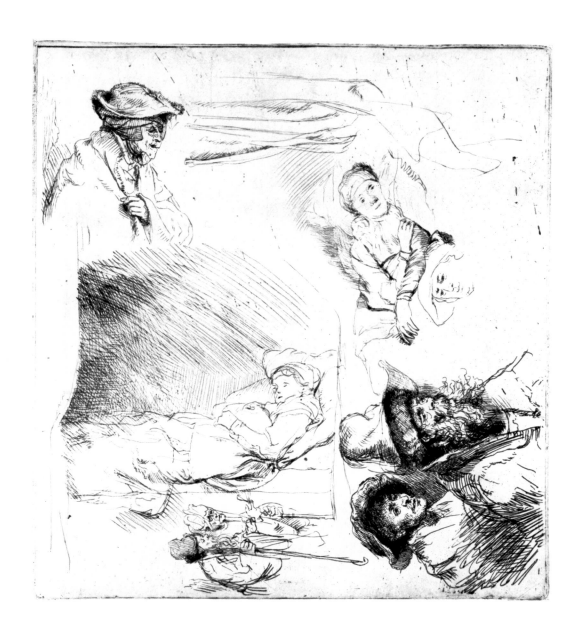

142

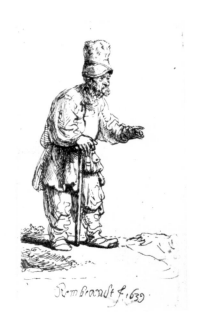

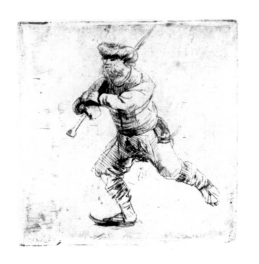

143　　　　　　　　　　　　　　　144

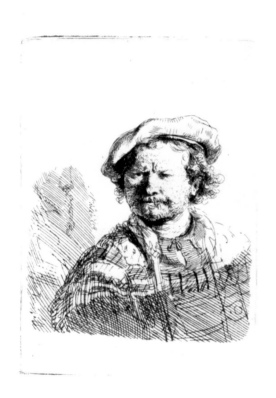

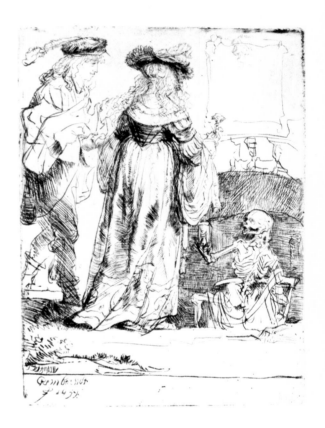

145

146

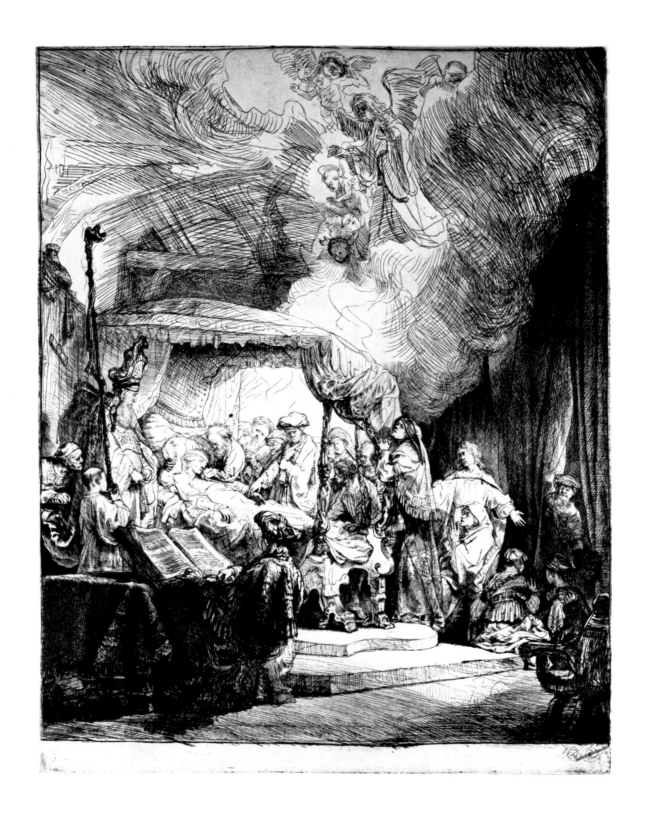

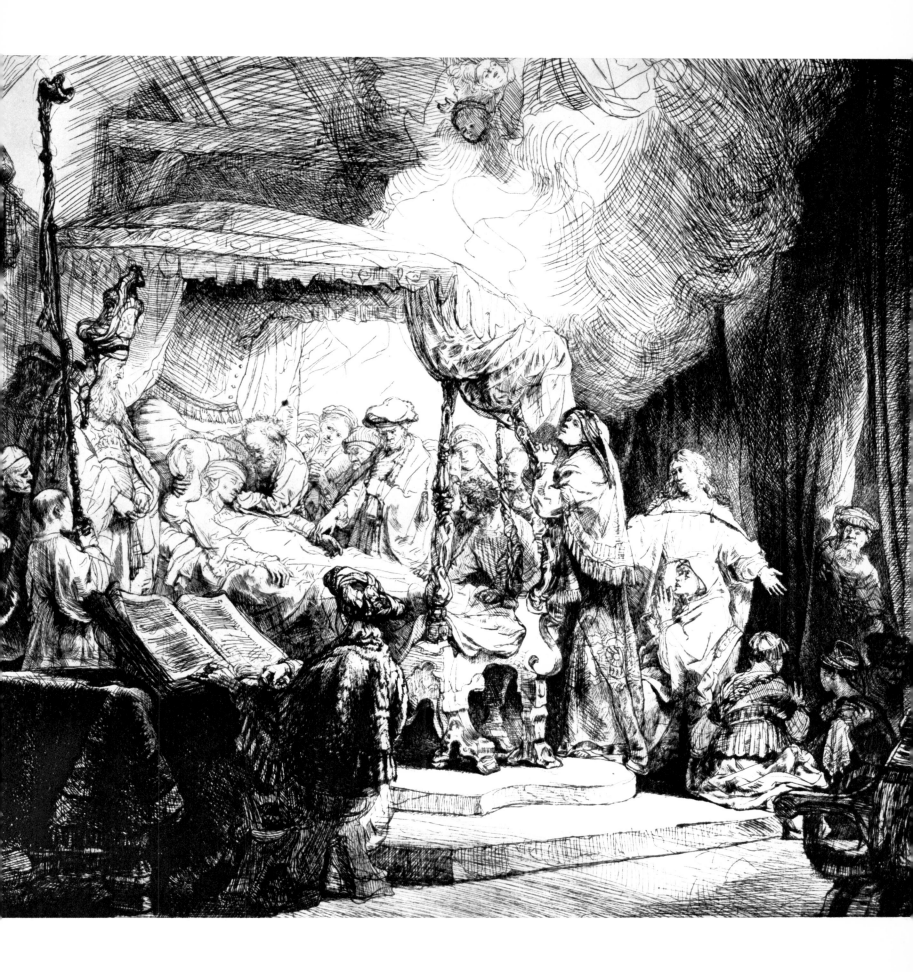

147, *detail*

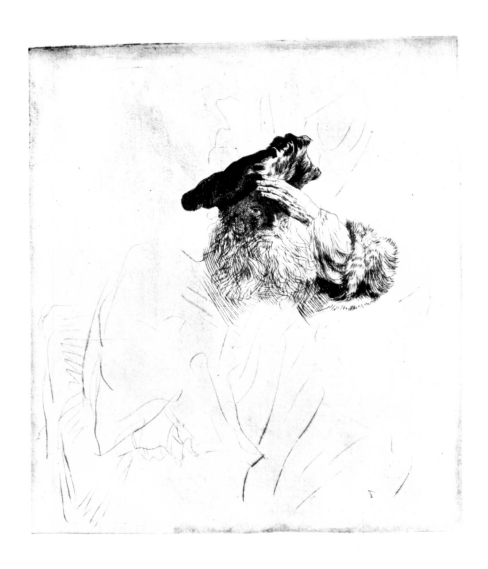

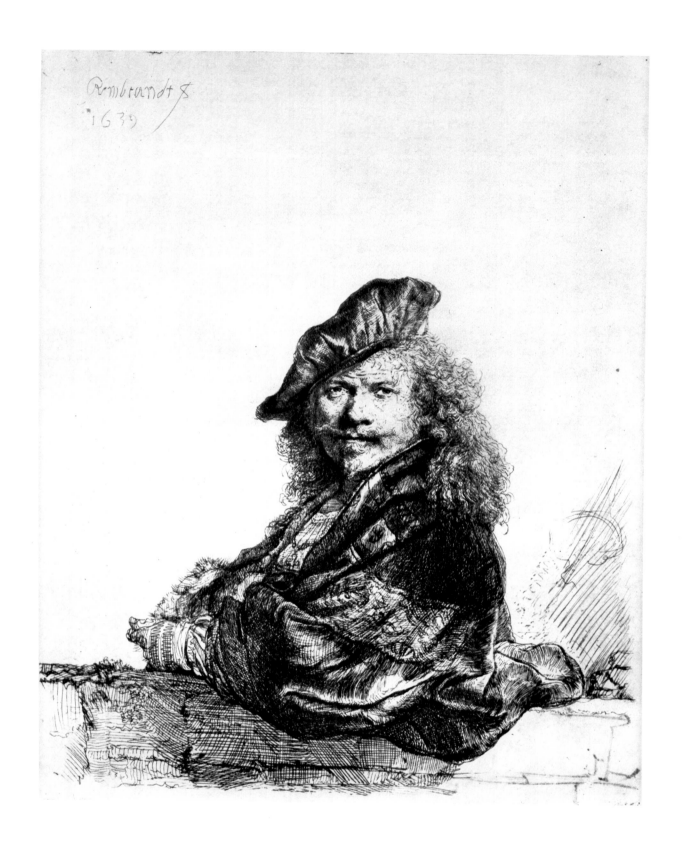

149

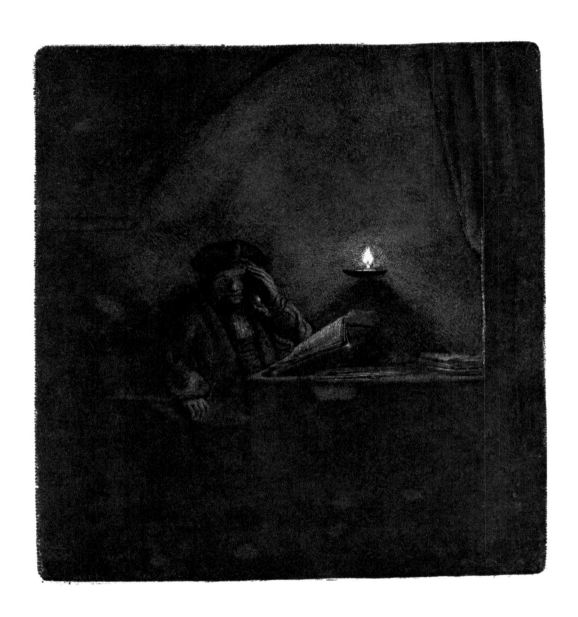

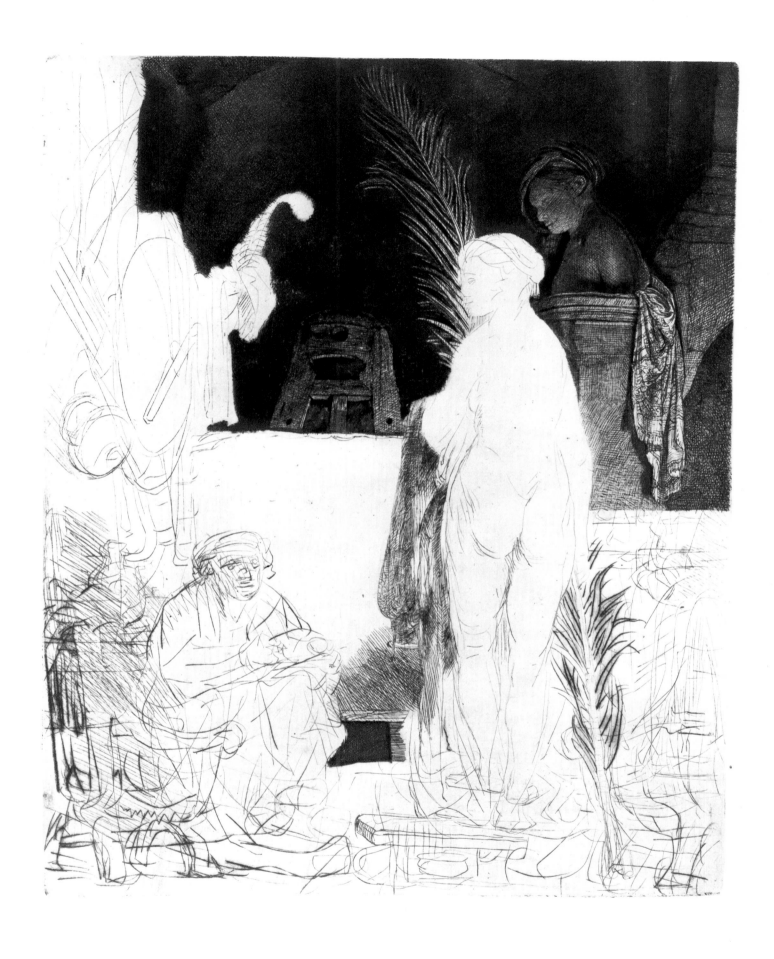

151

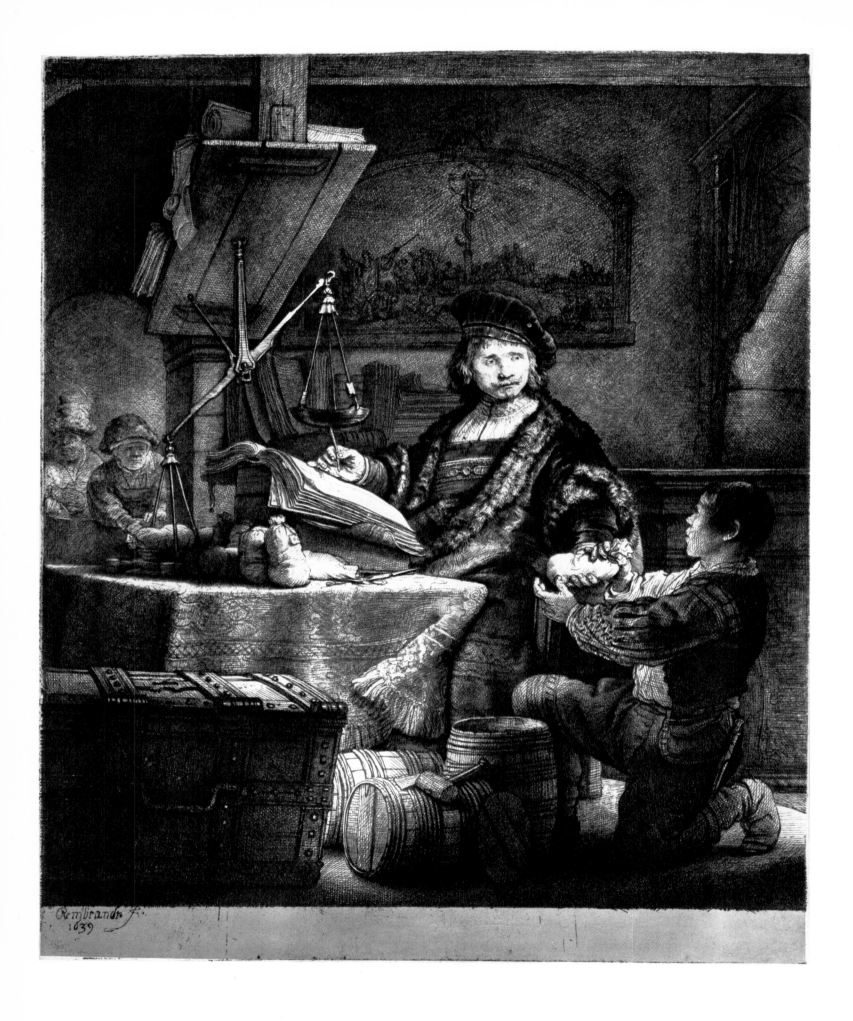

Rembrandt f.
1639

152

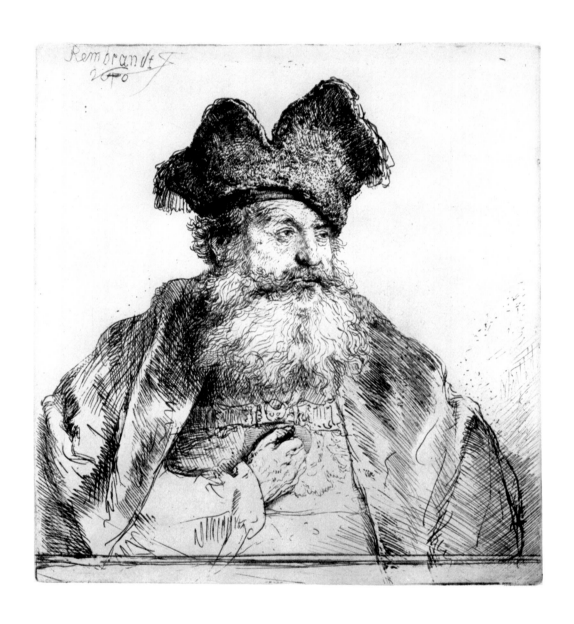

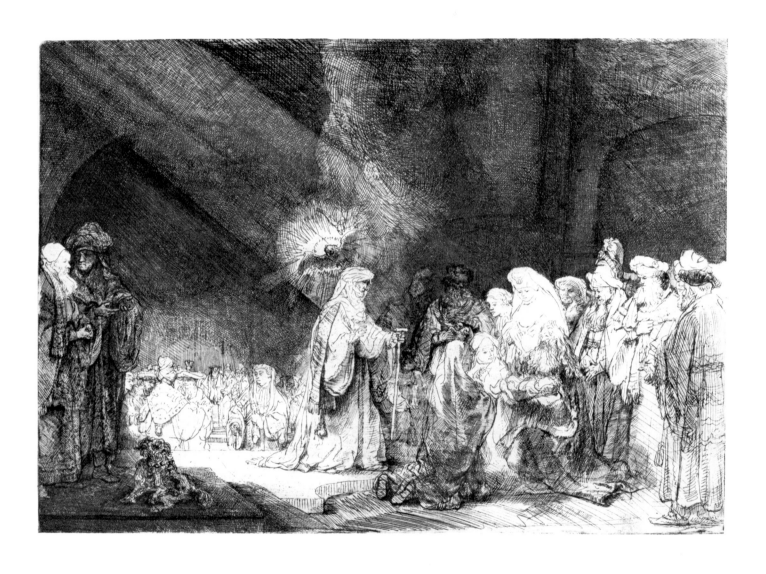

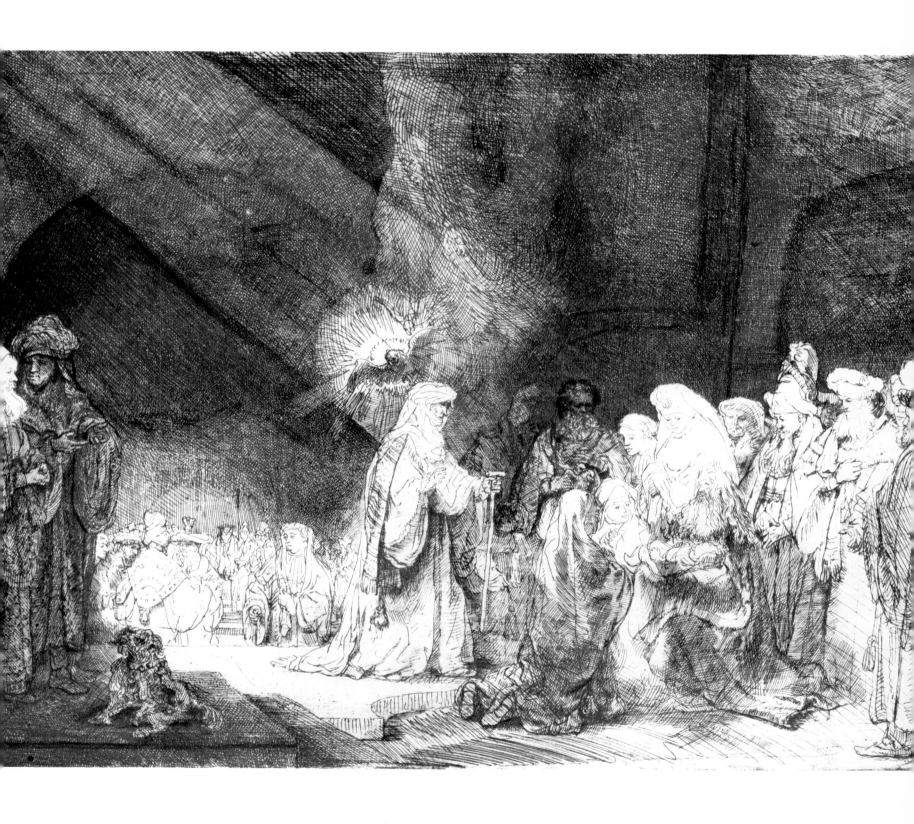

154, detail

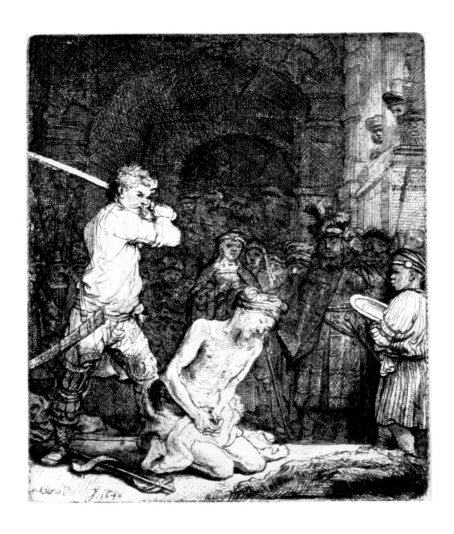

155

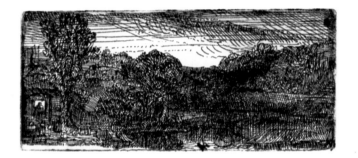

156 157

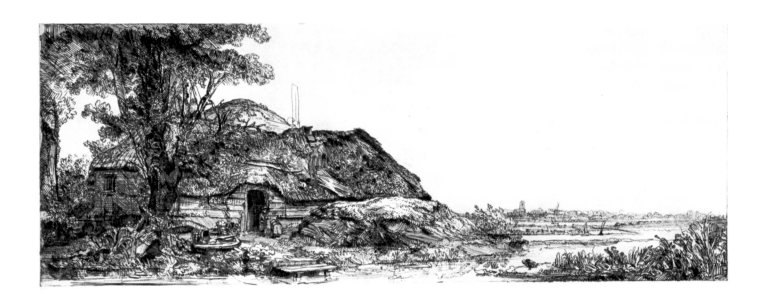

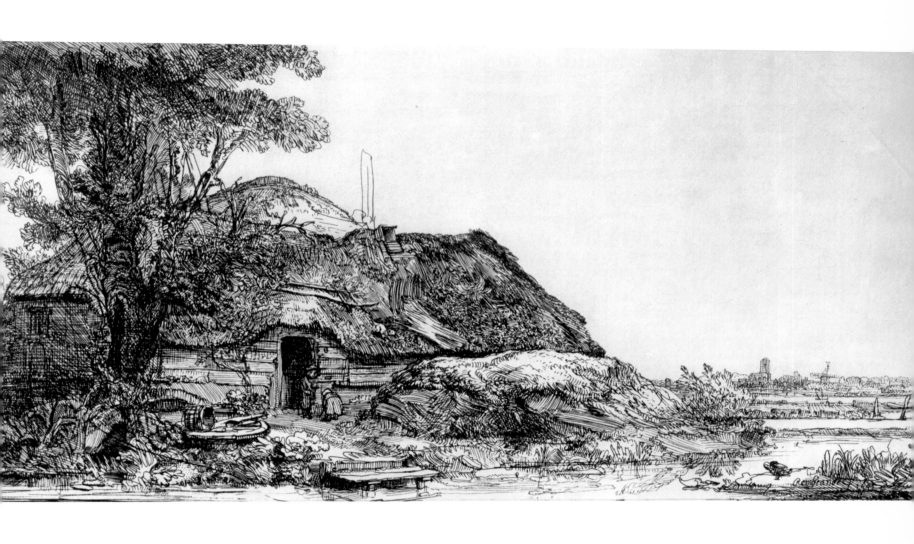

158, detail

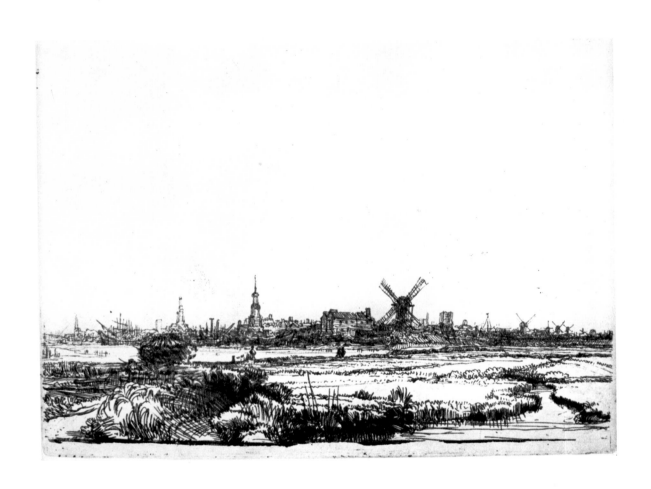

159

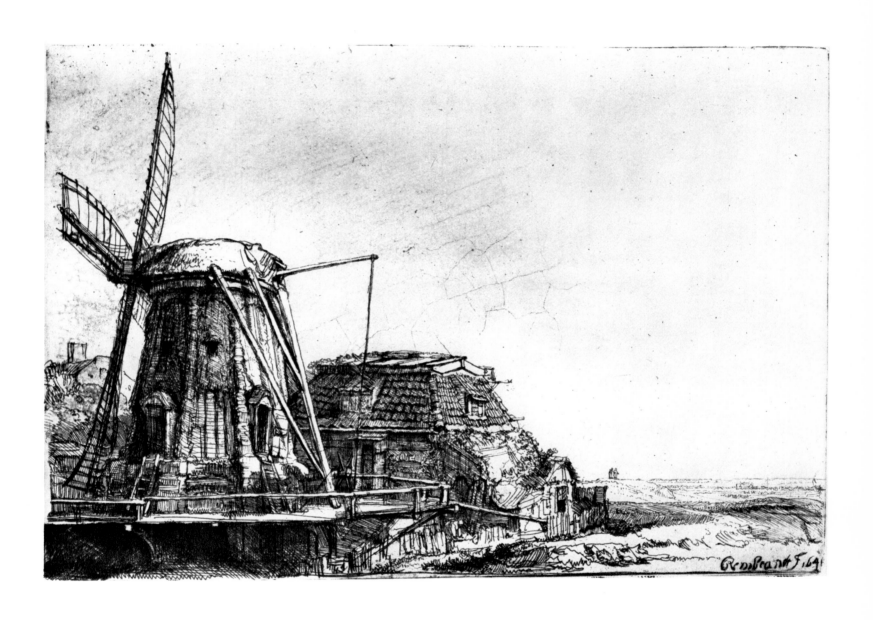

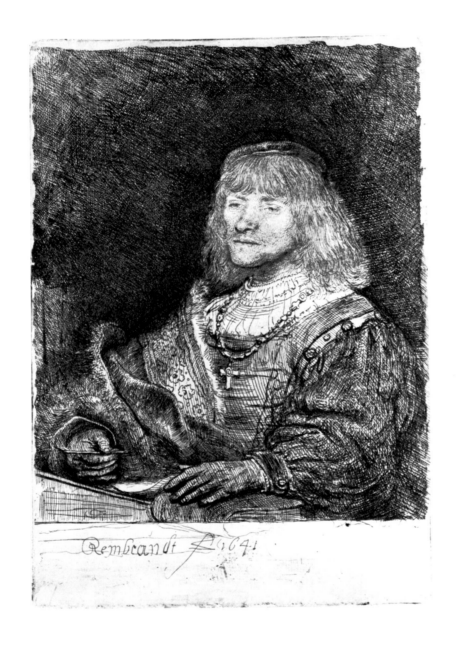

161

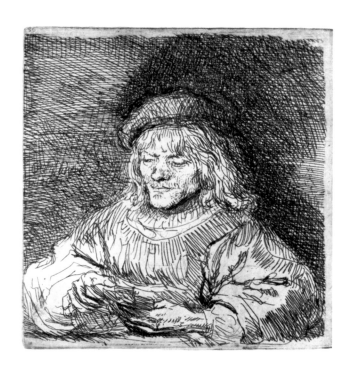

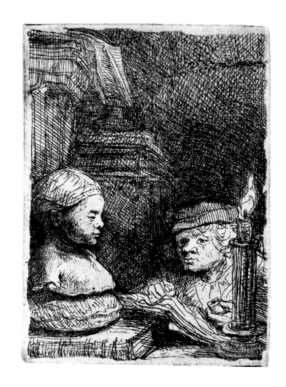

162

163

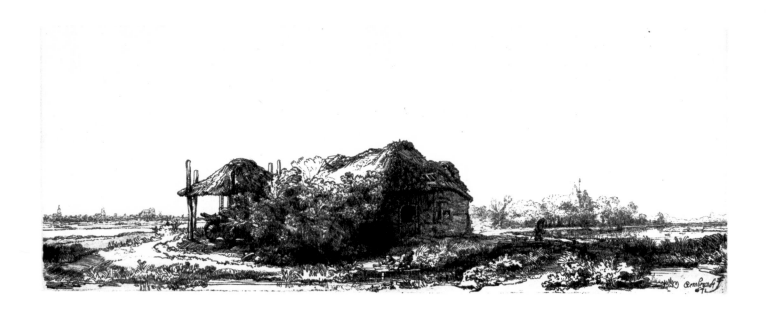

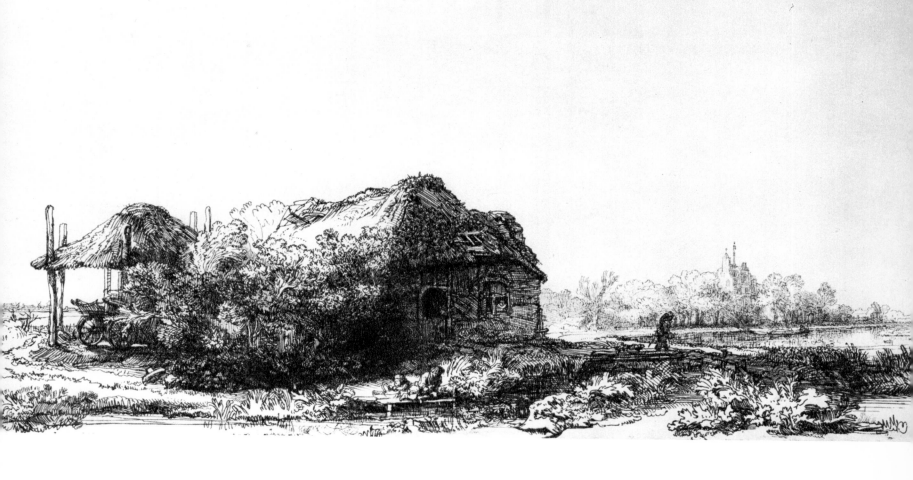

164, detail

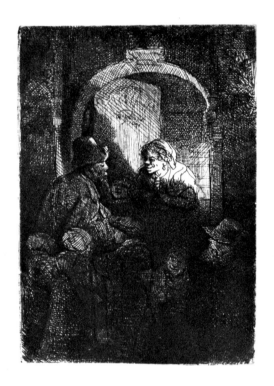

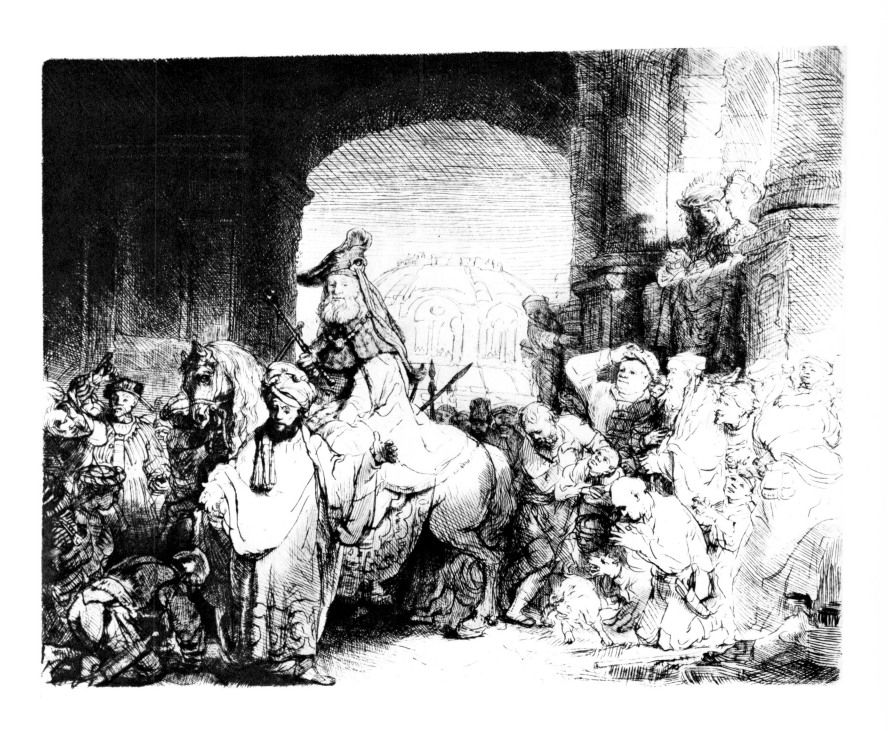

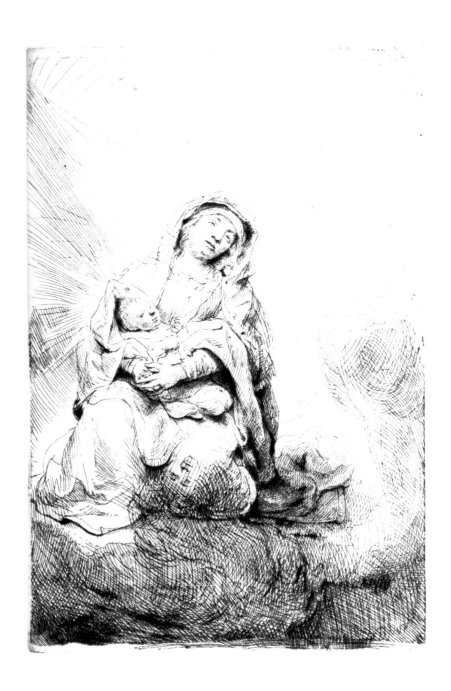

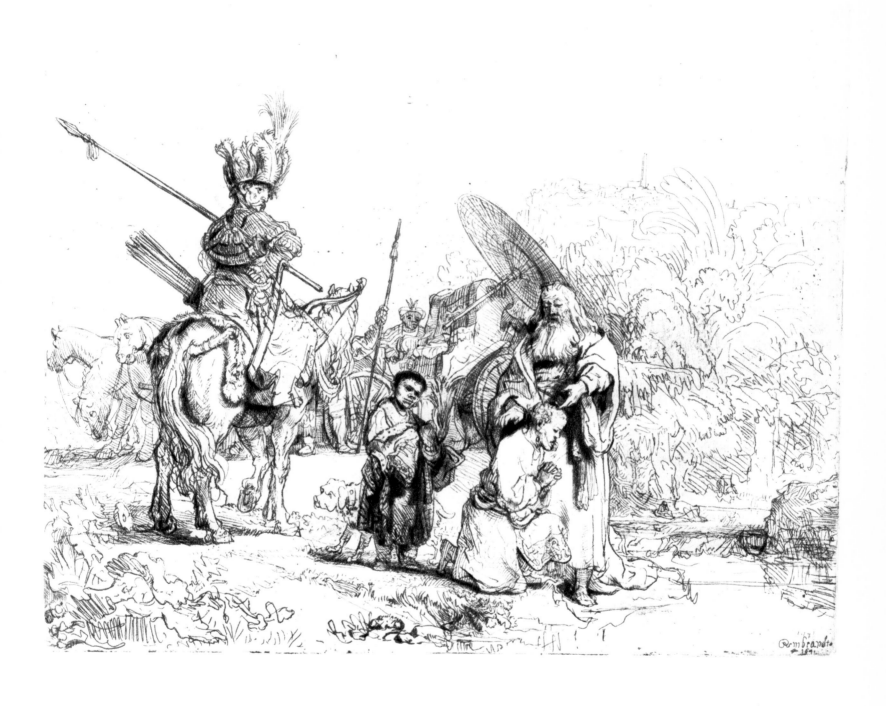

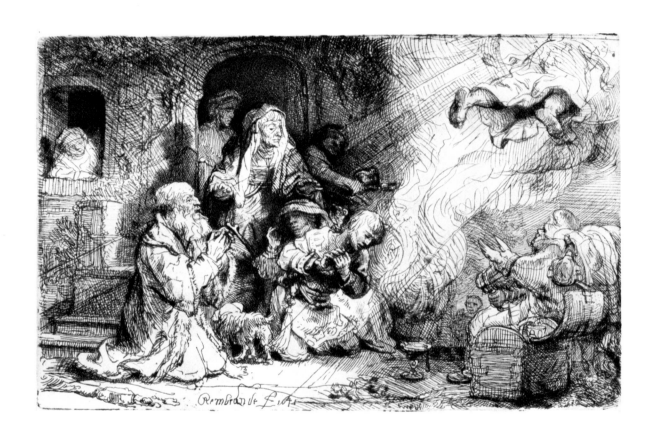

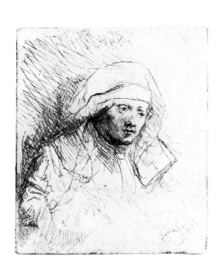

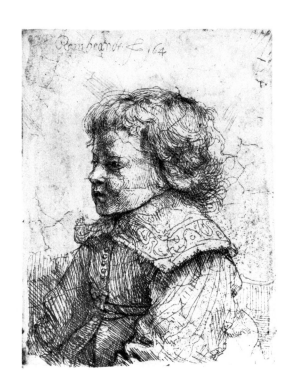

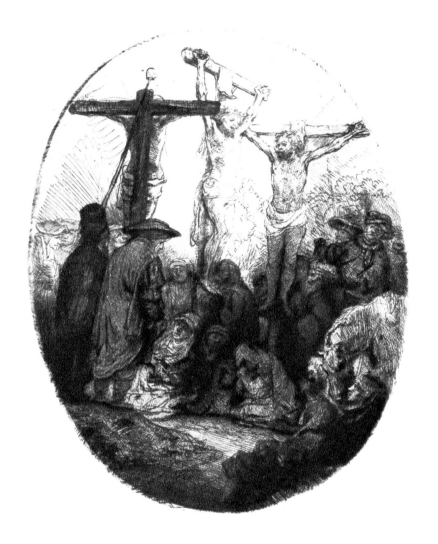

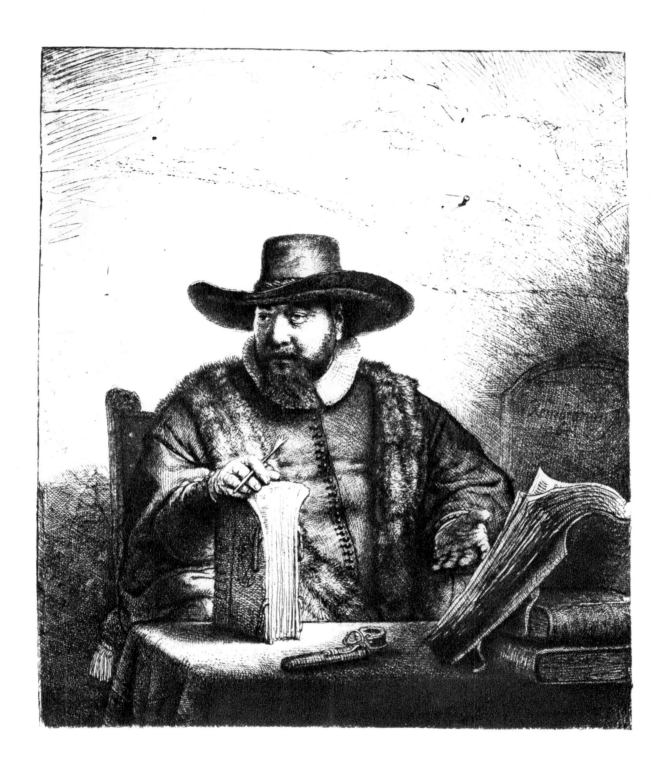

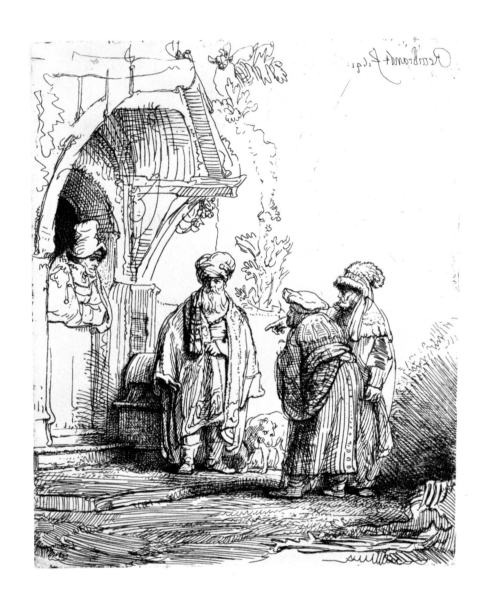

174

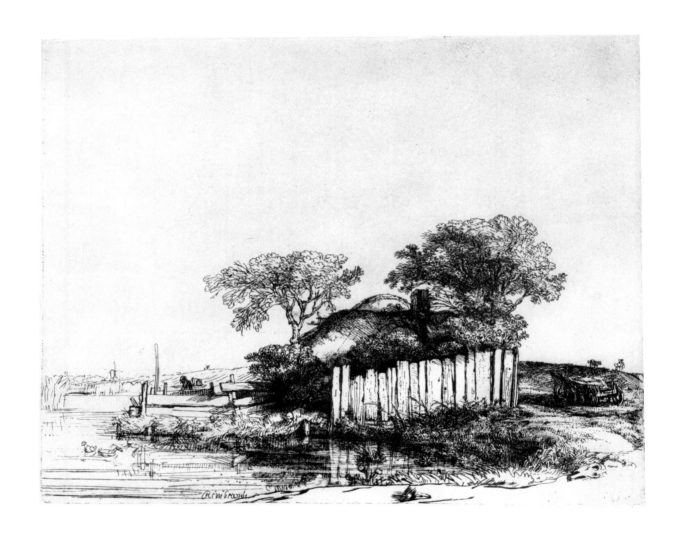

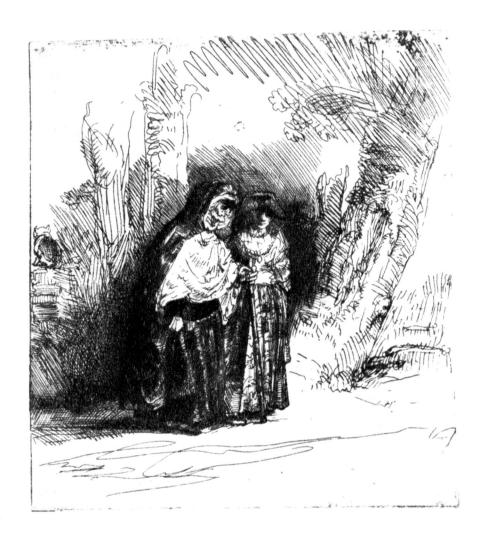

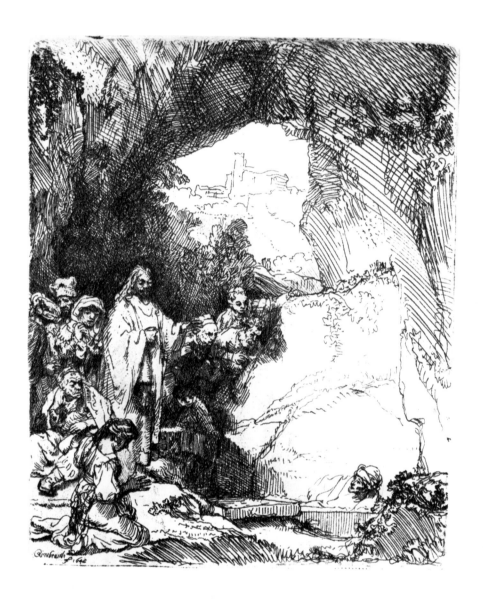

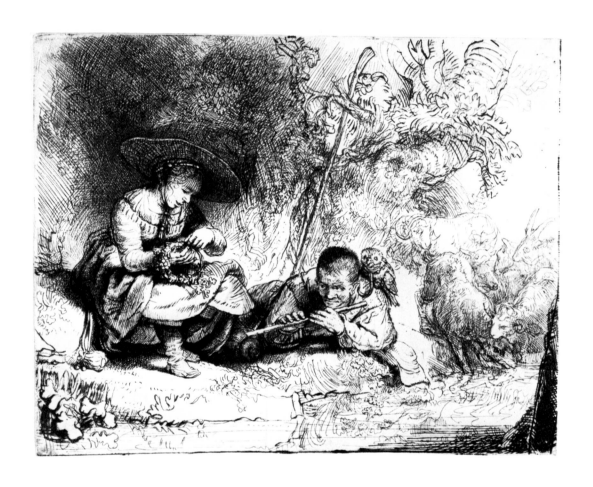

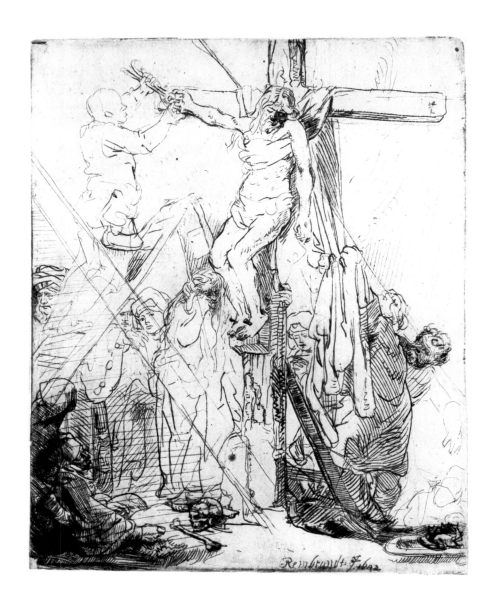

180 181

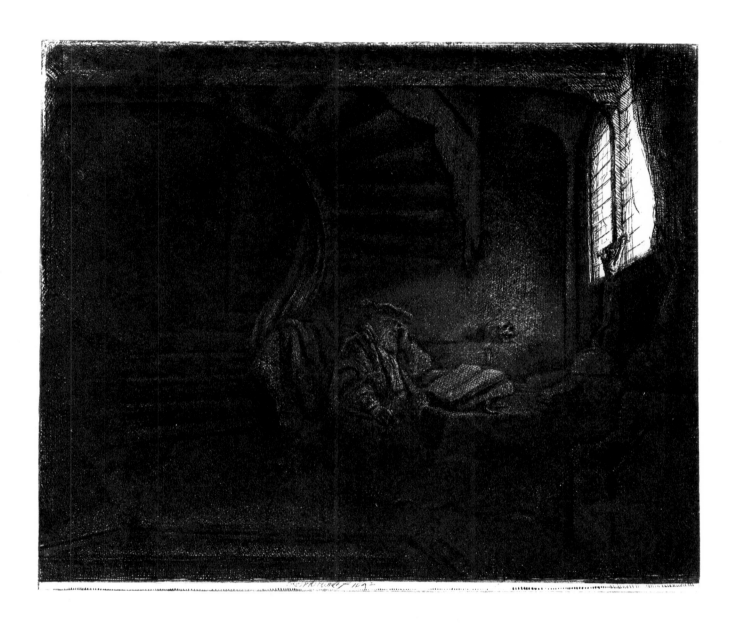

184

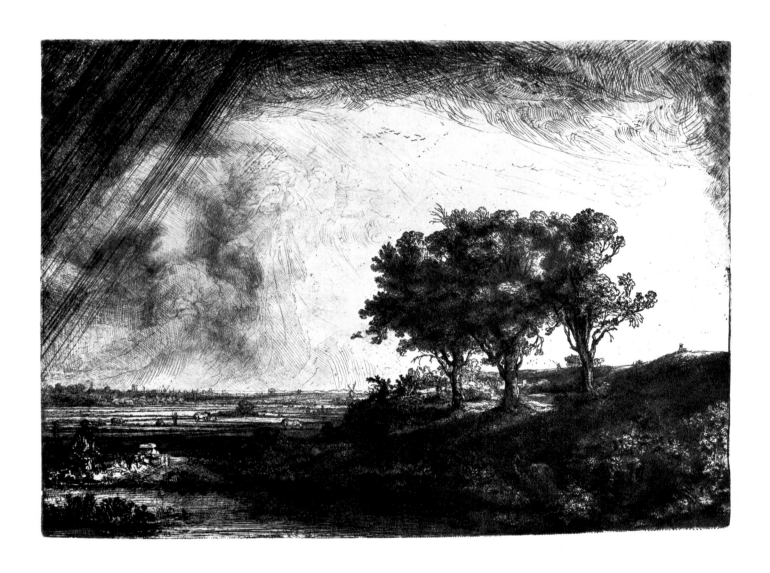

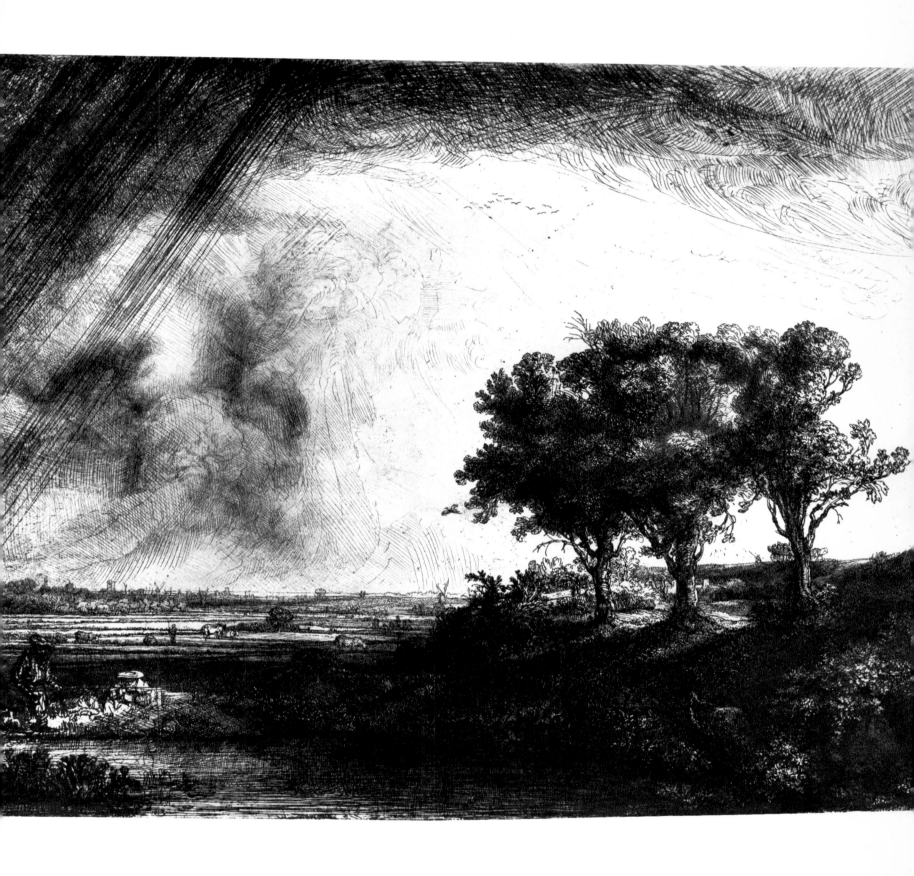

185, detail

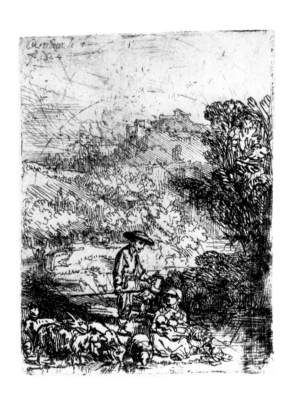

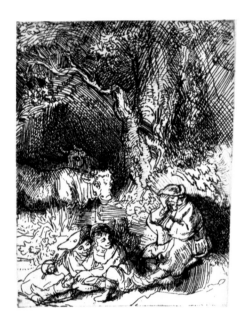

186 187

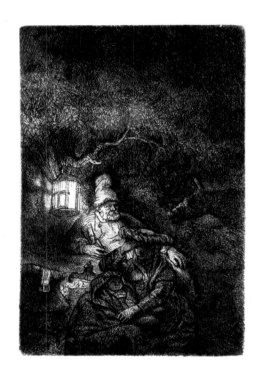

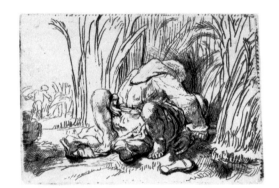

188 189

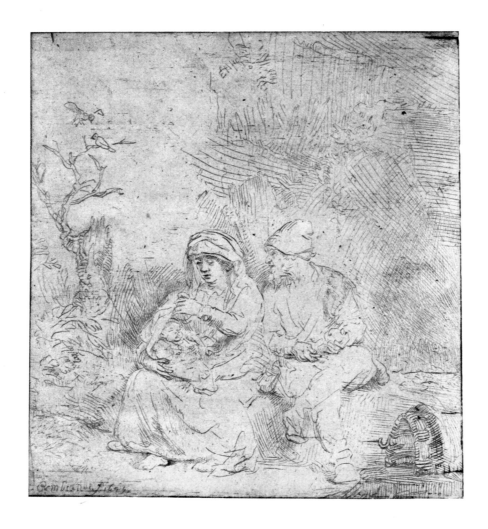

190

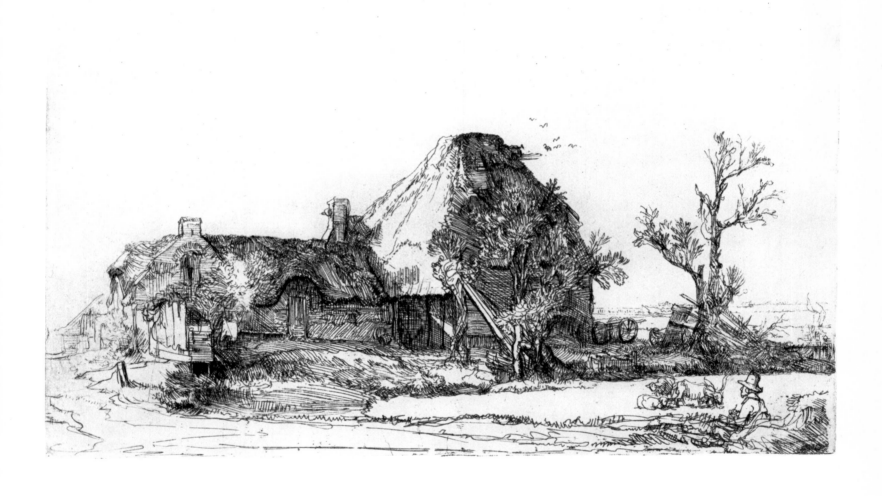

191

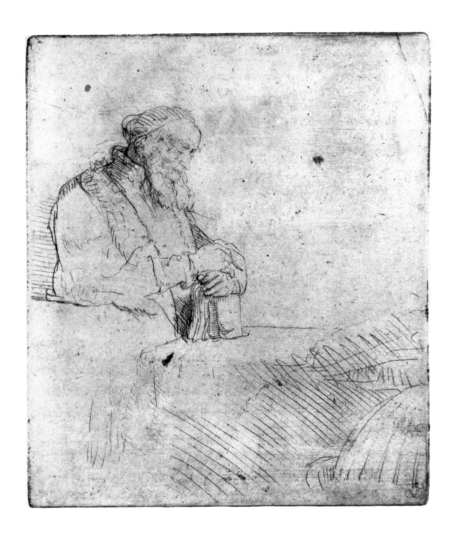

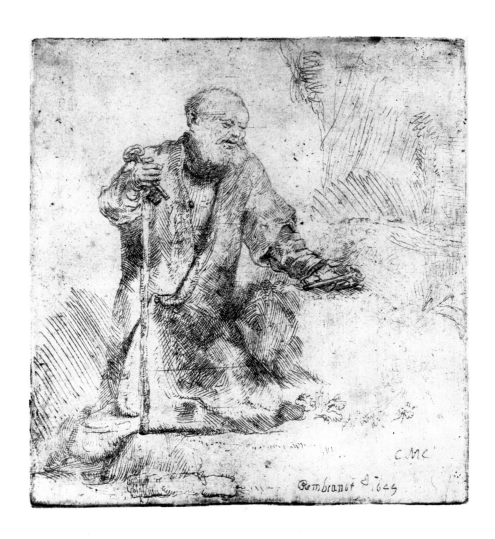

193

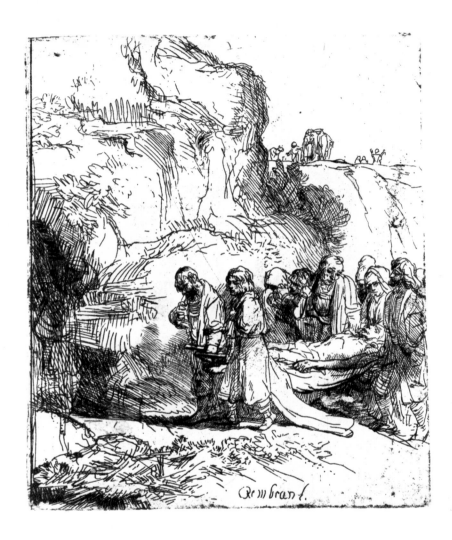

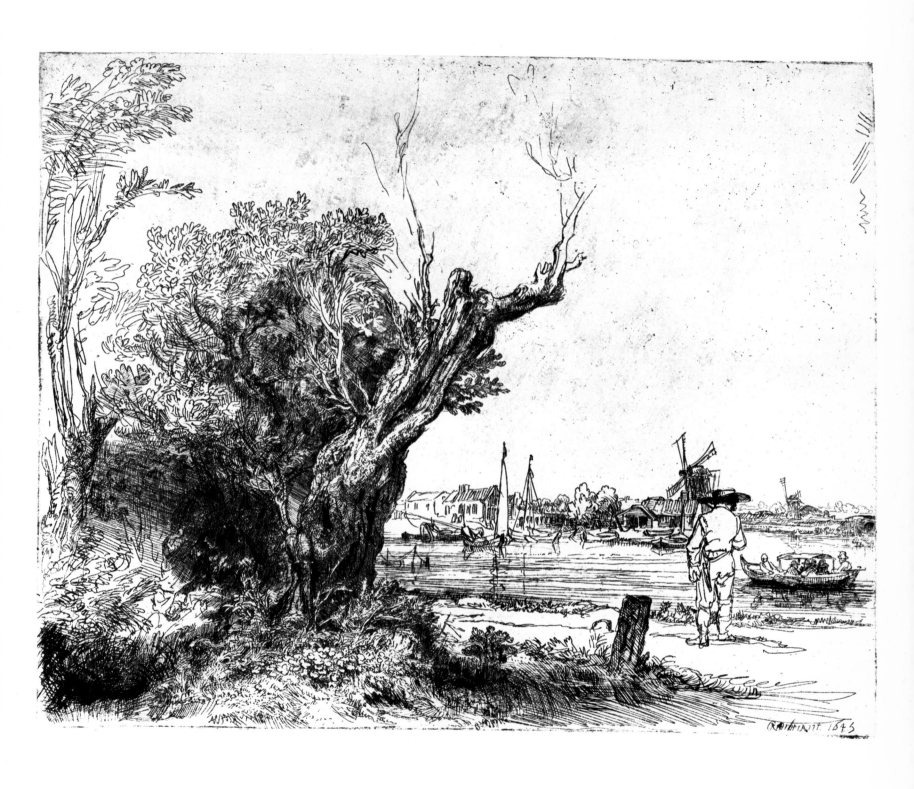

195

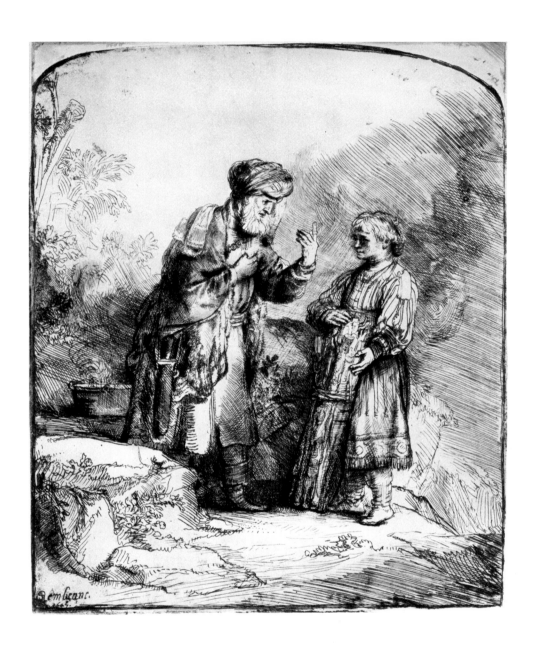

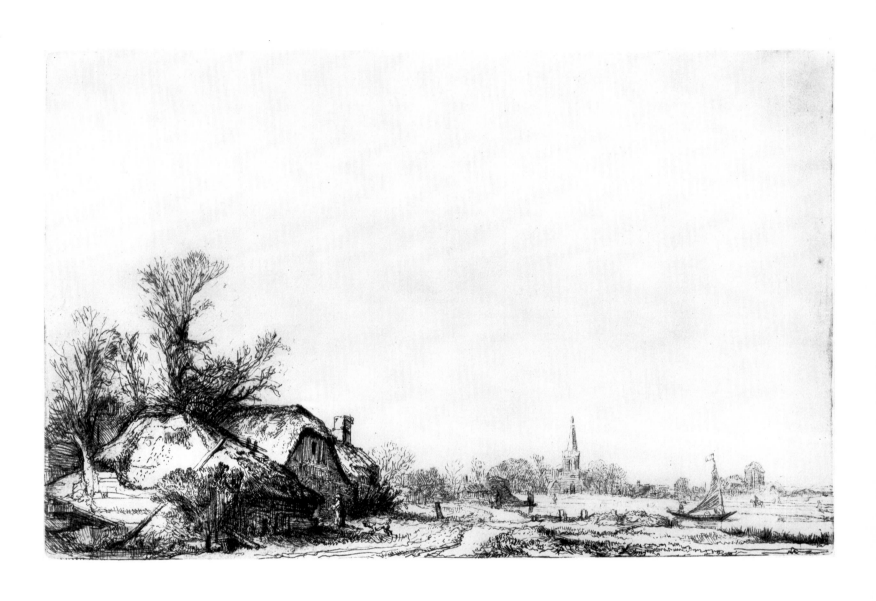

197

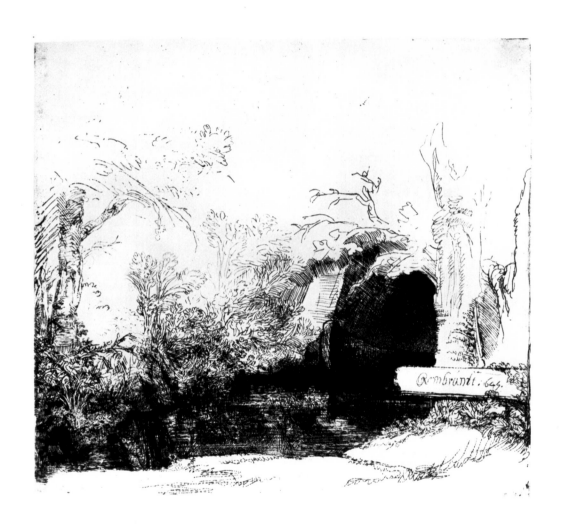

198

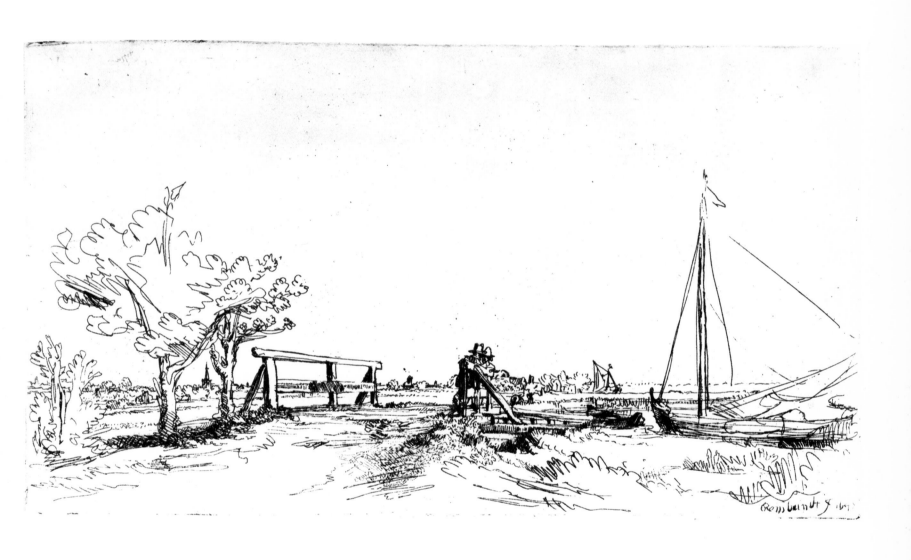

199

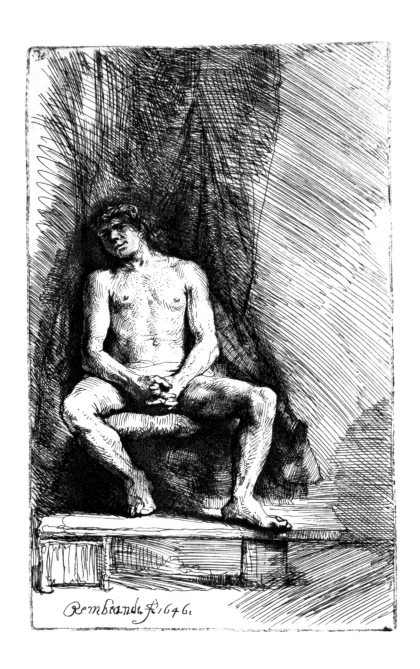

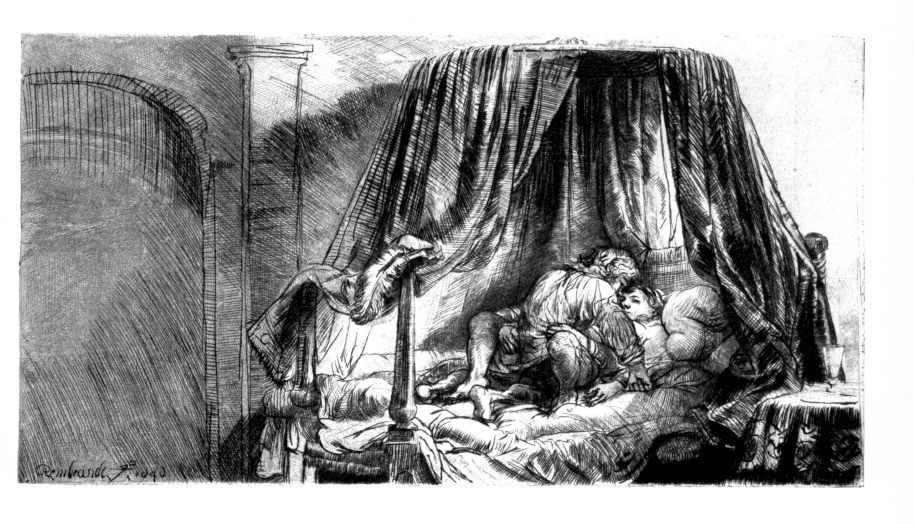

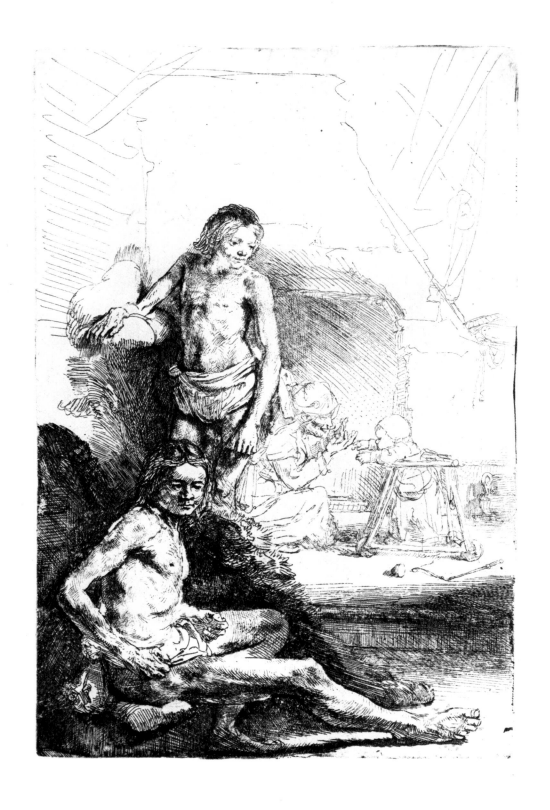

202

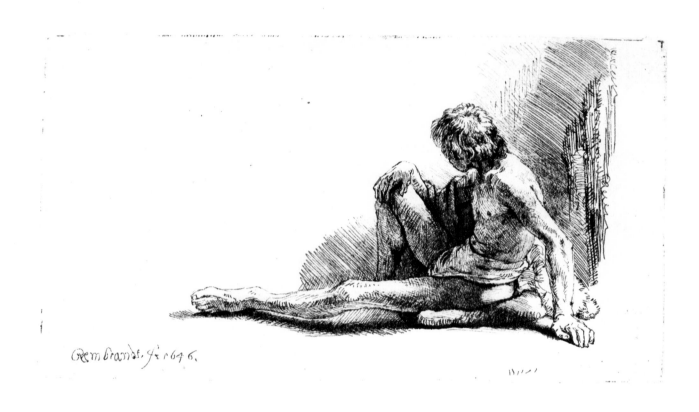

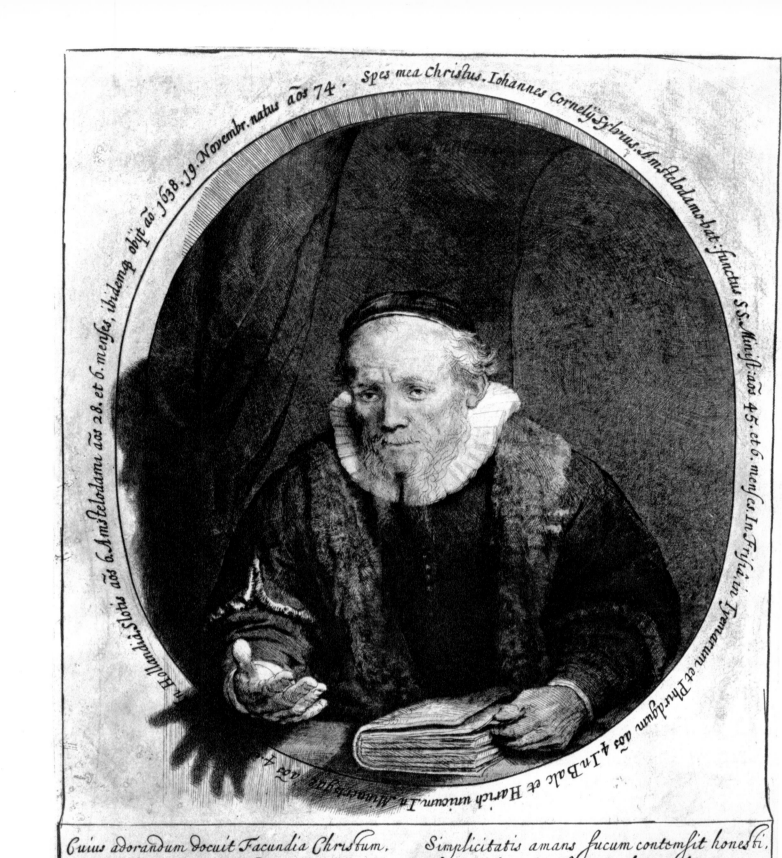

Spes mea Christus. Iohannes Cornelij Sylvius. Amstelodamobat: functus S.S. Minist: aos 45. et 6. menses.In.Frisia.in Tennarum et Phirdum aos 4.In Balc et Harich unicum.I.a Minist:que aos 4.

19. Novembr. natus aos 74.

obijt ao 1638.19. Novembr. natus aos 74.

in Hollandia Slotis aos 6.Amstelodami aos 28. et 6. menses, ibidemq obijt ao 1638.

Cuius adorandum docuit Facundia Christum.
 Et populis veram pandit ad astra viam.
Talis erat Sylvi facies. audivimus illum
 : Amstelijs isto civibus oro loqui.
Hoc Frisijs præcepta dedit; pietasq. severo
 Relligioq. diu vindice tuta stetit.
Præluxit, veneranda suis virtutibus, ætas.
 Erudytq. ipsos fessa senecta viros.

Simplicitatis amans fucum contemsit honesti.
 Nec sola voluit fronte placere bonis.
Sic statuit:Iesum vita meliore doceri
 Rectiús, et vocum fulmina posse minus.
Amstela, sis memor extincti. qui condidit urbem
 Moribus, hanc ipso fulsijt ille Deo.
 C. Barlæus.
Haud amplius deprædico illius dotes.
 Quas æmulor. frustraqué persequor versu.
 P. S.

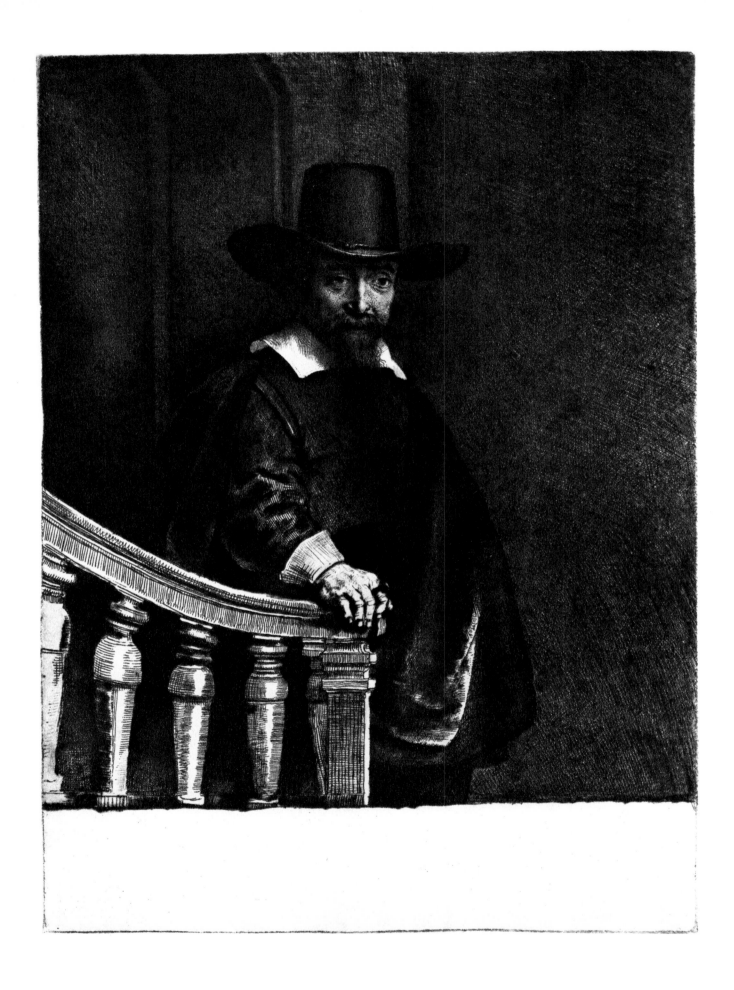

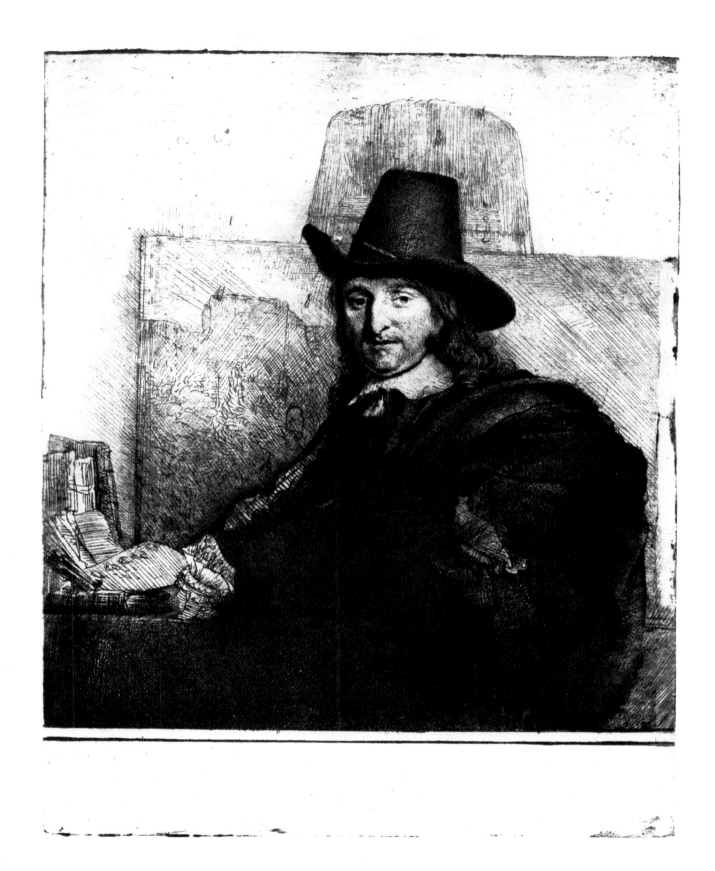

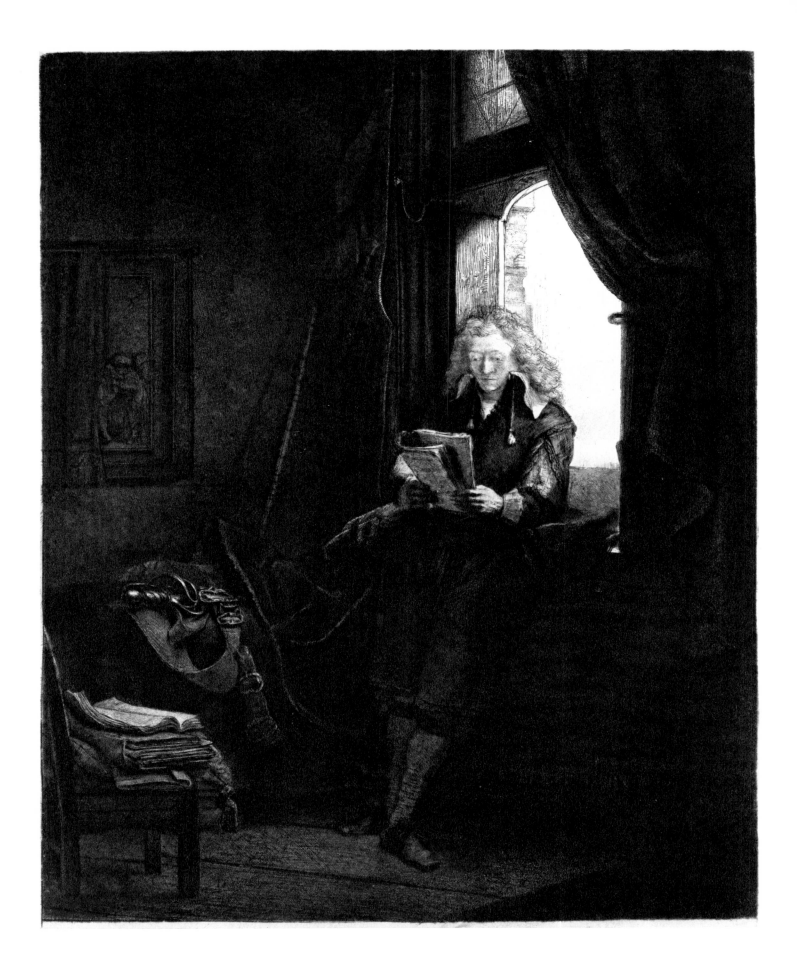

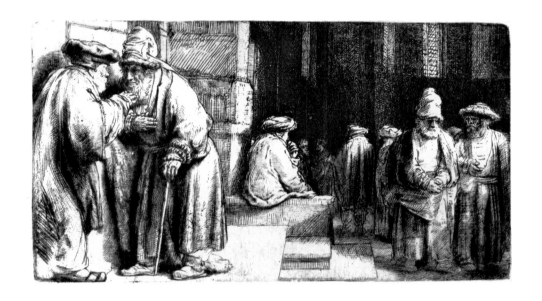

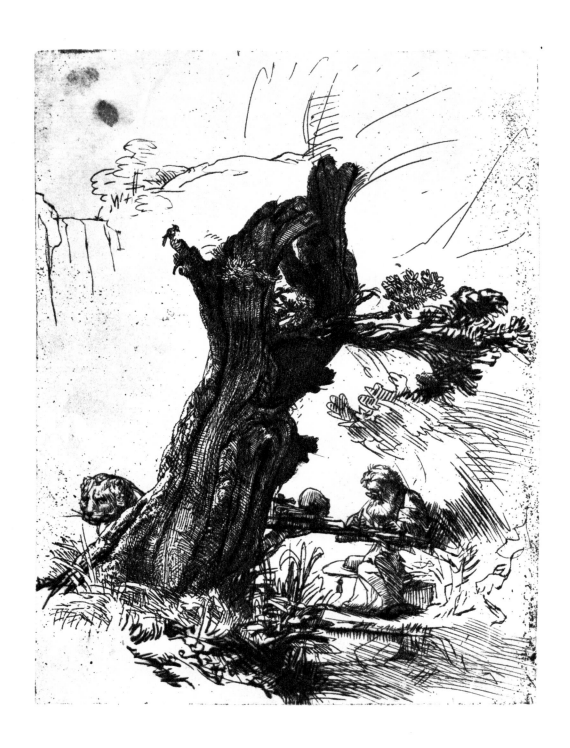

210

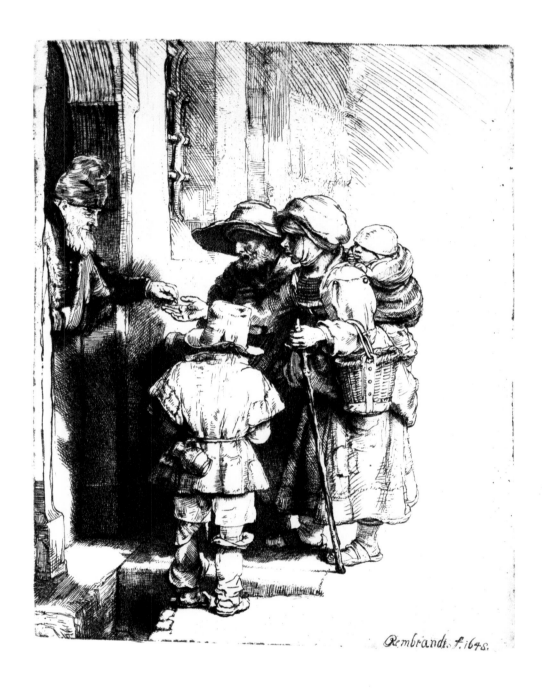

Rembrandt. f. 1648.

211

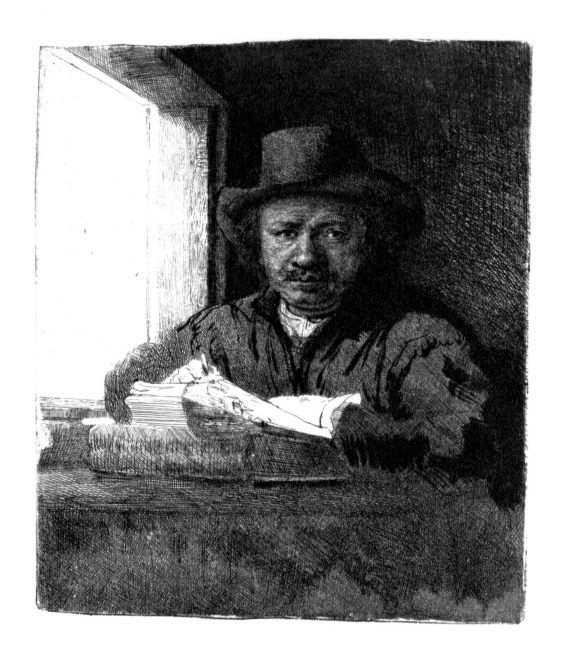

212

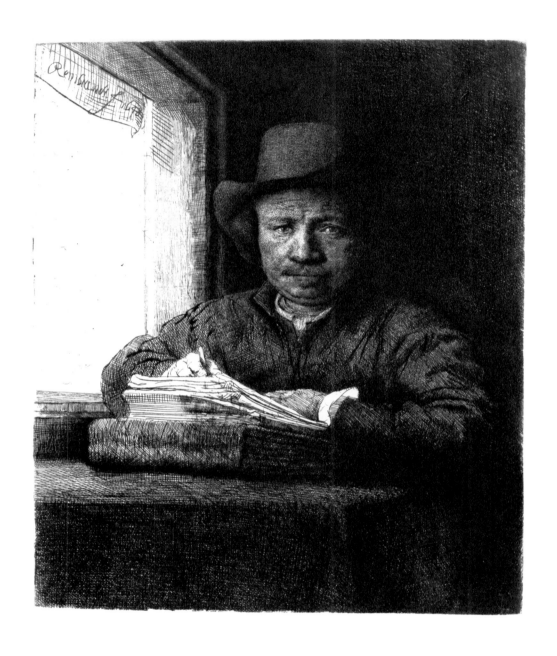

213

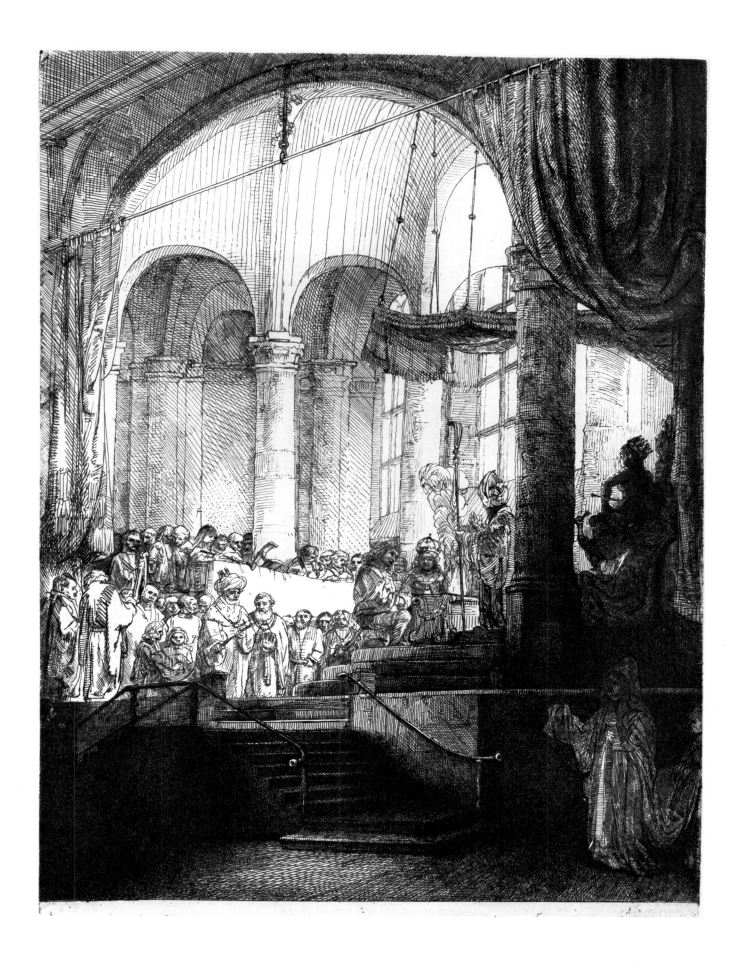

215

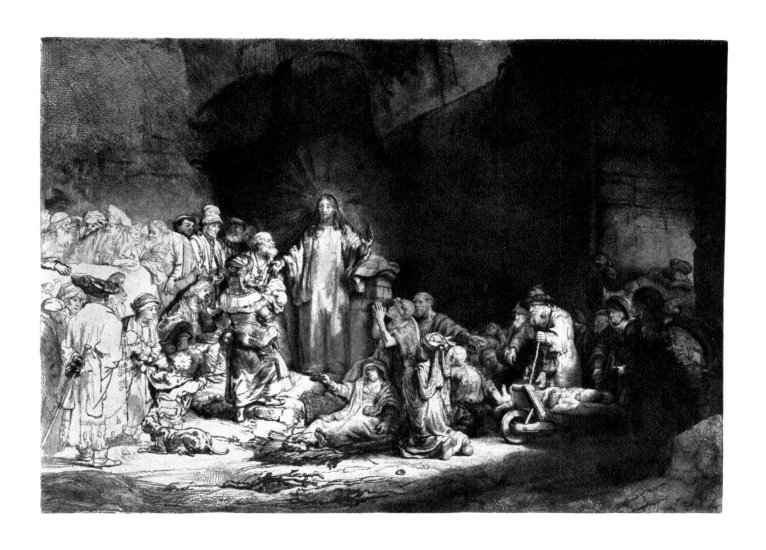

216

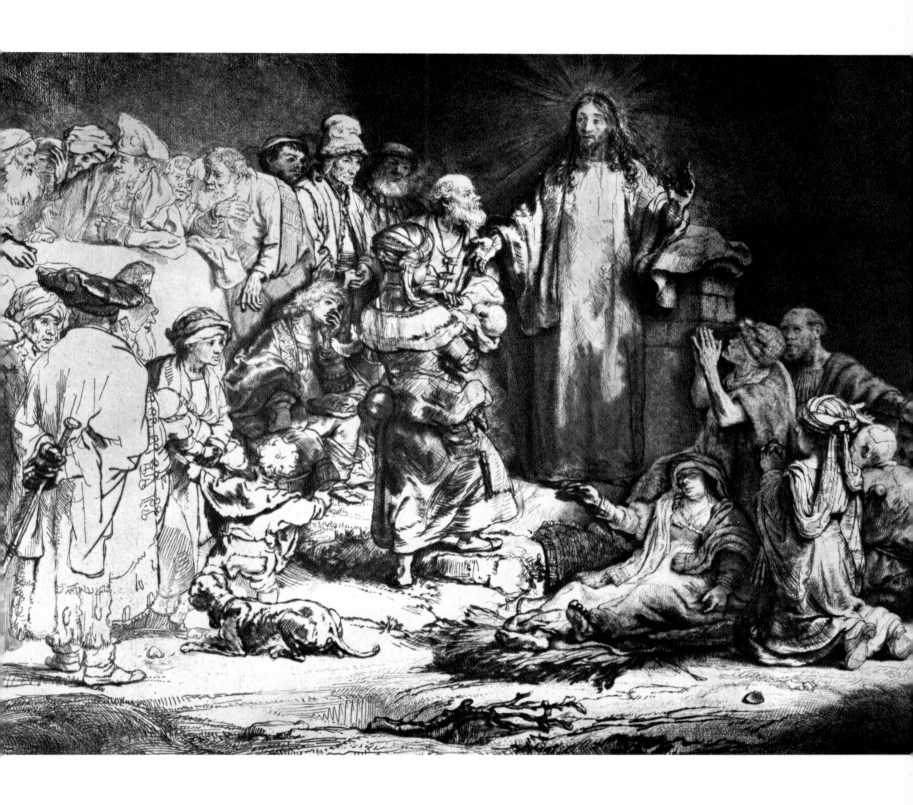

216, detail

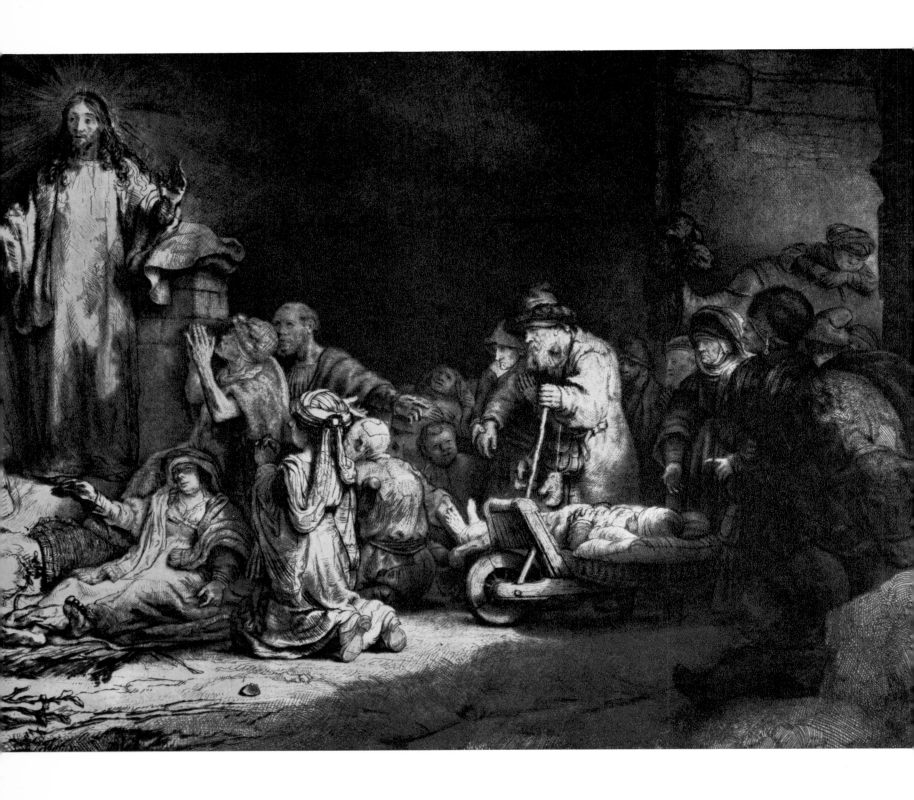

216, detail

Rembrandt. f.1650.

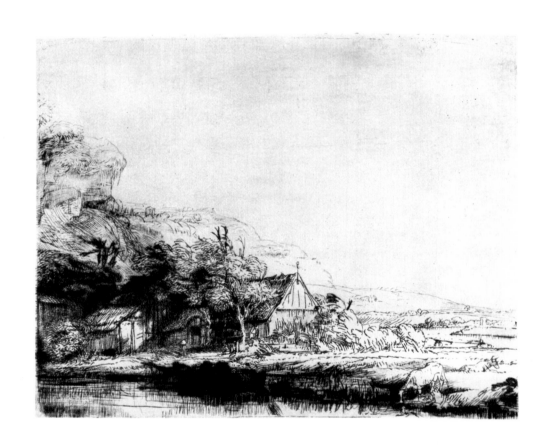

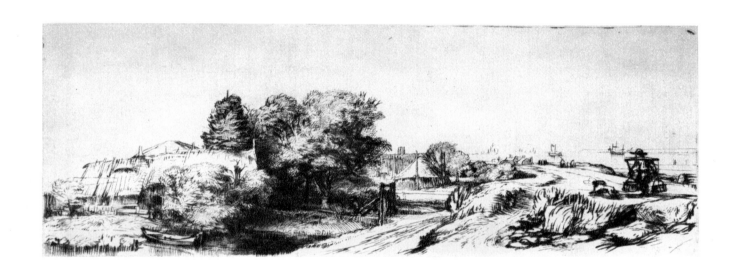

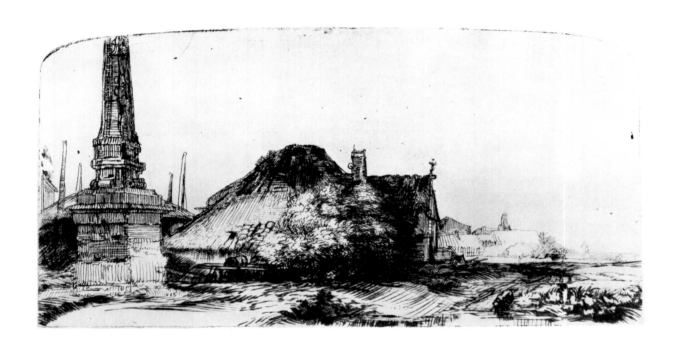

220

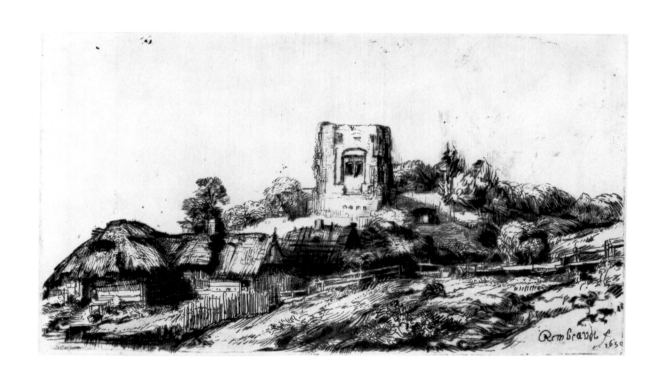

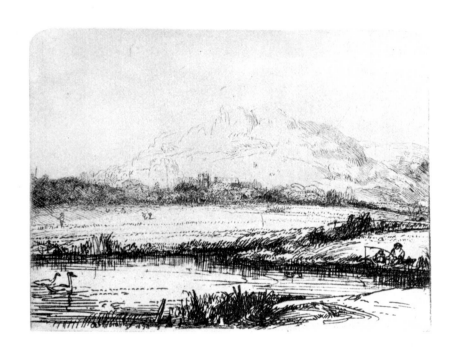

222

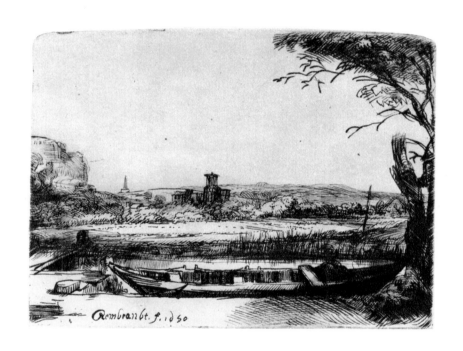

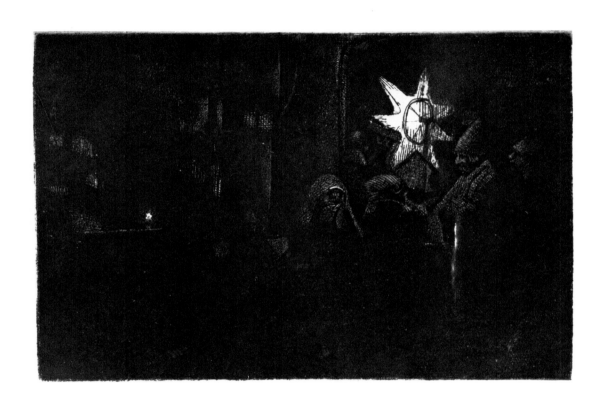

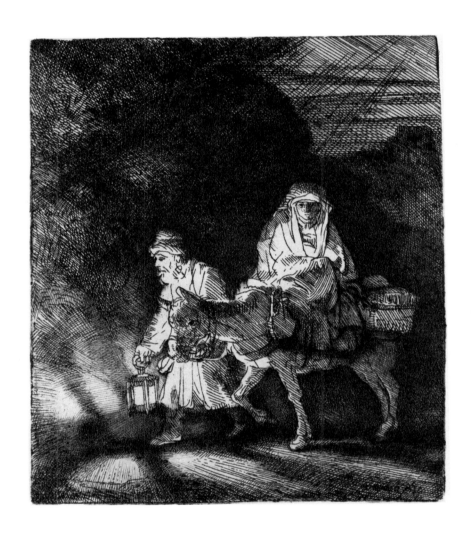

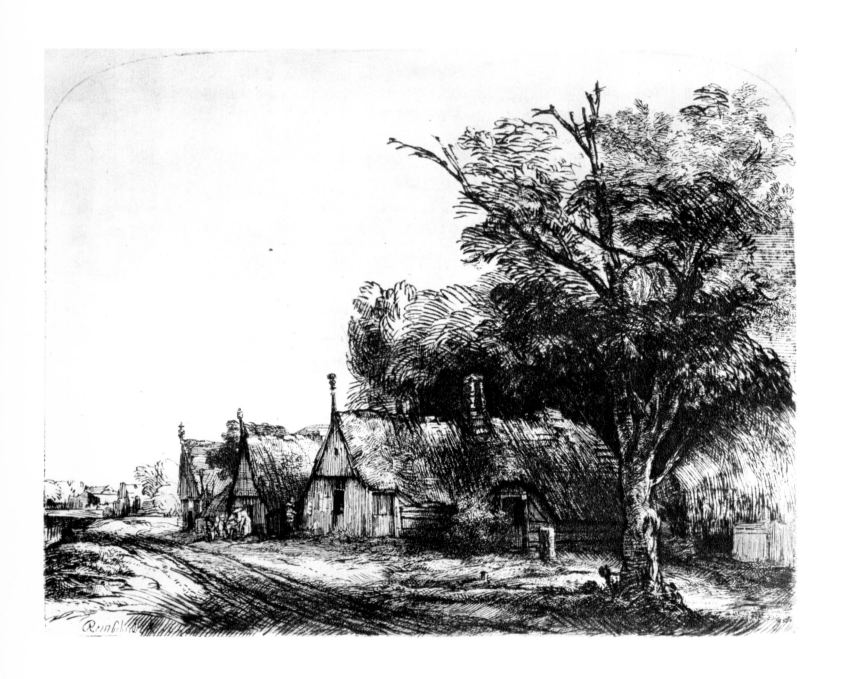

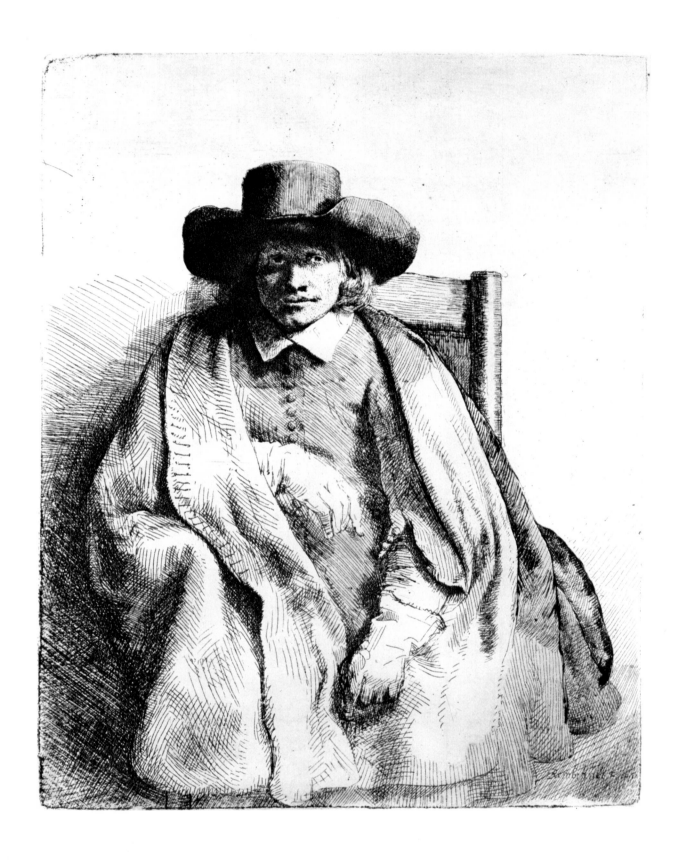

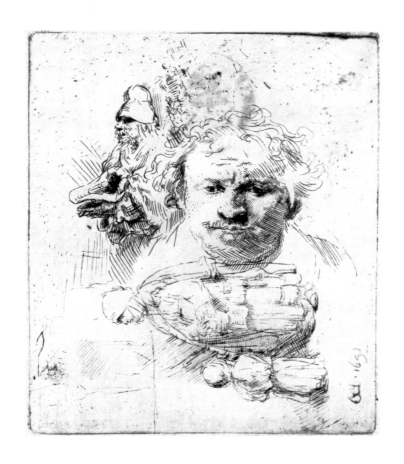

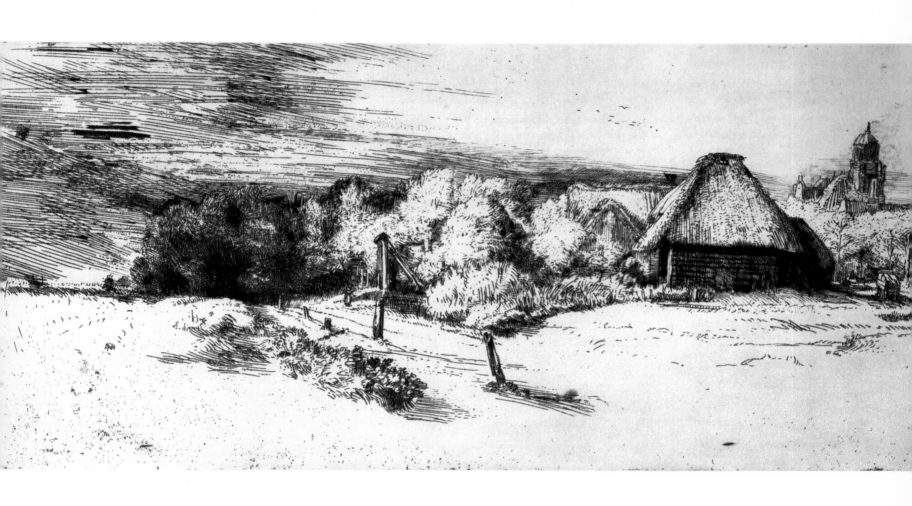

230, detail

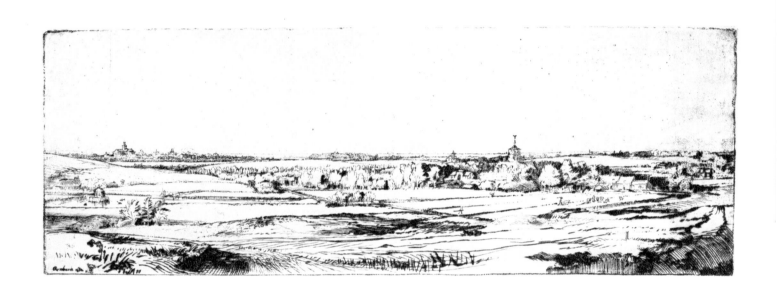

231

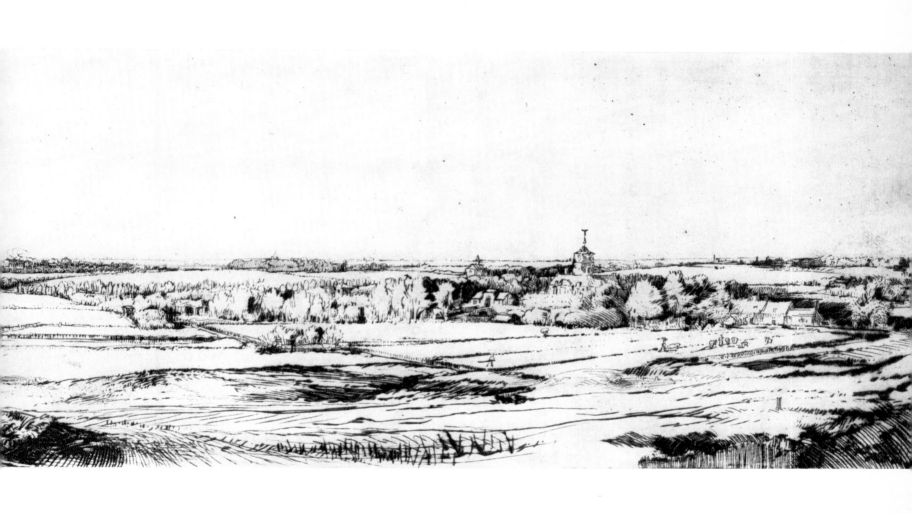

231, detail

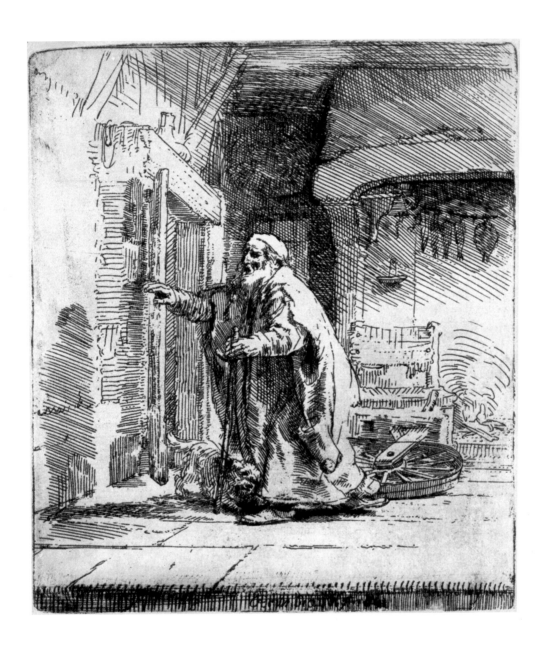

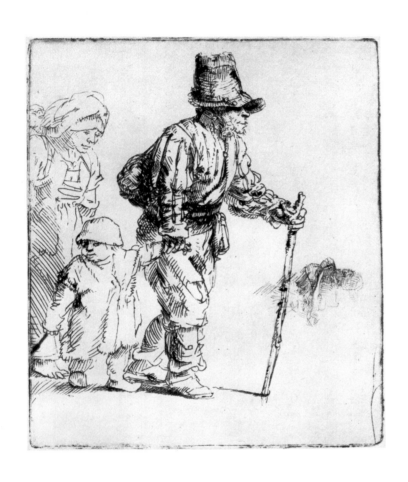

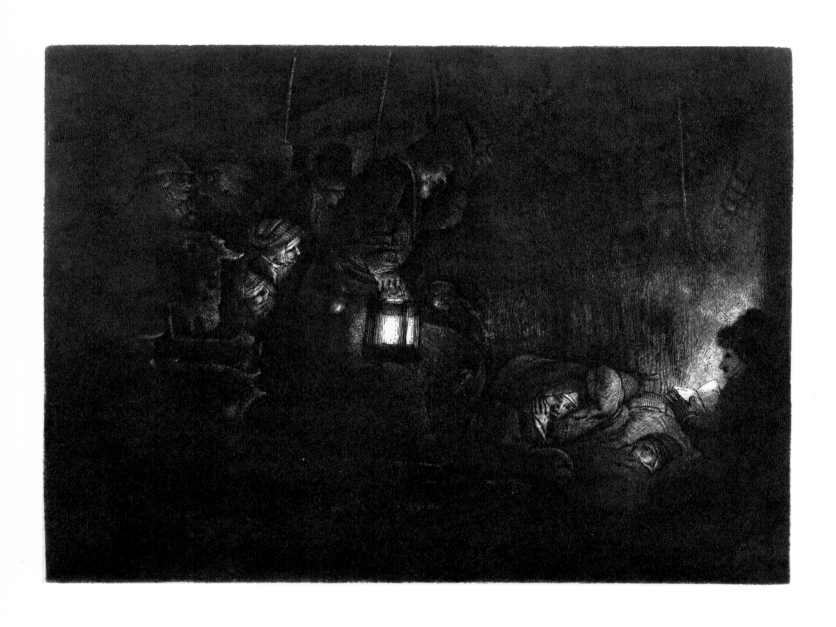

234

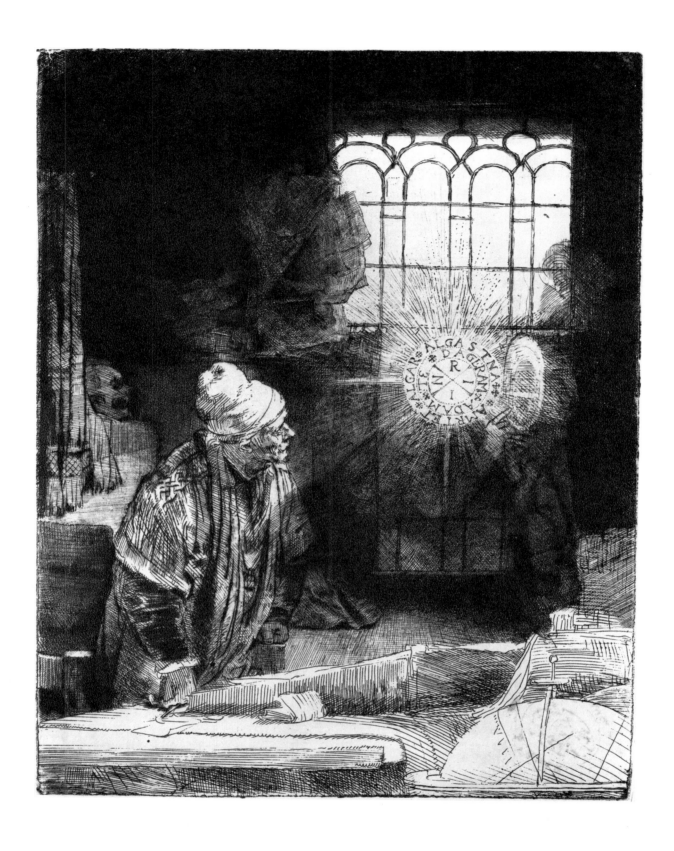

235

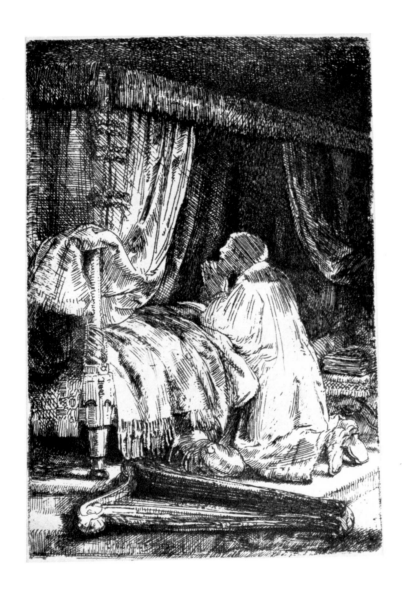

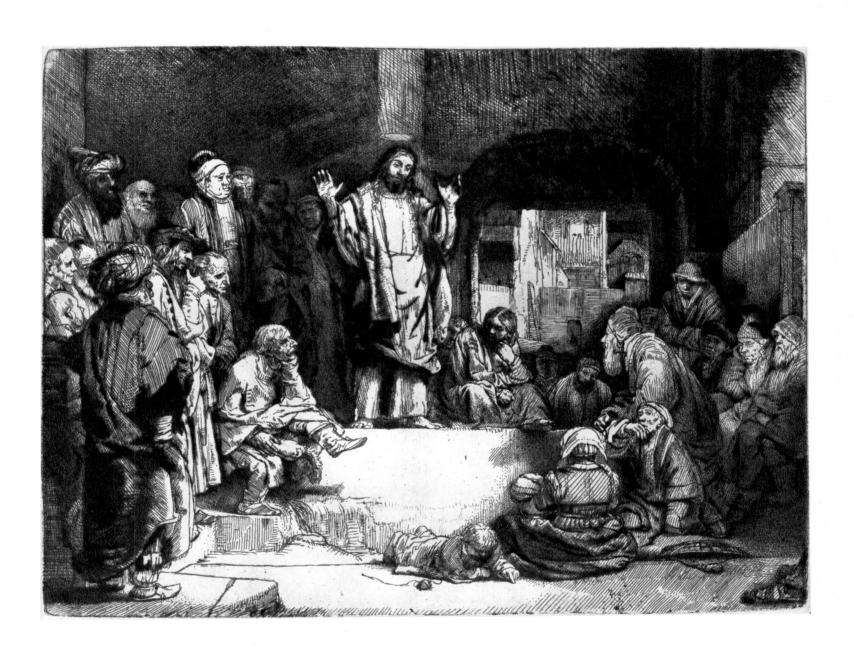

237

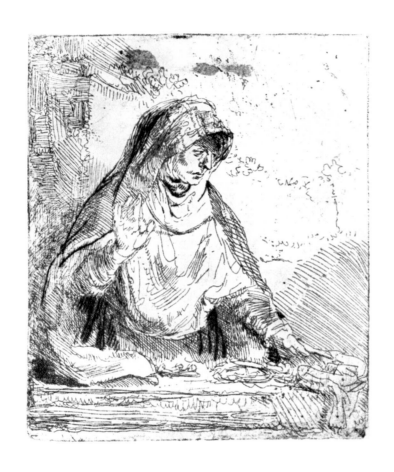

238

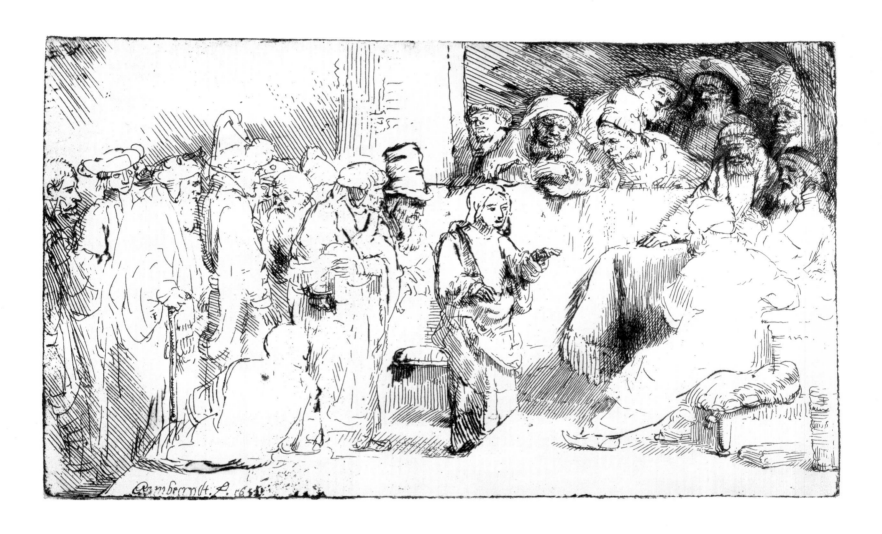

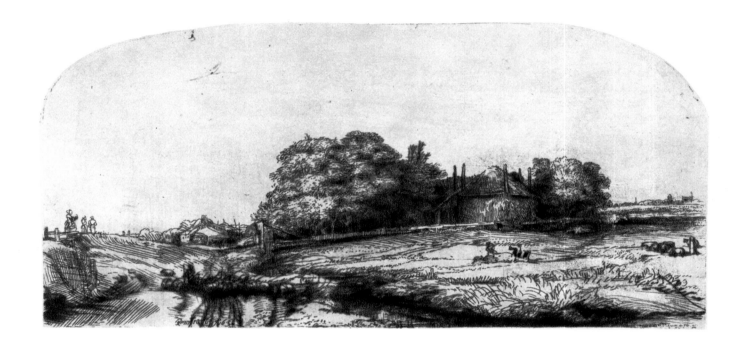

240

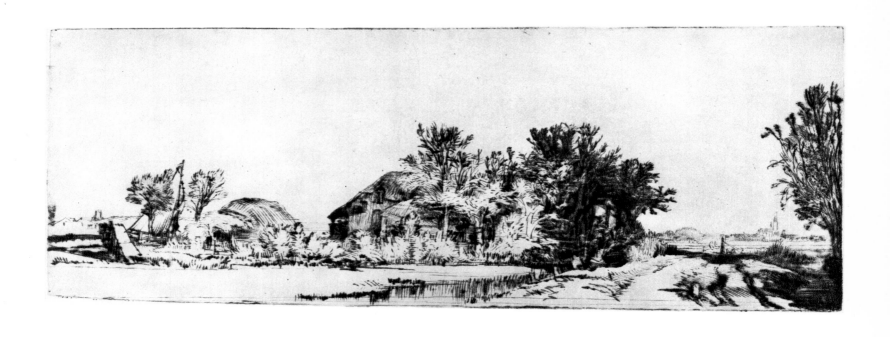

241

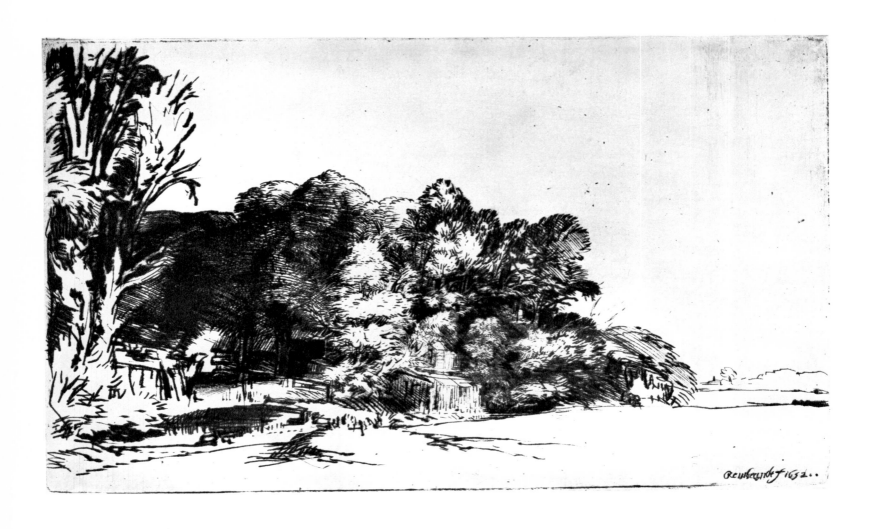

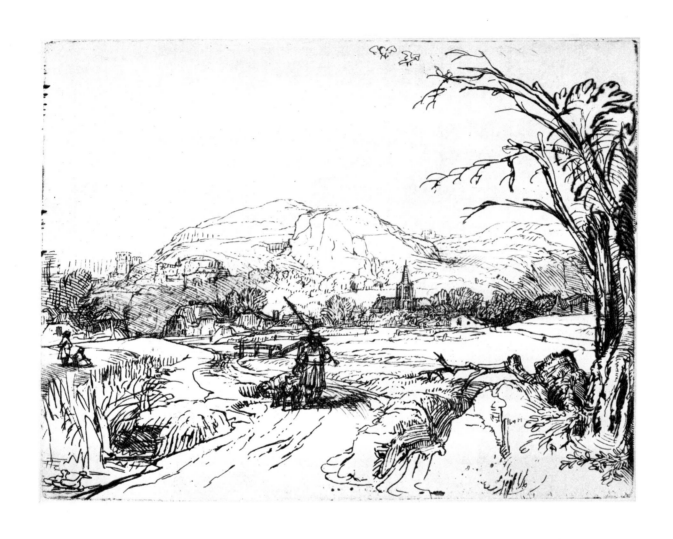

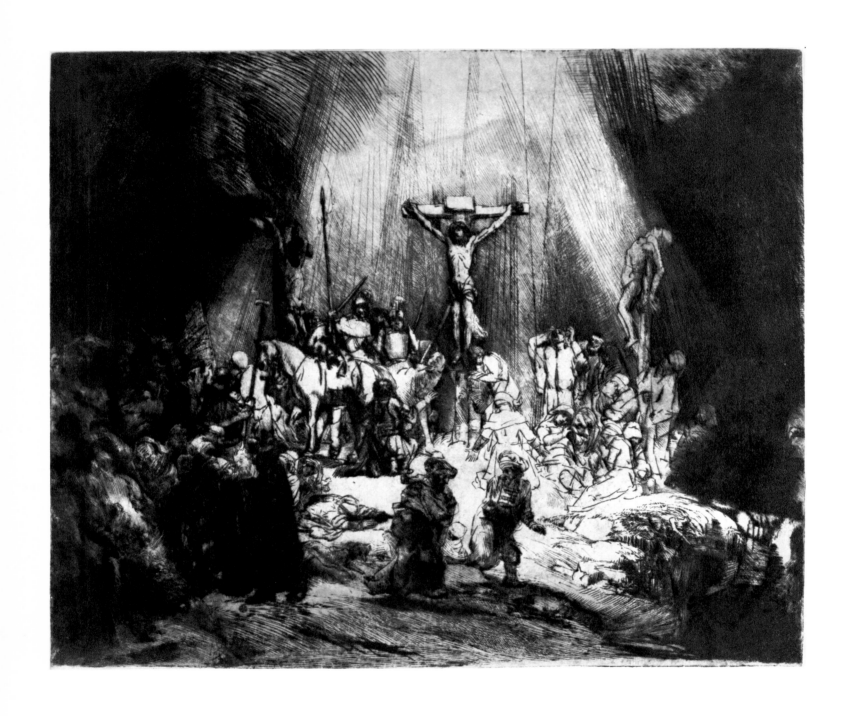

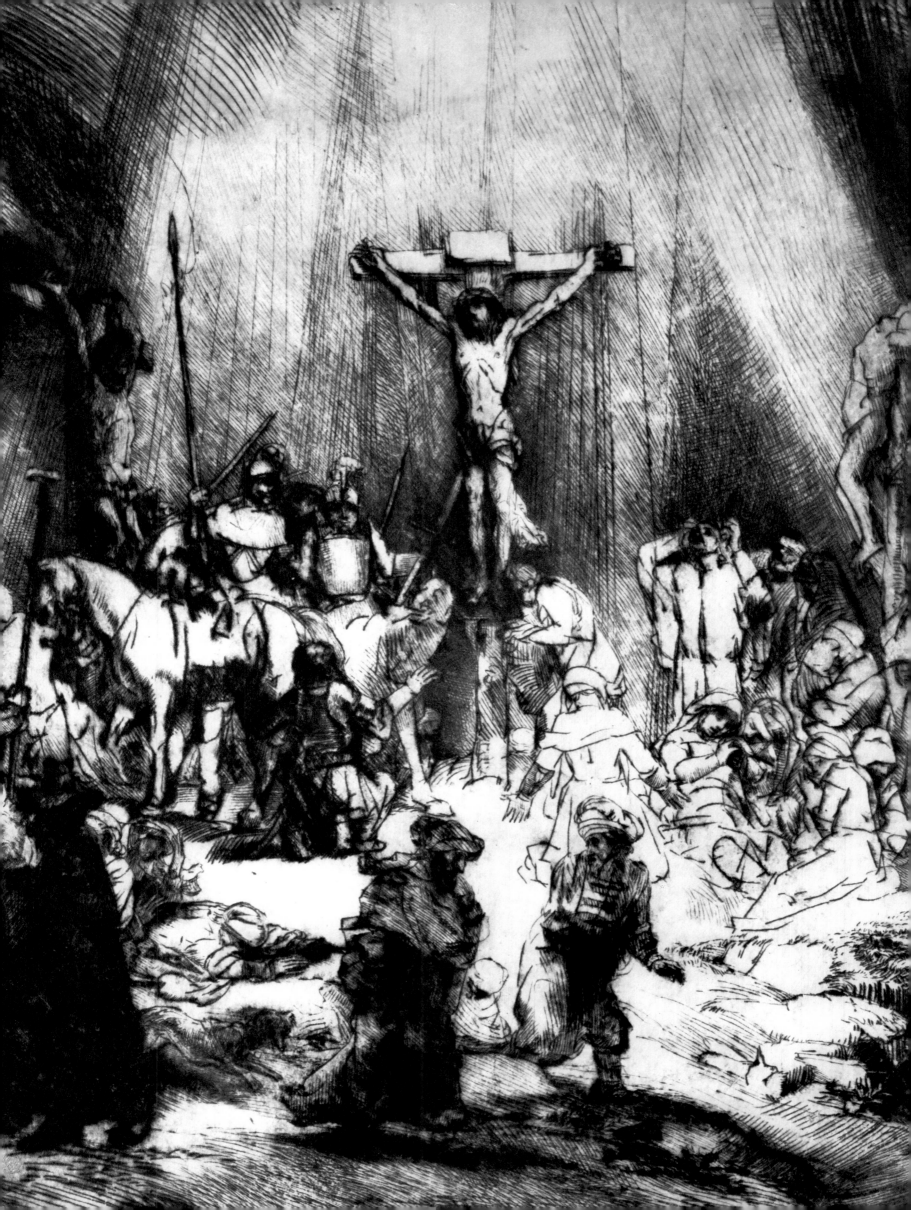

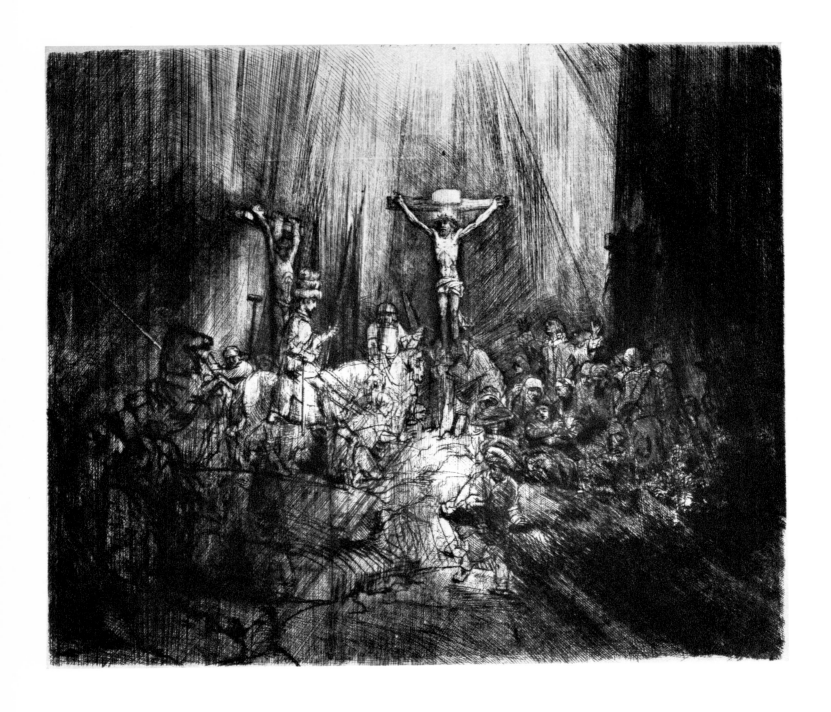

245

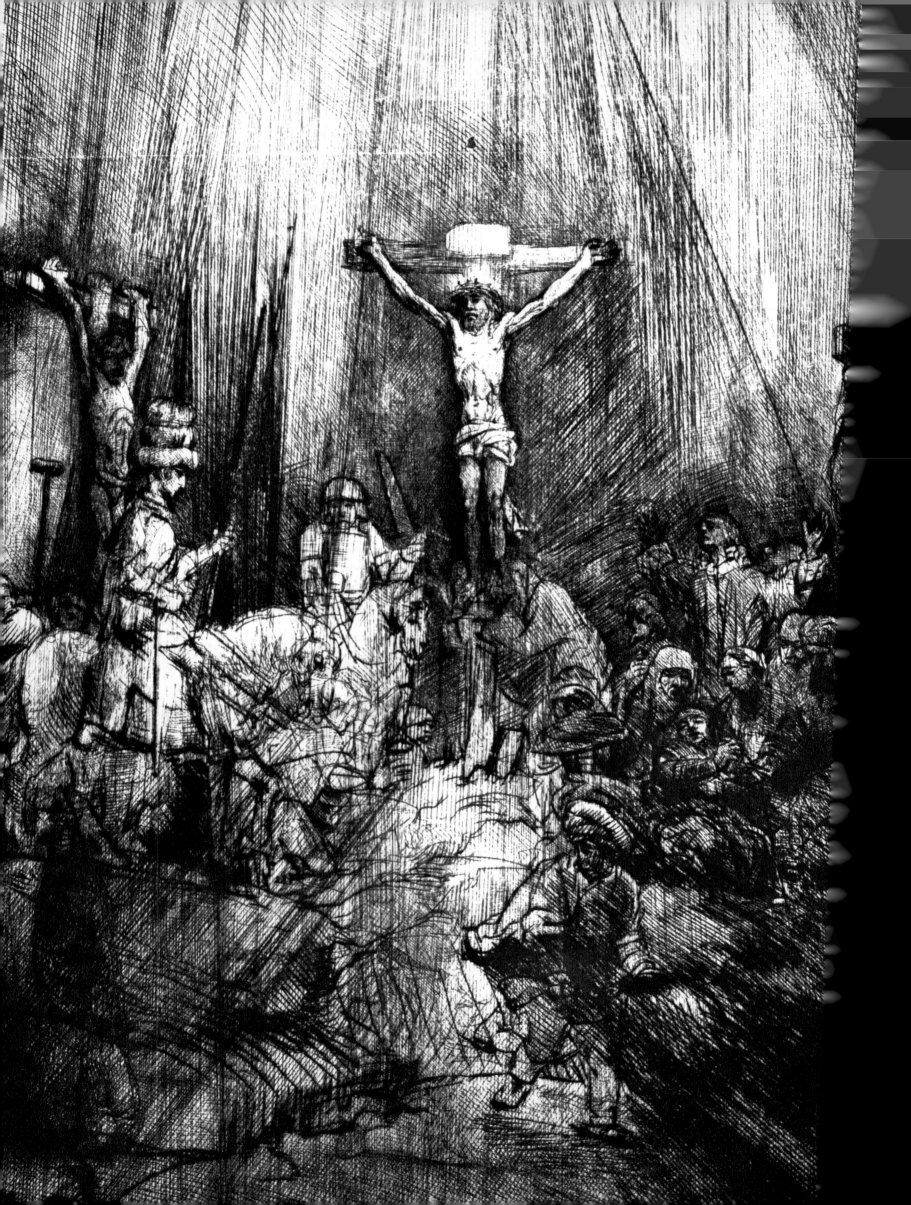

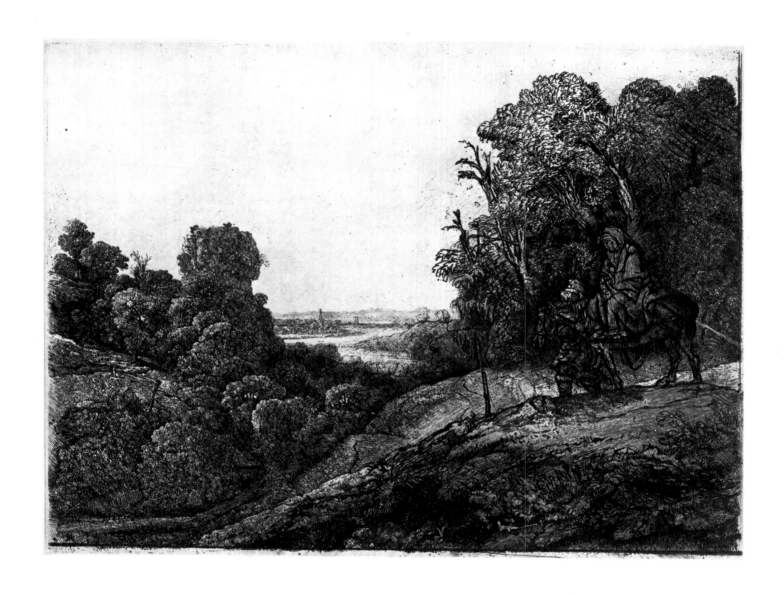

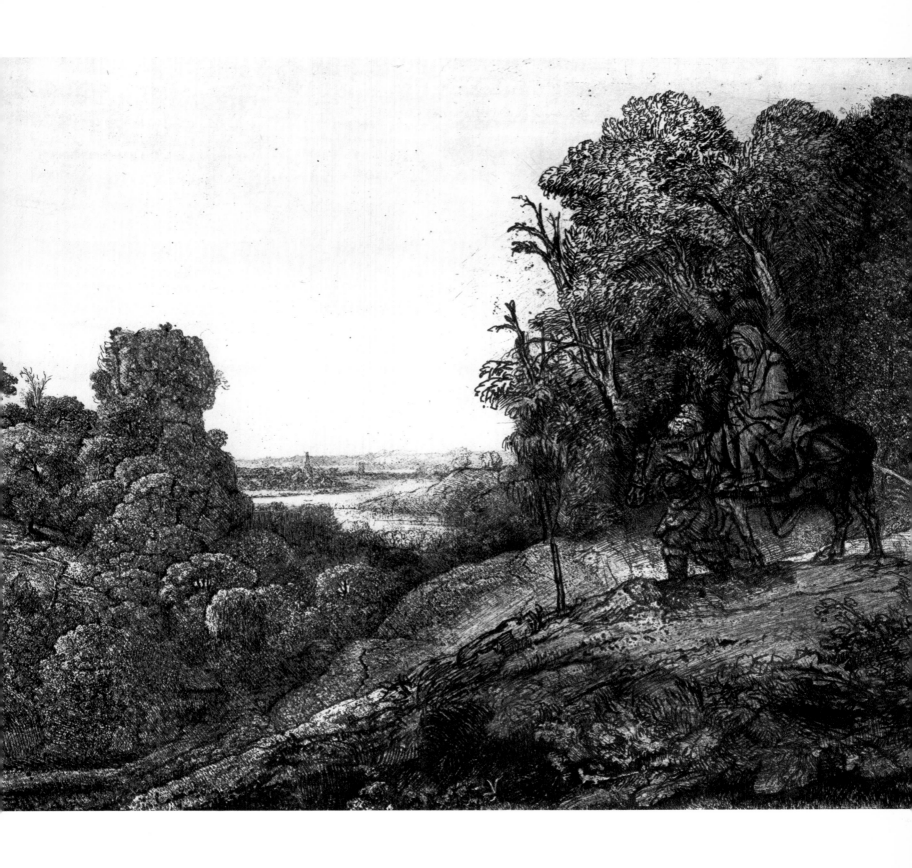

246, *detail*

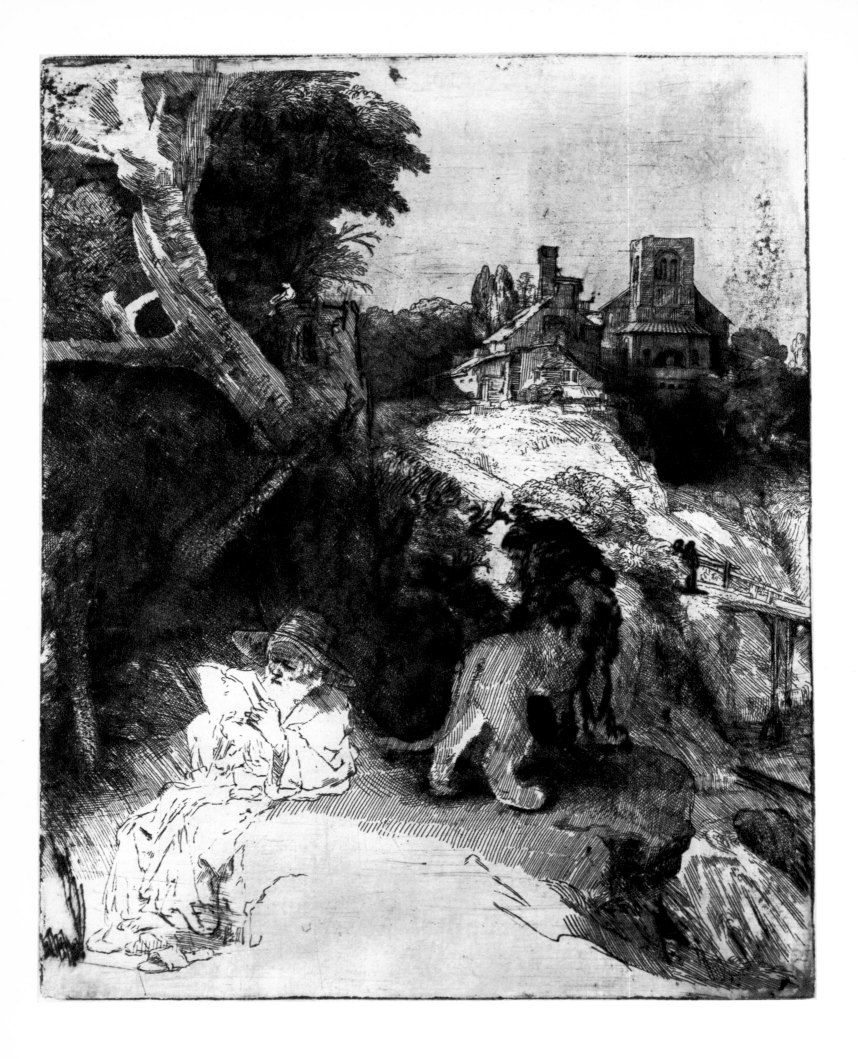

247

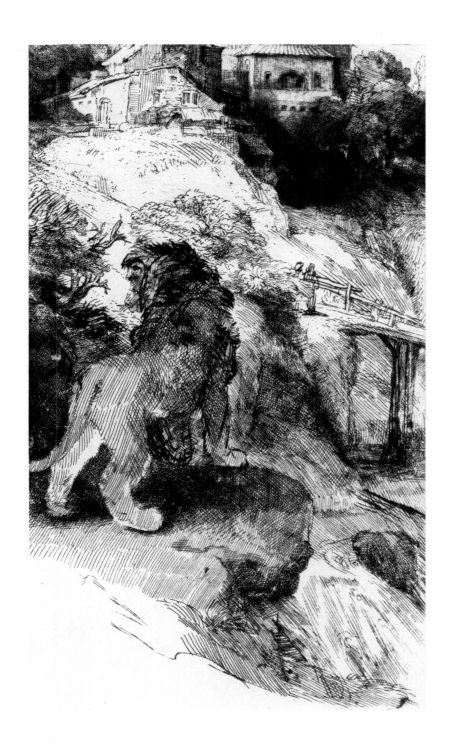

248, detail

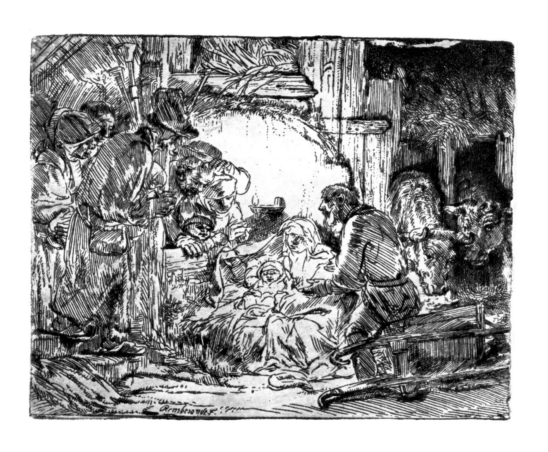

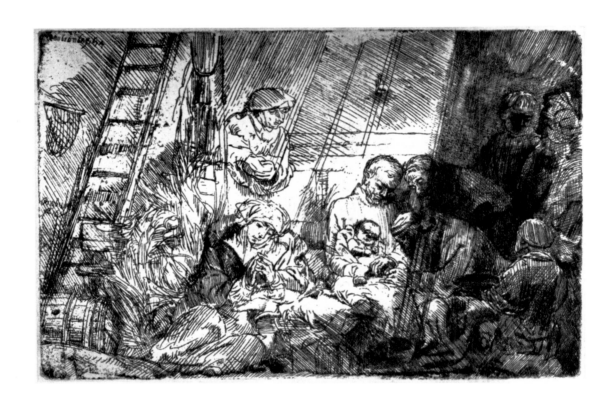

251

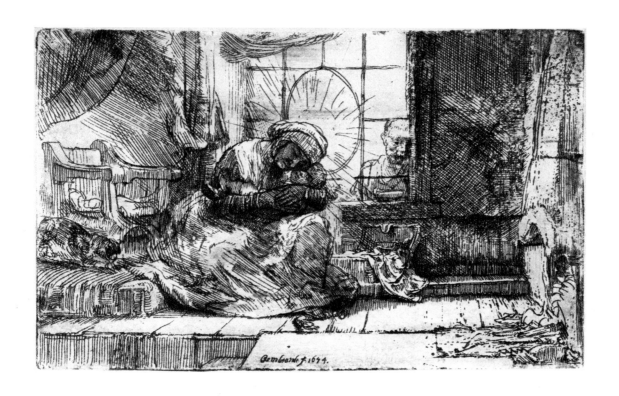

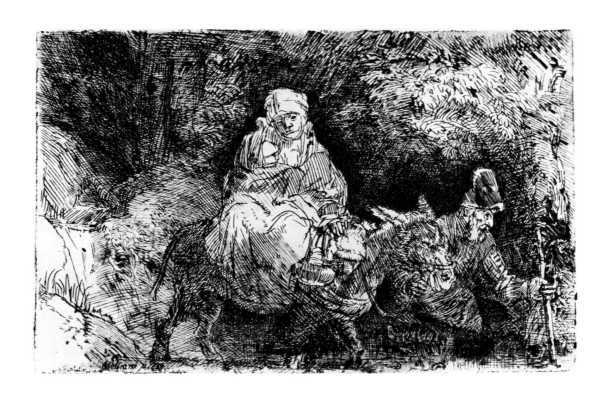

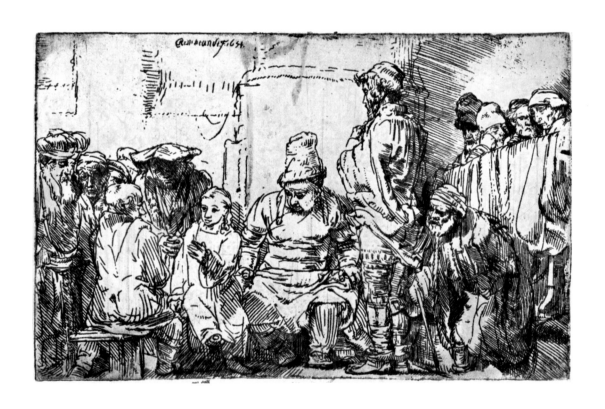

254

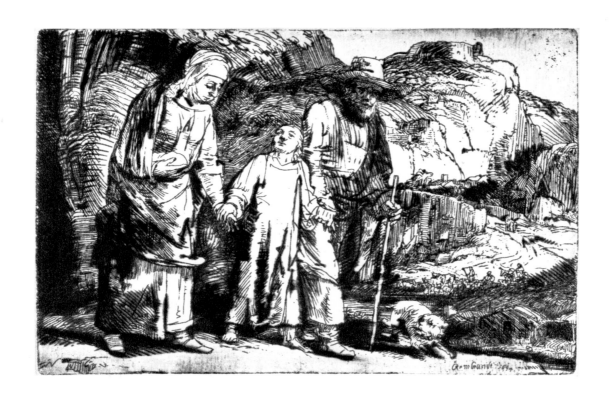

255

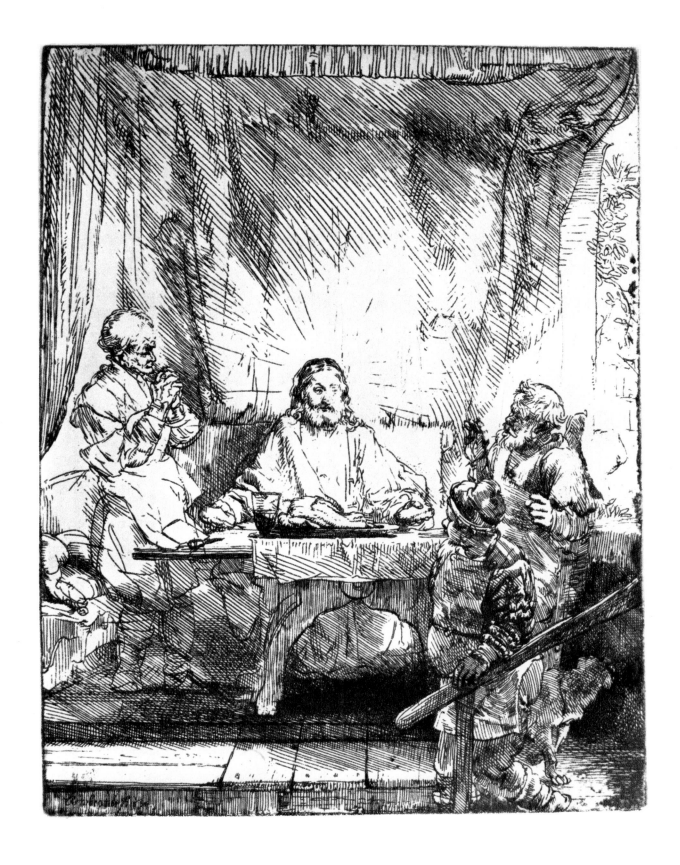

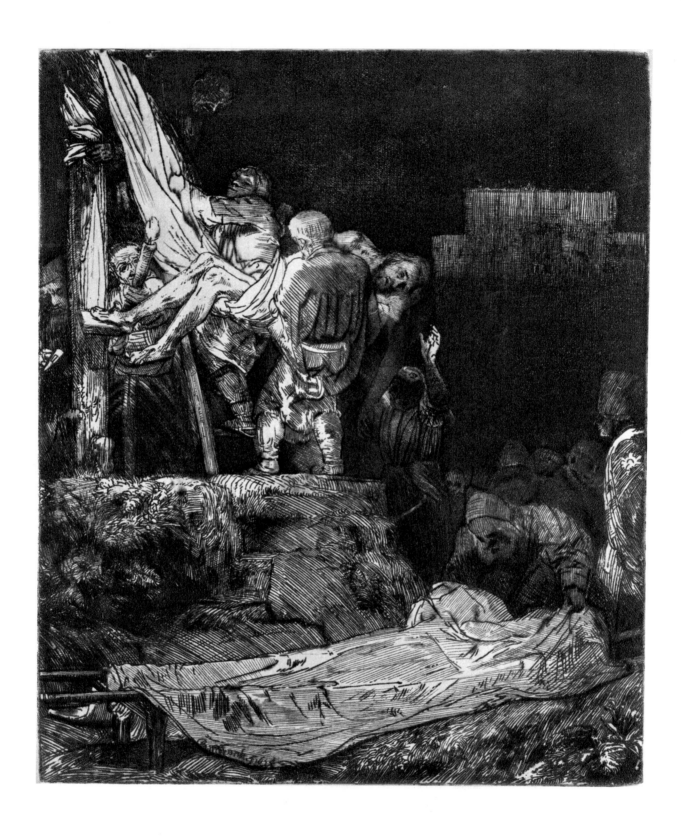

257

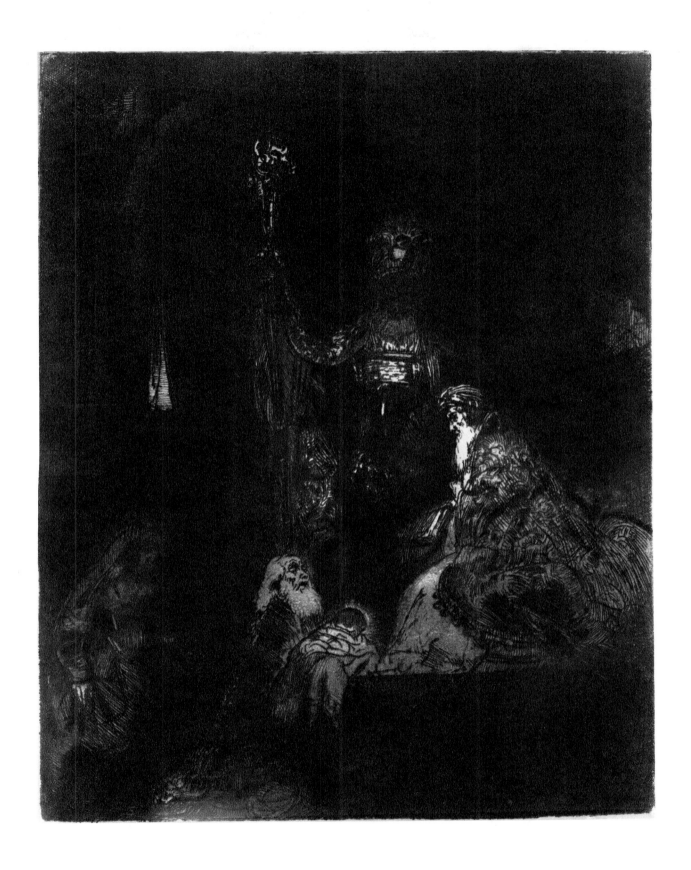

258

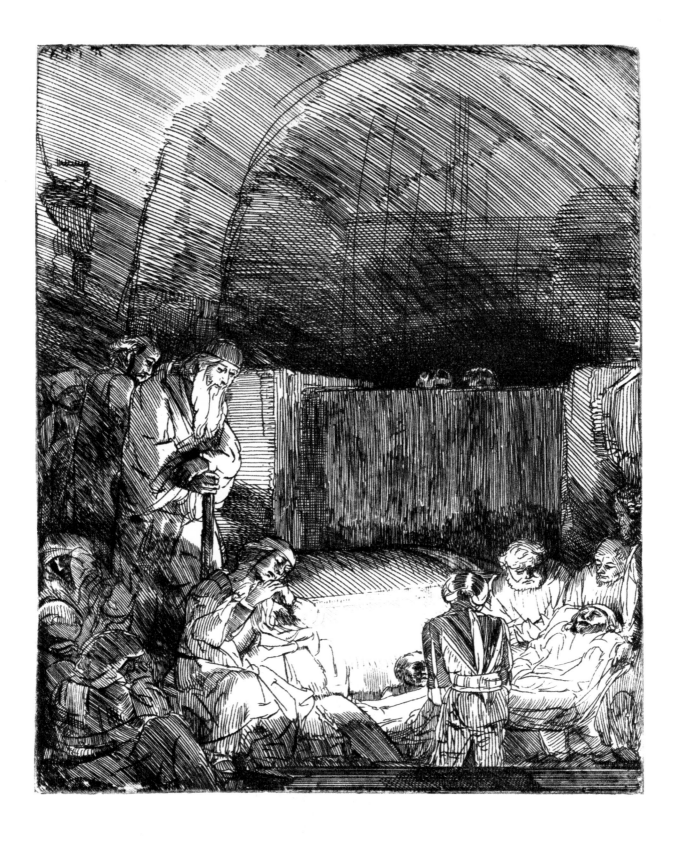

259

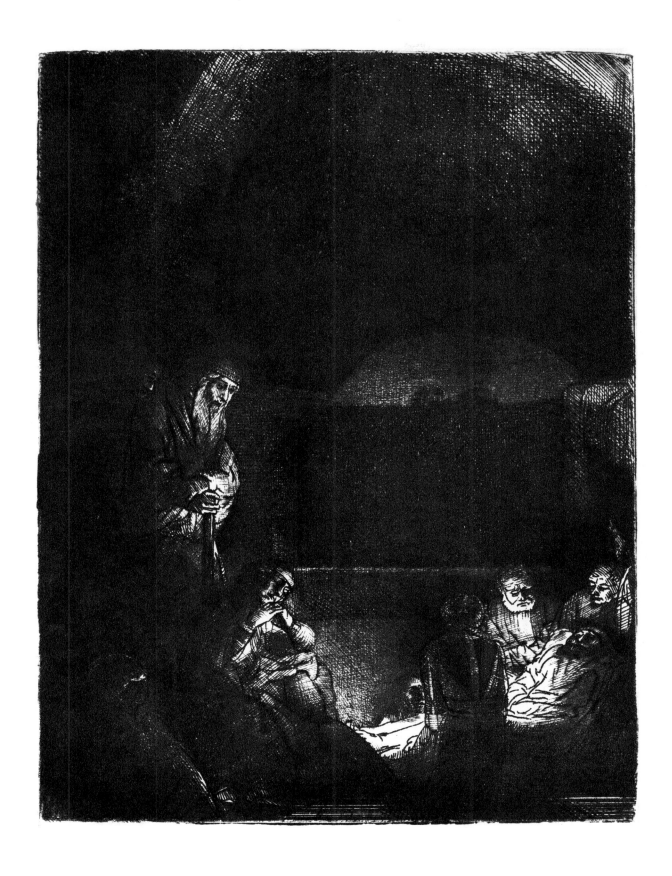

260

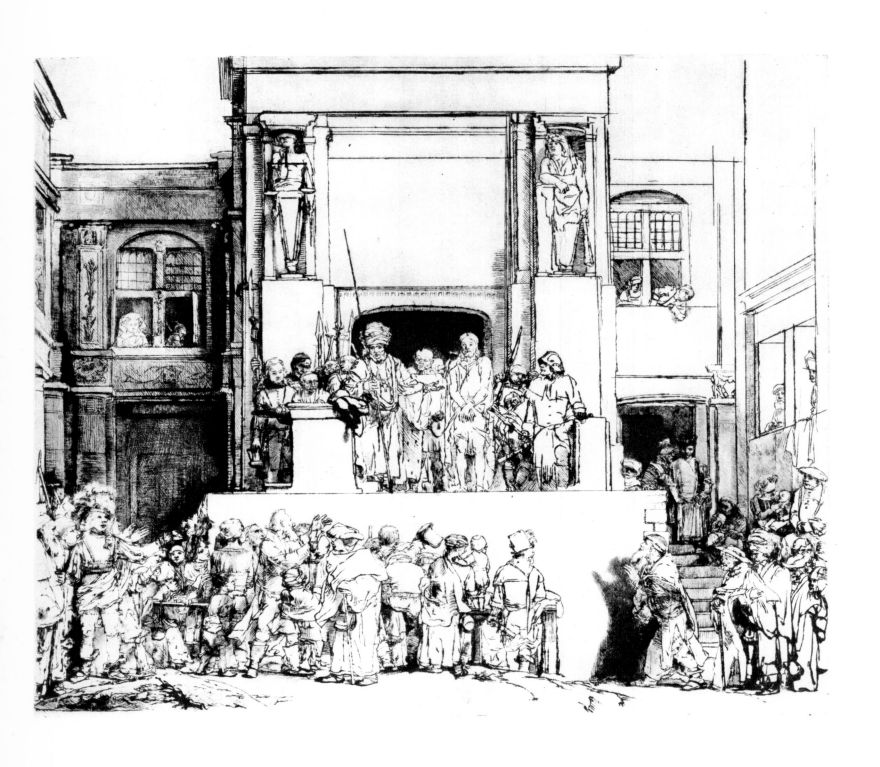

261 261, deta

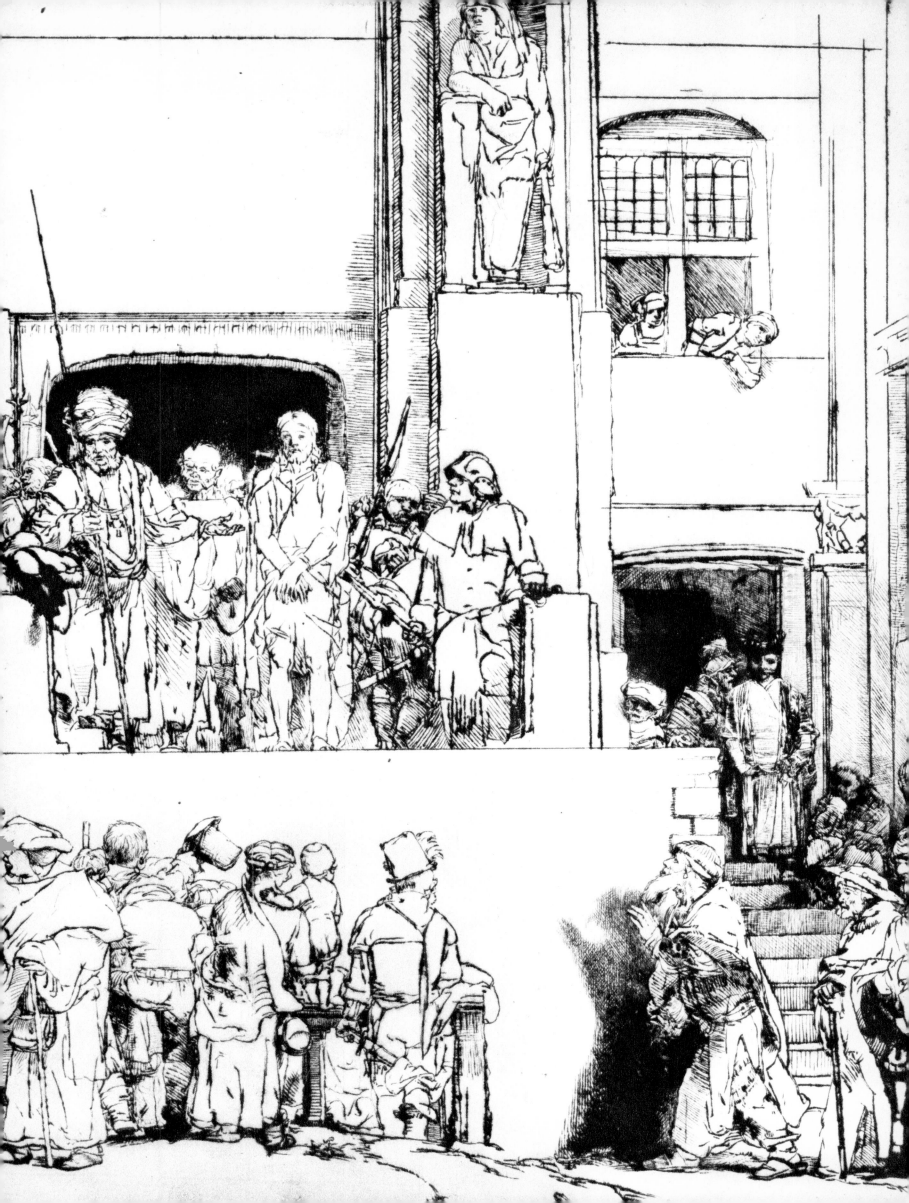

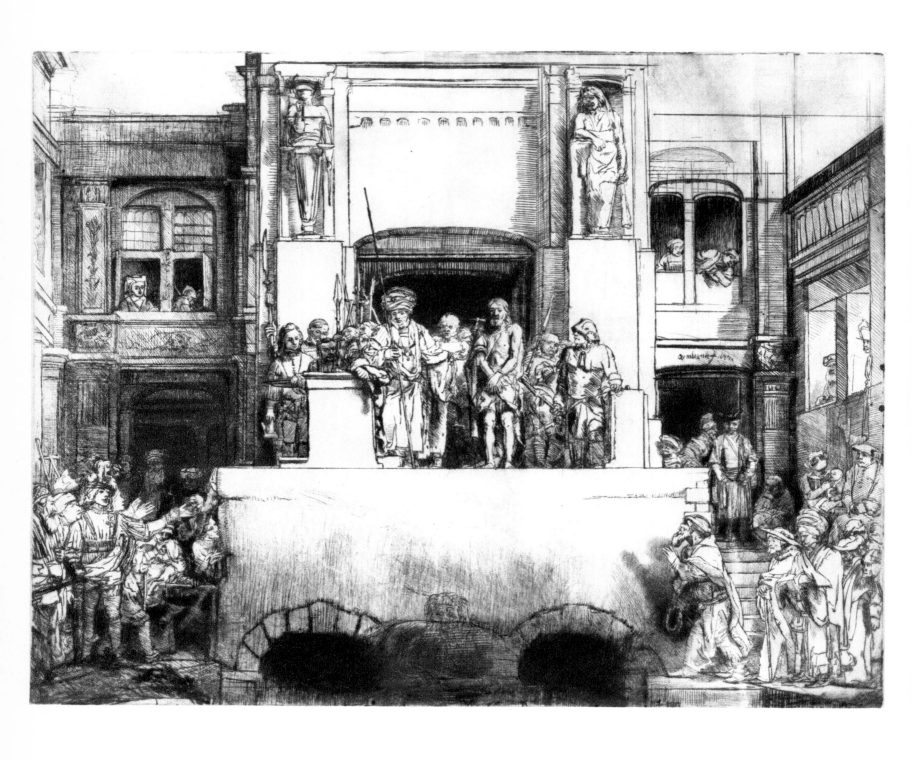

262

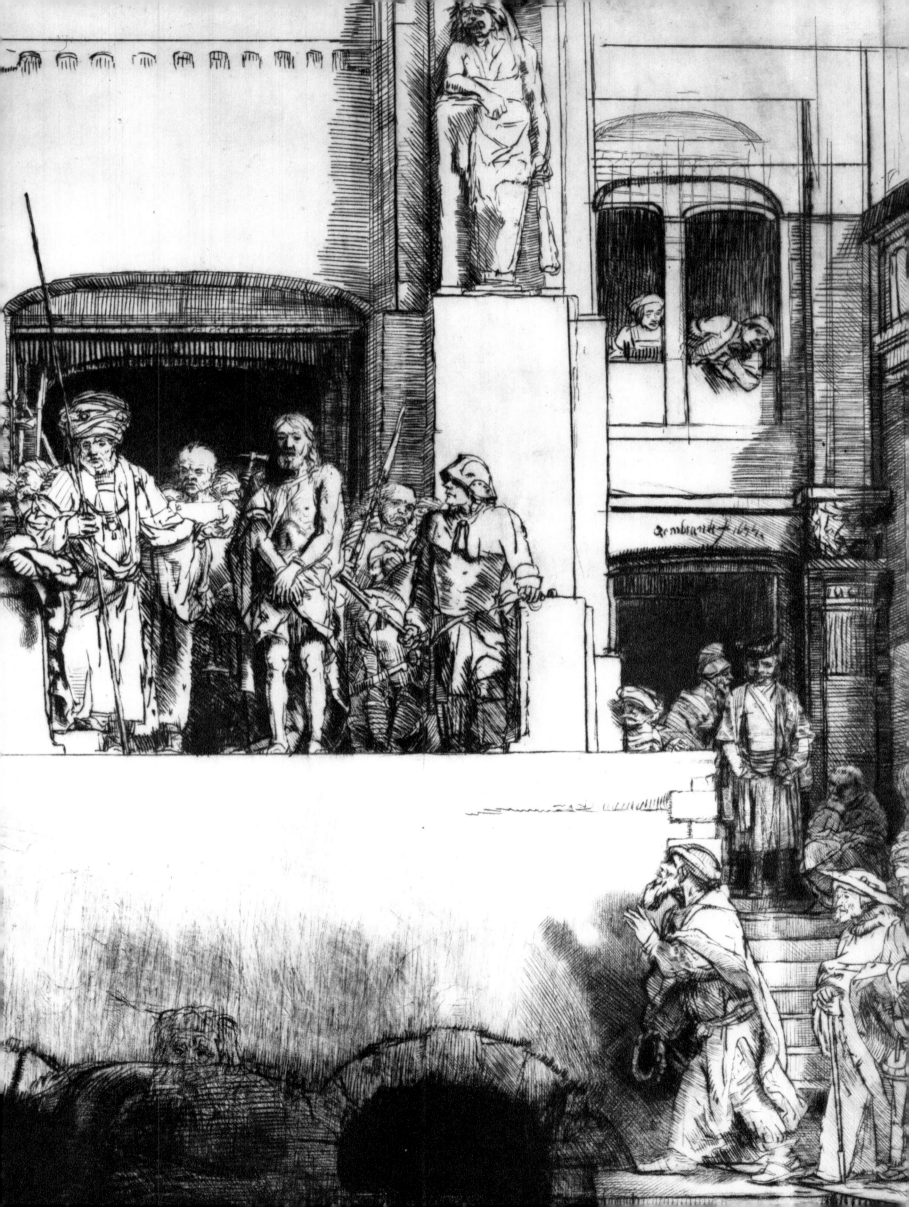

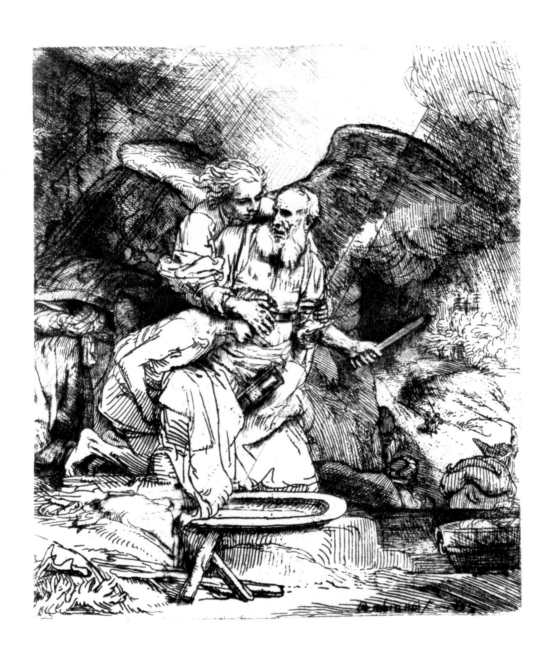

263

265

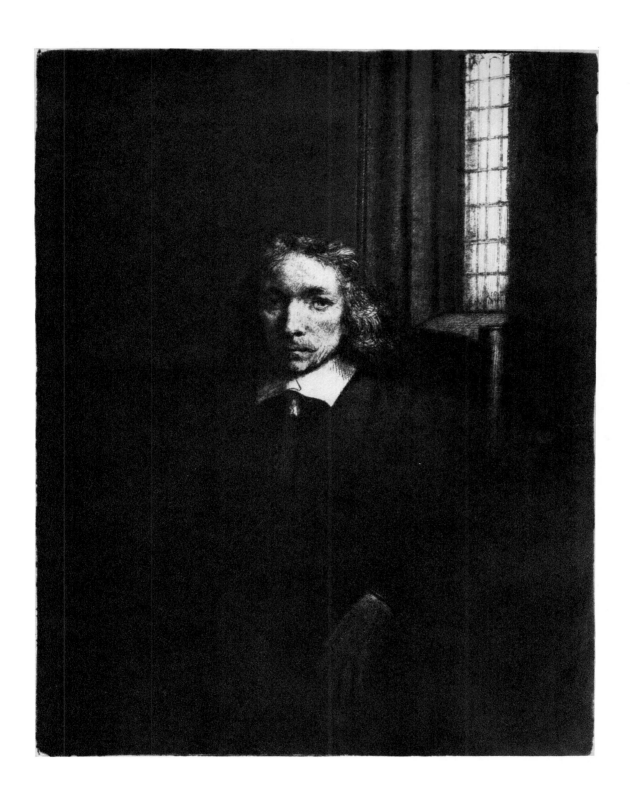

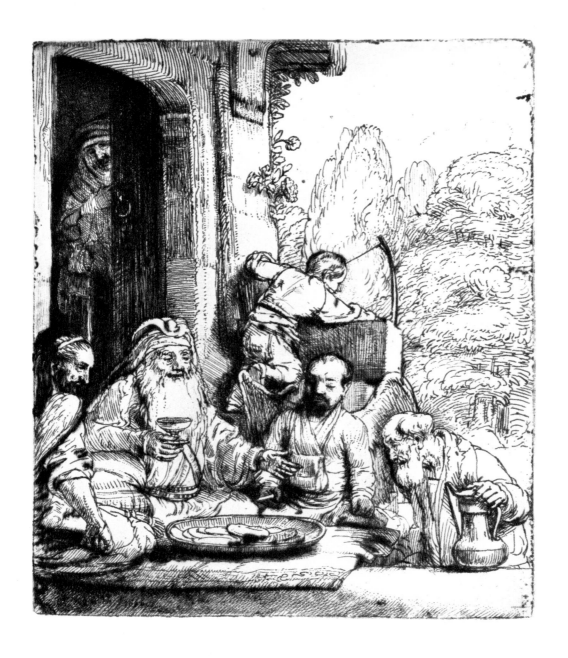

267

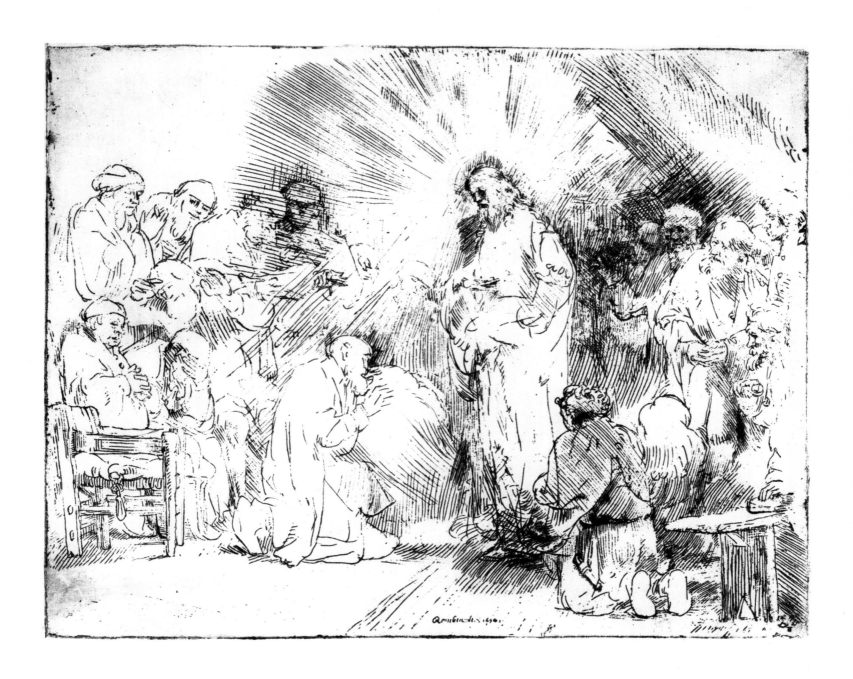

271

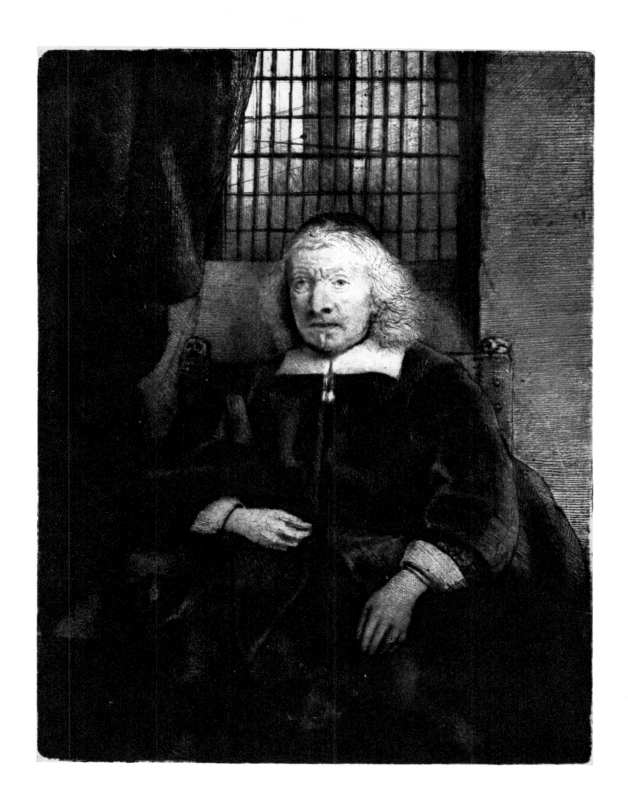

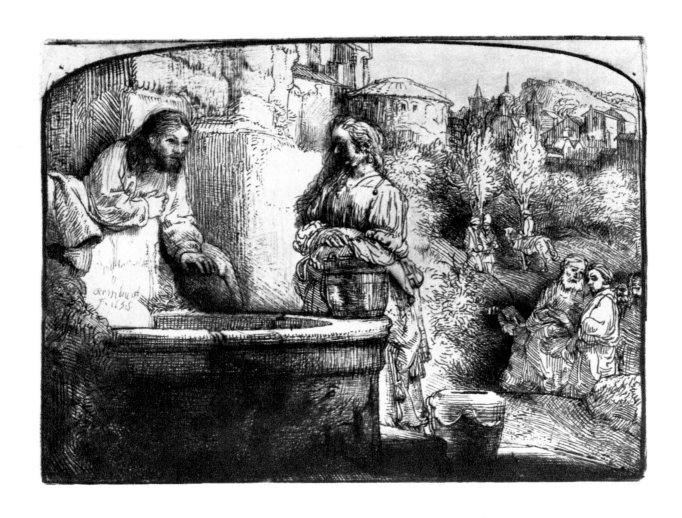

273

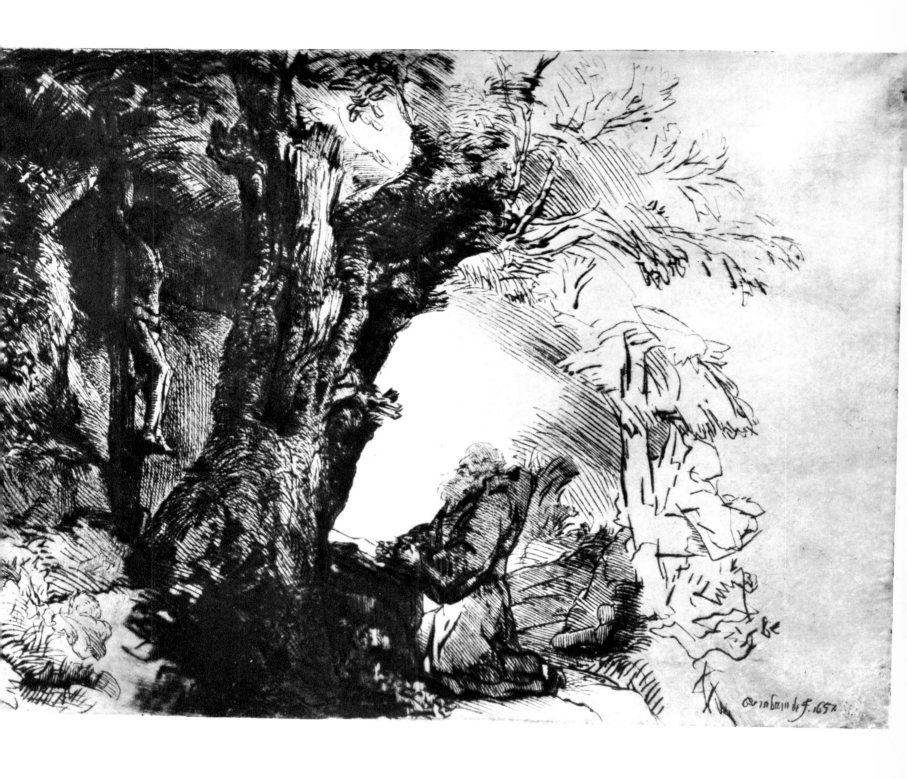

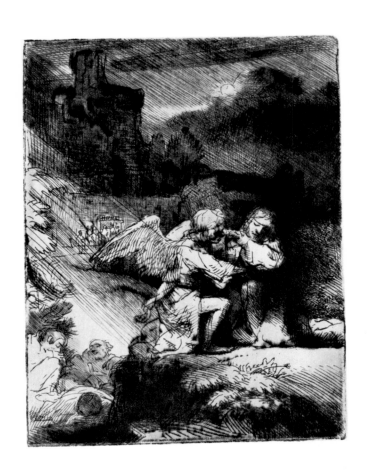

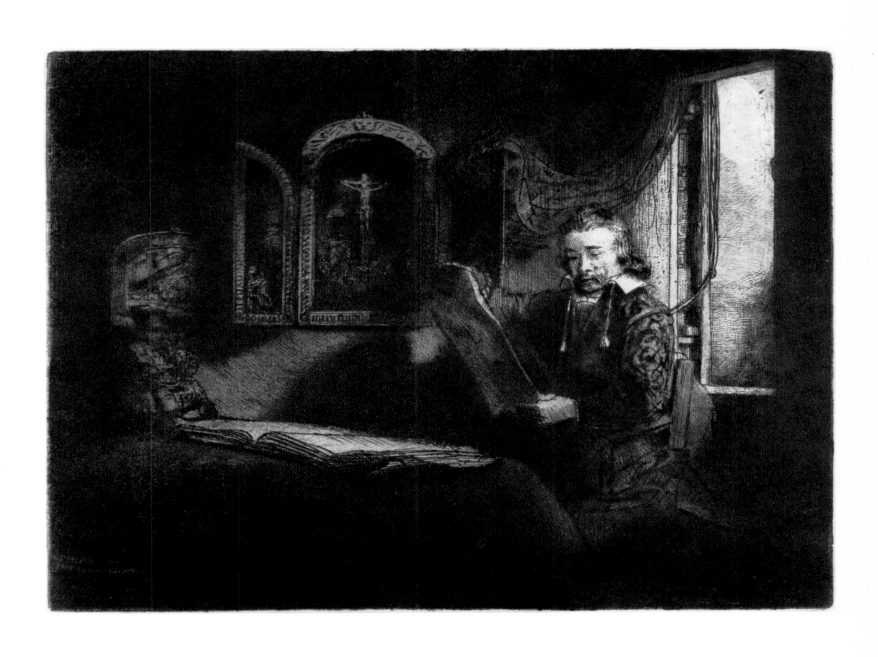

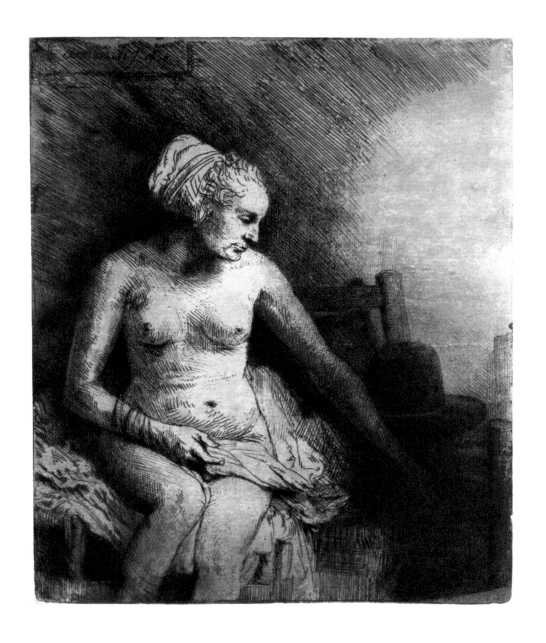

277

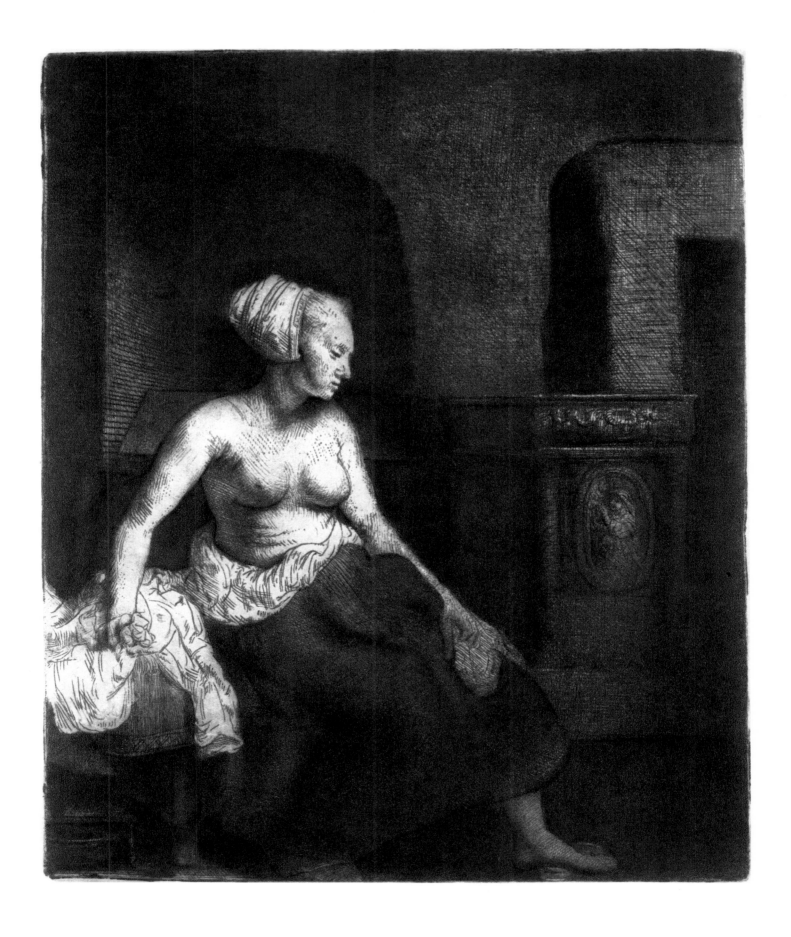

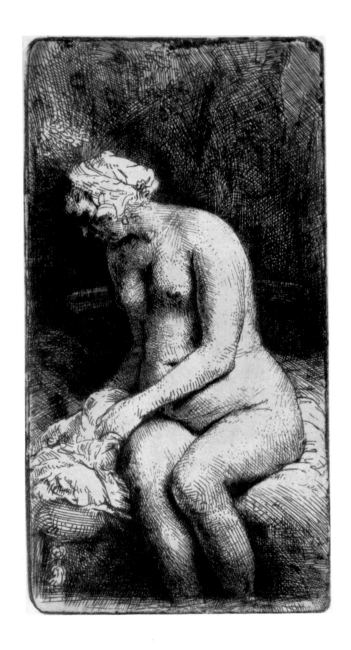

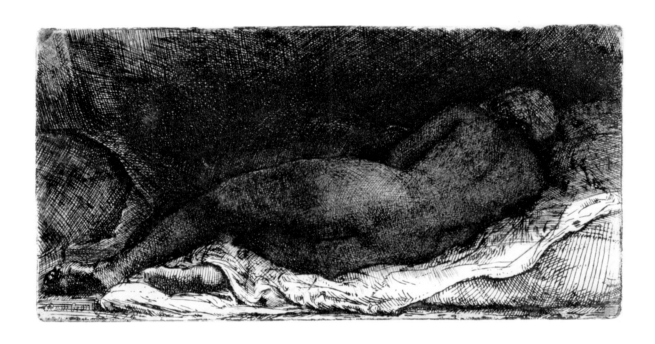

280

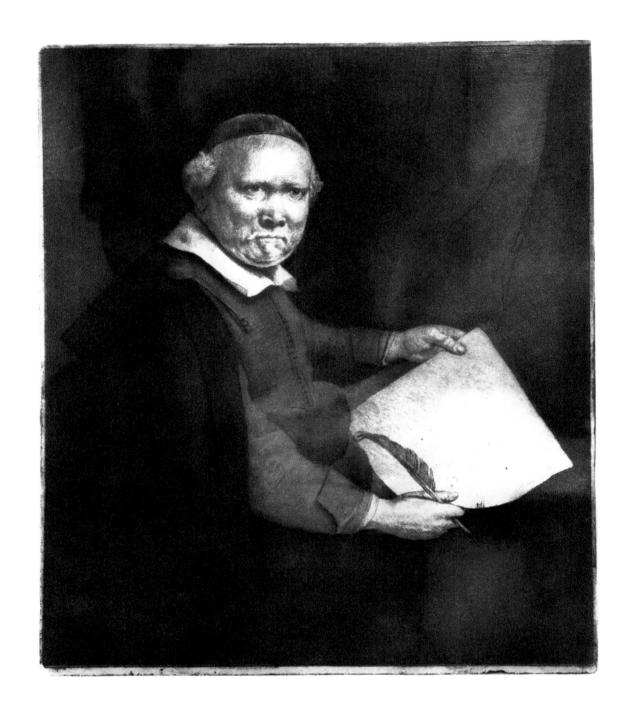

281 281, deta

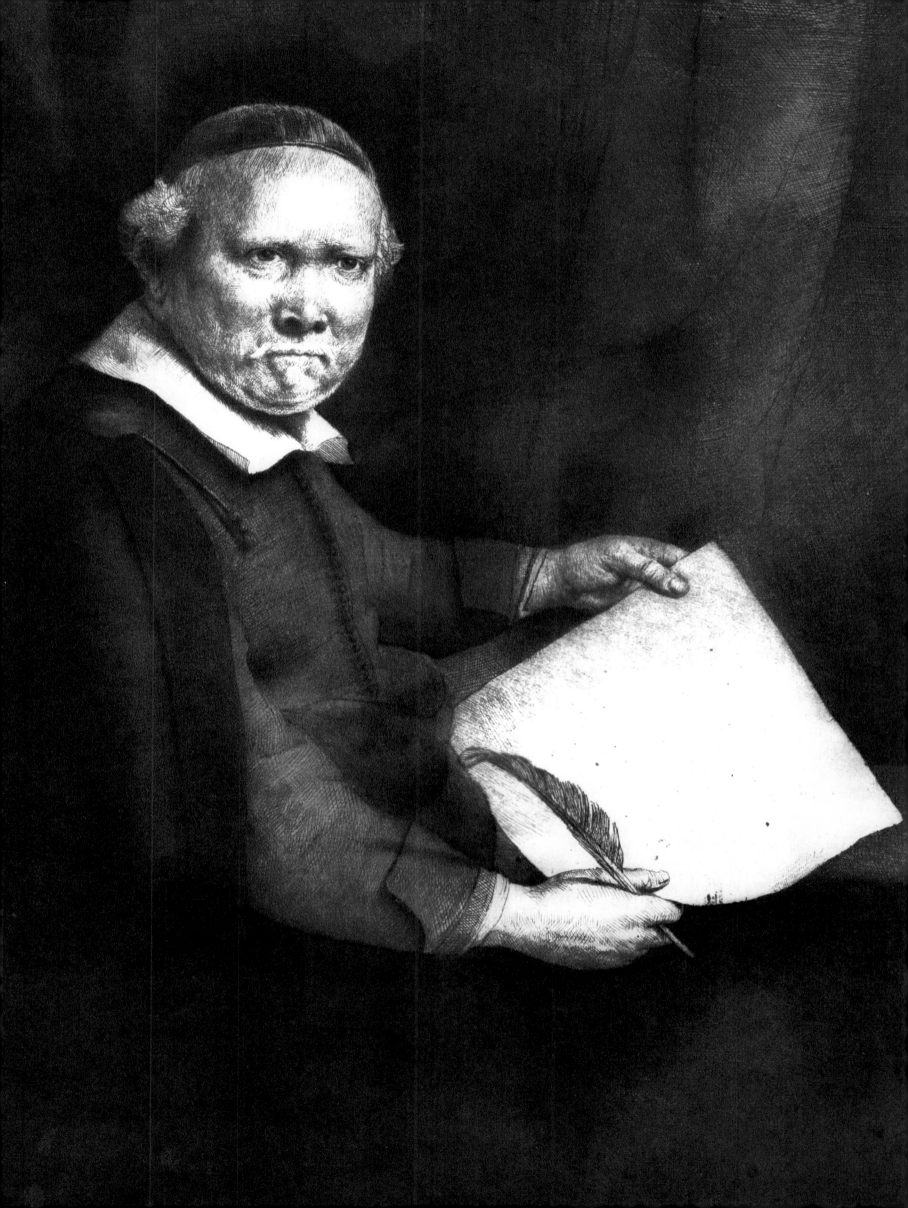

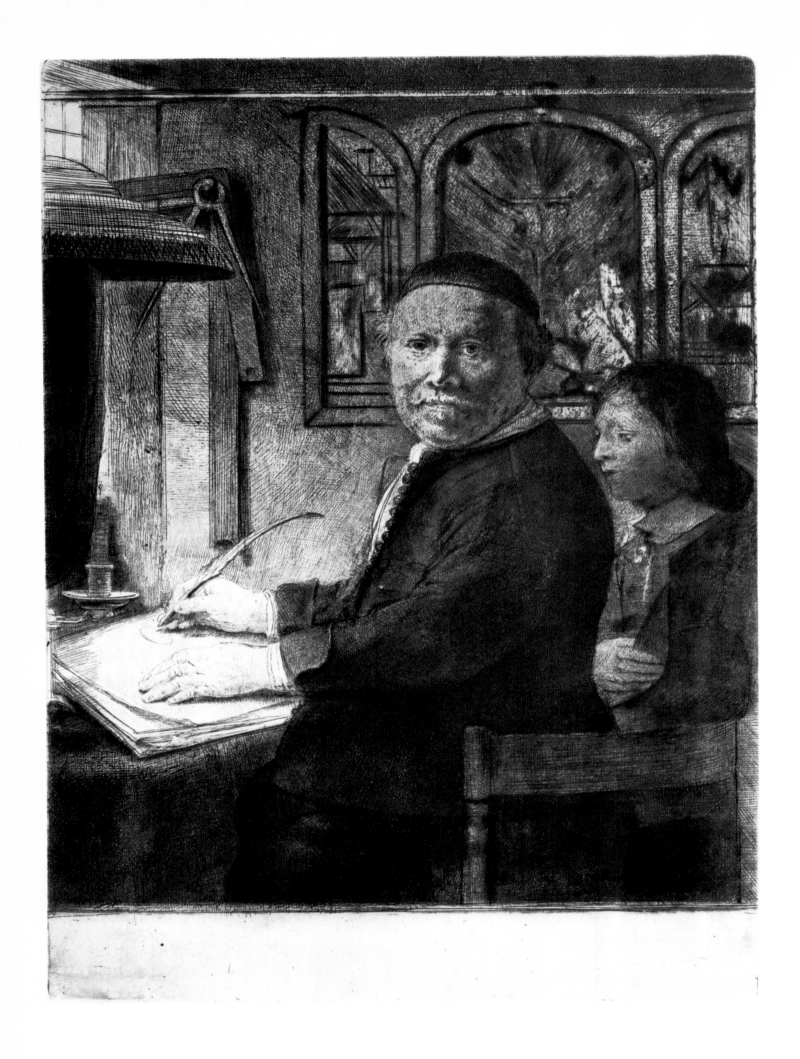

282

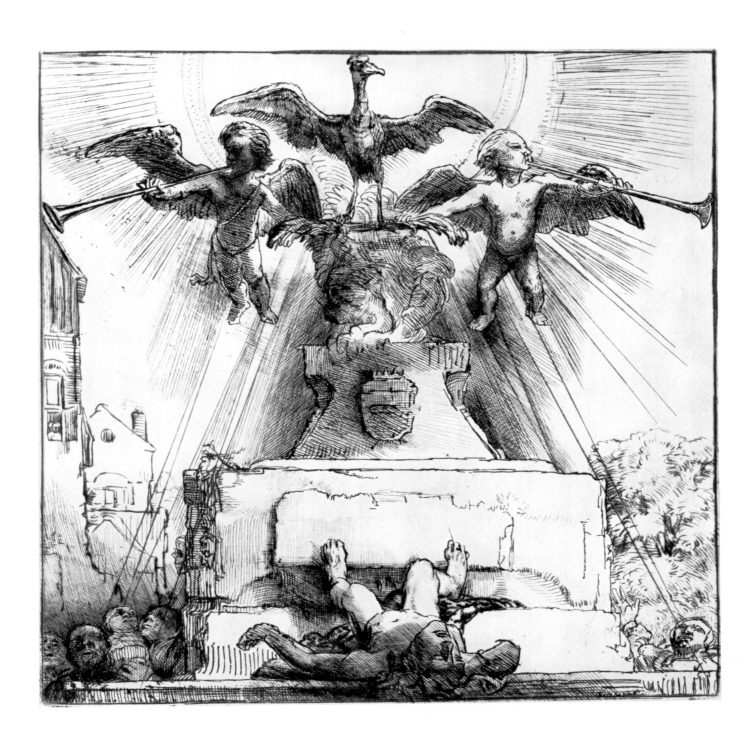

283

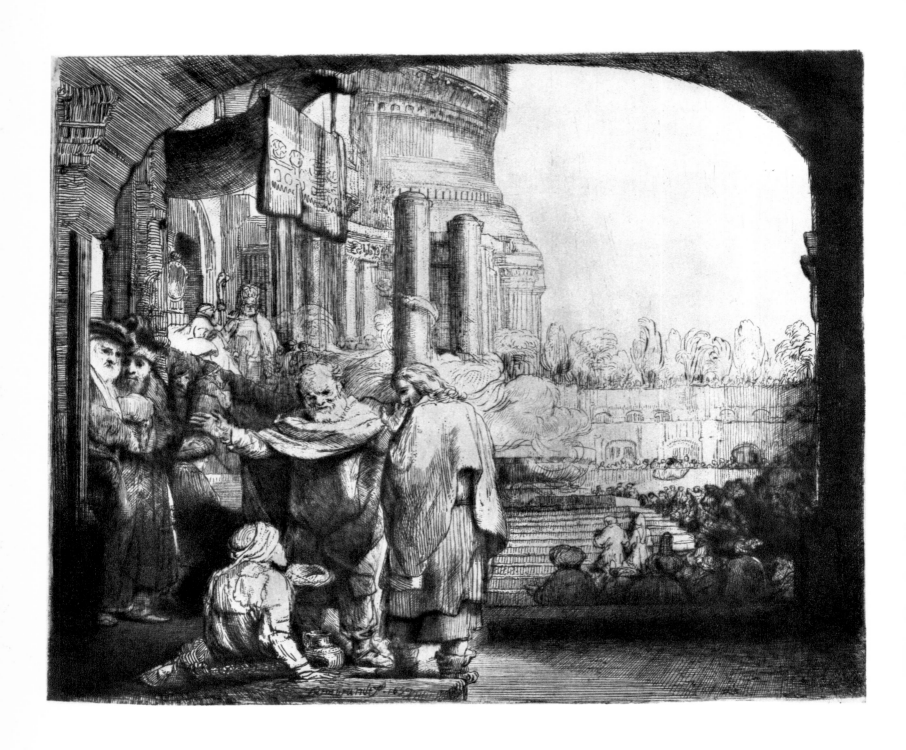

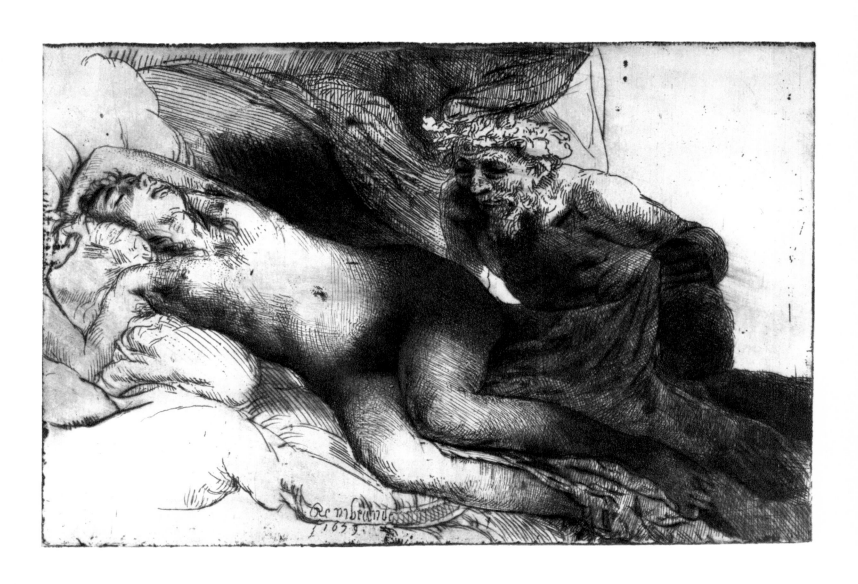

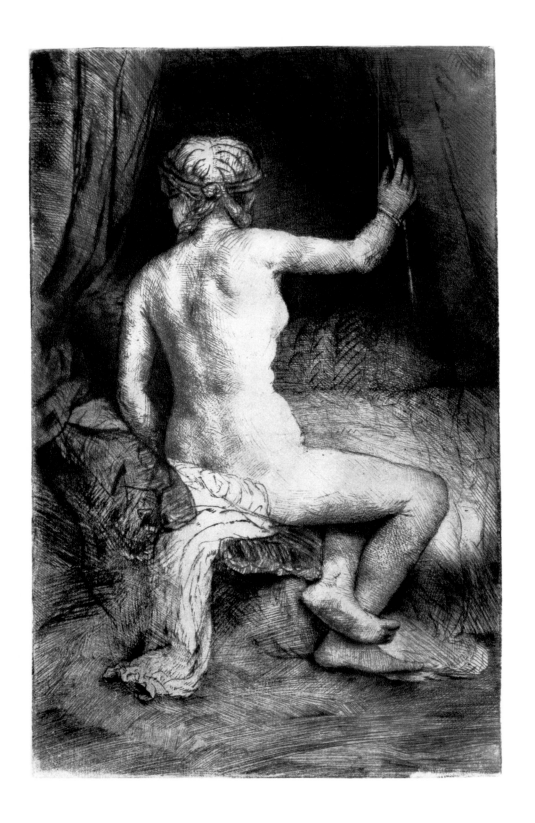

286

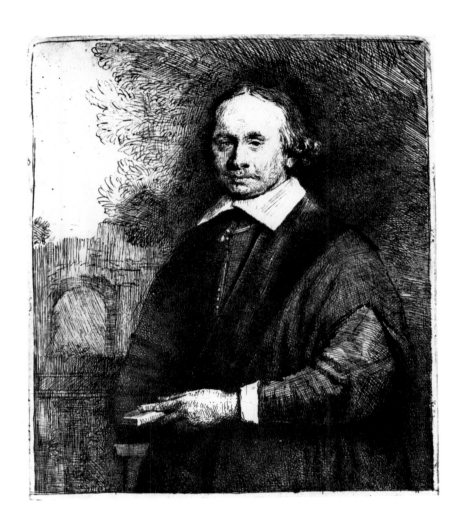

BIBLIOGRAPHICAL NOTE

All etchings are reproduced in actual size, except for those larger than the dimensions of this book. The reproductions of nineteen large etchings (two of them later, greatly altered states of the original plates) have been reduced, but a detail is given in the original size; measurements in inches of these large plates are included in the list of plates.

The etchings here reproduced are those accepted as authentic by most modern connoisseurs of Rembrandt's work. The reproductions have been made from the finest existing impressions in public collections throughout the world, except for two prints chosen from private collections.

The numbers marked *B.* following the titles refer to the second, and most important, catalogue of Rembrandt's graphic work: Adam Bartsch, *Catalogue raisonné de toutes les estampes qui forment l'œuvre de Rembrandt, et ceux de ses principaux imitateurs,* composé par Gersaint, Helle, Glomy et Yver; nouvelle édition entièrement refondue, corrigée et considérablement augmentée par Adam Bartsch; Vienna, 1797. In the case of prints from more than one state of the etched plate (*i.e.*, a plate etched and re-etched, perhaps several times), the state reproduced is indicated by the roman numeral that follows the *B.* number.

The first catalogue was that of Edmé François Gersaint, *Catalogue raisonné de toutes les pièces qui forment l'œuvre de Rembrandt,* composé par feu M. Gersaint et mis au jour, avec les augmentations nécessaires par les sieurs Helle et Glomy; Paris, 1751. This catalogue is here referred to as *G.* (see title entry for plate 1).

Since Bartsch's work, six catalogues of significance have been published: Charles Blanc, *L'Oeuvre complet de Rembrandt décrit et commenté: Catalogue raisonné de toutes les estampes du maître et de ses peintures,* orné de bois gravés et 40 eaux-fortes [de Flameng] par Charles Blanc; 2 vols., Paris, 1859–61. Dimitri Rovinski, *L'Oeuvre gravé de Rembrandt: Reproductions de planches dans tous leurs états successifs, avec un catalogue raisonné*; St. Petersburg, 1890. Woldemar von Seidlitz, *Kritisches Verzeichnis der Radierungen Rembrandts, zugleich eine Anleitung zu deren Studium*; Leipzig, 1895. Arthur M. Hind, *A Catalogue of Rembrandt's Etchings*; 2 vols., London, 1st edition 1912, 2nd edition 1923. Ludwig Münz, *Rembrandt's Etchings*; 2 vols., London, 1952. George Biörklund, *Rembrandt's Etchings: True and False,* a summary catalogue prepared with the assistance of Osbert H. Barnard; Stockholm, 1955.

The English titles of the etchings have been taken from the second edition of Hind's *Catalogue,* simplified as it seemed desirable or modified as recent research makes necessary. This catalogue is here referred to as *H.* (see title entry for plate 22).

◄ *Please fold out*

1626

1	The Circumcision	G. 48; I	Rijksmuseum, Amsterdam
2	The Rest on the Flight to Egypt	B. 59	Rijksmuseum, Amsterdam

1627

3	The Flight into Egypt	B. 54; I	Rijksmuseum, Amsterdam
4	Seated Beggar	B. 160	Rijksmuseum, Amsterdam

1628

5	Rembrandt Leaning Forward	B. 5; I	Rijksmuseum, Amsterdam
6	Rembrandt's Mother: Bust	B. 354; I	British Museum, London
7	Rembrandt's Mother: Head	B. 352; I	Rijksmuseum, Amsterdam
8	Beggar in Tall Hat and Long Cloak	B. 376	Rijksmuseum, Amsterdam
9	Peter and John at the Temple Gate	B. 95	Rijksmuseum, Amsterdam
10	Beggar Man and Beggar Woman	B. 183	Rijksmuseum, Amsterdam
11	Rembrandt Leaning Forward, as if Listening	B. 9	British Museum, London
12	A Stout Man in a Large Cloak	B. 184	Bibliothèque Nationale, Paris
13	Rembrandt with High, Curly Hair	B. 27	British Museum, London
14	Rembrandt with a Broad Nose	B. 4	Rijksmuseum, Amsterdam

1629

15	Rembrandt with Fur Cap: Oval Border	B. 12	Rijksmuseum, Amsterdam
16	St. Jerome Kneeling: Large Plate *(15¼ × 13")*	B. 106	Rijksmuseum, Amsterdam
17	Old Woman with a String of Onions	B. 134; I	Rijksmuseum, Amsterdam
18	The Blindness of Tobit: A Sketch	B. 153; I	Rijksmuseum, Amsterdam
19	The Small Lion Hunt: One Lion	B. 116	Rijksmuseum, Amsterdam
20	Two Studies of Beggars	B. 182	Bibliothèque Nationale, Paris
21	Head of Man in Fur Cap, Crying Out	B. 327; I	Rijksmuseum, Amsterdam
22	Head of Old Man with Snub Nose	H. 389	British Museum, London
23	The Leper with His Clapper *(date added later)*	B. 171; III	Bibliothèque Nationale, Paris
24	Seated Beggar and His Dog *(date added later)*	B. 175; II	Bibliothèque Nationale, Paris
25	Old Beggar Woman with a Gourd	B. 168; I	Rijksmuseum, Amsterdam
26	Beggar with a Crippled Hand, Leaning on a Stick	B. 166; I	Rijksmuseum, Amsterdam
27	Beggar in High Cap, Leaning on a Stick	B. 162	Rijksmuseum, Amsterdam
28	Rembrandt Bareheaded: Bust, Roughly Etched	B. 338	Rijksmuseum, Amsterdam
29	St. Paul in Meditation	B. 149	Bibliothèque Nationale, Paris

1630

30	Rembrandt in Cloak with Falling Collar *(date altered)*	B. 15; II	Rijksmuseum, Amsterdam
31	Rembrandt with Curly Hair and Small White Collar	B. 1; I	Albertina, Vienna
32	Old Man with Flowing Beard and White Sleeve	B. 291	Rijksmuseum, Amsterdam
33	Beggar Man and Woman Conversing	B. 164	Rijksmuseum, Amsterdam
34	Seated Beggar, Warming His Hands at a Chafing Dish	B. 173; I	Rijksmuseum, Amsterdam
35	Beggar Leaning on a Stick	B. 163	Rijksmuseum, Amsterdam
36	Ragged Peasant with Hands behind Him, Holding a Stick	B. 172; I	Rijksmuseum, Amsterdam
37	The White Negress	B. 357; I	Rijksmuseum, Amsterdam
38	Old Man with Flowing Beard	B. 309	Rijksmuseum, Amsterdam
39	Rembrandt in a Cap, Laughing	B. 316; III	Rijksmuseum, Amsterdam
40	Christ Disputing with the Doctors: Small Plate	B. 66; II	Rijksmuseum, Amsterdam
41	Rembrandt Open-Mouthed, as if Shouting	B. 13; I	Rijksmuseum, Amsterdam
42	Studies of Men's Heads	B. 366; I	Bibliothèque Nationale, Paris
43	Man in Cloak and Fur Cap, Leaning against a Bank	B. 151; I	Rijksmuseum, Amsterdam
44	Beggar Man and Woman behind a Bank	B. 165; I	Bibliothèque Nationale, Paris
45	Rembrandt's Father (?) with a Chain *(5 × 3⅞"; reproduction slightly reduced)*	B. 292; II	Bibliothèque Nationale, Paris
46	Rembrandt's Father (?): Profile	B. 294; II	Rijksmuseum, Amsterdam

47	Rembrandt in a Cap, Open-Mouthed and Staring	B. 320	*Rijksmuseum, Amsterdam*
48	Rembrandt Angry	B.10; I	*Rijksmuseum, Amsterdam*
49	Three Studies of an Old Man's Head (Rembrandt's Father?)	B. 374	*Rijksmuseum, Amsterdam*
50	Rembrandt Scowling: Octagonal Border	B. 336	*Rijksmuseum, Amsterdam*
51	Rembrandt with Cap Pulled Forward	B. 319; III	*Rijksmuseum, Amsterdam*
52	Rembrandt in Fur Cap and Light Dress	B. 24; I	*Rijksmuseum, Amsterdam*
53	The Small Lion Hunt: Two Lions	B.115; II	*Rijksmuseum, Amsterdam*
54	The Presentation in the Temple: Small Plate	B. 51; I	*Rijksmuseum, Amsterdam*
55	The Circumcision: Small Plate	B. 48	*Rijksmuseum, Amsterdam*
56	Bust of a Man (Rembrandt's Father?) Wearing a High Cap	B. 321; I	*British Museum, London*
57	Bust of a Man (Rembrandt's Father?) Wearing a Close Cap	B. 304; I	*Rijksmuseum, Amsterdam*
58	Diana at the Bath	B. 201	*Rijksmuseum, Amsterdam*
59	Beggar with Left Hand Extended (*date added later*)	B.150; II	*Rijksmuseum, Amsterdam*
60	Peasant with Hands behind Back (*date added later*)	B.135; I	*British Museum, London*
61	Beggar Seated on a Bank	B.174	*Rijksmuseum, Amsterdam*
62	Beggar with a Wooden Leg	B.179; I	*Rijksmuseum, Amsterdam*

1631

63	Jupiter and Antiope: Small Plate	B. 204; II	*Rijksmuseum, Amsterdam*
64	Rembrandt in Heavy Fur Cap	B.16	*Rijksmuseum, Amsterdam*
65	The Blind Fiddler	B.138; I	*Rijksmuseum, Amsterdam*
66	A Man Making Water	B.190	*Rijksmuseum, Amsterdam*
67	A Woman Making Water	B.191	*Rijksmuseum, Amsterdam*
68	Naked Woman Seated on a Mound	B.198; I	*Rijksmuseum, Amsterdam*
69	Rembrandt's Mother with Hand on Chest	B. 349; I	*Rijksmuseum, Amsterdam*
70	Old Man with Flowing Beard, Looking Down Left	B. 315; I	*British Museum, London*
71	Rembrandt with Long Bushy Hair	B.8; I	*Bibliothèque Nationale, Paris*
72	Rembrandt's Mother Seated, in Oriental Headdress	B. 348; I	*British Museum, London*
73	Bearded Man (Rembrandt's Father?) in Furred Oriental Cap and Robe	B.263; II	*Rijksmuseum, Amsterdam*
74	Rembrandt's Mother at a Table	B. 343; I	*Rijksmuseum, Amsterdam*
75	Old Man with Flowing Beard, Looking Down Right	B. 260; II	*Rijksmuseum, Amsterdam*
76	Rembrandt in Soft Hat and Embroidered Cloak	B. 7; III	*Rijksmuseum, Amsterdam*

1632

77	Old Man with Beard, Fur Cap, and Velvet Cloak	B. 262; II	*Bibliothèque Nationale, Paris*
78	Studies of the Head of Rembrandt and Beggars	B.363; I	*Rijksmuseum, Amsterdam*
79	Polander Leaning on a Stick	B.141; I	*Rijksmuseum, Amsterdam*
80	Turbaned Soldier on Horseback	B.139	*British Museum, London*
81	A Cavalry Fight	B.117; I	*Rijksmuseum, Amsterdam*
82	The Holy Family	B. 62	*Rijksmuseum, Amsterdam*
83	The Persian	B.152	*Rijksmuseum, Amsterdam*
84	St. Jerome Praying: Arched Print	B.101; I	*Rijksmuseum, Amsterdam*
85	The Raising of Lazarus: Large Plate (14⅜ × 10⅛″)	B. 73; II	*Rijksmuseum, Amsterdam*
86	The Rat-Killer	B.121; I	*British Museum, London*

1633

87	The Flight into Egypt: Small Plate	B. 52; I	*Rijksmuseum, Amsterdam*
88	Joseph's Coat Brought to Jacob	B. 38; I	*Bibliothèque Nationale, Paris*
89	Jan Cornelisz Sylvius, Preacher	B. 266; I	*Rijksmuseum, Amsterdam*
90	The Good Samaritan	B. 90; I	*Rijksmuseum, Amsterdam*
91	The Descent from the Cross: Second Large Plate (20⅞ × 16⅛″)	B. 81; I	*Rijksmuseum, Amsterdam*
92	The Ship of Fortune (illustration for the book Der Zeevaert Lof [Praise of Seafaring] by E. Herckmans, Amsterdam, 1634)	B.111; I	*Bibliothèque Nationale, Paris*
93	Rembrandt's Mother in Cloth Headdress (2½ × 2⅜″; reproduction slightly reduced)	B. 351; I	*British Museum, London*
94	Rembrandt in Cap and Scarf: Face Dark	B. 17; I	*Rijksmuseum, Amsterdam*

1634

95	The Strolling Musicians	B. 119; I	Rijksmuseum, Amsterdam
96	Rembrandt with Plumed Cap and Lowered Saber	B. 23; I	Rijksmuseum, Amsterdam
97	One of a Pair of Beggars (inspired by analogous subjects by H. S. Beham)	B. 178	Rijksmuseum, Amsterdam
98	The Other of the Pair of Beggars	B. 177	Rijksmuseum, Amsterdam
99	Two Tramps, a Man and a Woman	B. 144	Rijksmuseum, Amsterdam
100	Saskia with Pearls	B. 347	Rijksmuseum, Amsterdam
101	Rembrandt with Raised Saber	B. 18; II	Rijksmuseum, Amsterdam
102	Rembrandt in a Soft Cap	B. 2	Rijksmuseum, Amsterdam
103	Woman Reading	B. 345; II	Rijksmuseum, Amsterdam
104	Note: This entry will be found with the titles listed under 1641		
105	Christ and the Woman of Samaria: Among Ruins	B. 71; I	Rijksmuseum, Amsterdam
106	The Angel Appearing to the Shepherds	B. 44; II	Rijksmuseum, Amsterdam
107	Joseph and Potiphar's Wife	B. 39; I	Rijksmuseum, Amsterdam
108	St. Jerome Reading	B. 100	Rijksmuseum, Amsterdam
109	Christ at Emmaus: Small Plate	B. 88	British Museum, London

1635

110	The Tribute Money	B. 68; I	Rijksmuseum, Amsterdam
111	The Crucifixion: Small Plate	B. 80	Rijksmuseum, Amsterdam
112	The Stoning of St. Stephen	B. 97; I	Rijksmuseum, Amsterdam
113	Old Bearded Man in Fur Cap, with Closed Eyes	B. 290	Rijksmuseum, Amsterdam
114	Christ Driving the Money-Changers from the Temple	B. 69; I	Rijksmuseum, Amsterdam
115	Head of an Oriental: Retouched by Rembrandt	B. 288	Rijksmuseum, Amsterdam
116	Head of an Oriental: Retouched by Rembrandt	B. 287	Rijksmuseum, Amsterdam
117	Rembrandt's Father (?): Retouched by Rembrandt	B. 286; I	Rijksmuseum, Amsterdam
118	Young Man in Velvet Cap	B. 289; II	Rijksmuseum, Amsterdam
119	St. Jerome Kneeling in Prayer	B. 102	Rijksmuseum, Amsterdam
120	Jan Uytenbogaert, Remonstrant Preacher	B. 279; I	British Museum, London
121	The Pancake Woman	B. 124; II	Rijksmuseum, Amsterdam
122	Polander Standing with Arms Folded	B. 140; I	Rijksmuseum, Amsterdam
123	The Quacksalver	B. 129	Rijksmuseum, Amsterdam
124	Ecce Homo: Large Plate, also called Christ Before Pilate (completed in 1636; 21⅝ × 17⅝″)	B. 77; III	Rijksmuseum, Amsterdam
125	Girl with Hair Falling on Her Shoulders, called The Great Jewish Bride	B. 340; II	Rijksmuseum, Amsterdam

1636

126	Samuel Menasseh ben Israel, Author	B. 269; II	Rijksmuseum, Amsterdam
127	Rembrandt and His Wife Saskia	B. 19; I	British Museum, London
128	Studies of the Head of Saskia and Others	B. 365; I	Rijksmuseum, Amsterdam
129	The Return of the Prodigal Son	B. 91	Rijksmuseum, Amsterdam

1637

130	Ferdinand Bol, Pupil of Rembrandt	B. 268; I	Bibliothèque Nationale, Paris
131	Three Heads of Women, One Asleep	B. 368	Rijksmuseum, Amsterdam
132	Three Heads of Women: First State, Showing Saskia Alone	B. 367; I	Rijksmuseum, Amsterdam
133	Abraham Casting Out Hagar and Ishmael	B. 30	Albertina, Vienna
134	Abraham Caressing Isaac	B. 33; I	Rijksmuseum, Amsterdam
135	Bearded Man in Velvet Cap with Jewel Clasp	B. 313	Bibliothèque Nationale, Paris
136	Old Woman Sleeping	B. 350	Rijksmuseum, Amsterdam

1638

137	Rembrandt in Velvet Cap and Plume, Embroidered Dress	B. 20; I	State Museums, Berlin (West)
138	Man in Broad-Brimmed Hat and Ruff	B. 311	Rijksmuseum, Amsterdam

139	Joseph Telling His Dreams	B. 37; II	Rijksmuseum, Amsterdam
140	Adam and Eve	B. 28; II	Rijksmuseum, Amsterdam
141	Study of Saskia as St. Catherine	B. 342	Bibliothèque Nationale, Paris
142	Studies, with Saskia Lying Ill in Bed	B. 369	Rijksmuseum, Amsterdam

1639

143	Peasant in High Cap, Leaning on a Stick	B. 133	Rijksmuseum, Amsterdam
144	The Skater	B. 156	British Museum, London
145	Rembrandt in Flat Cap, with Shawl about His Shoulders	B. 26	Rijksmuseum, Amsterdam
146	Youth Surprised by Death	B. 109	Rijksmuseum, Amsterdam
147	The Death of the Virgin (16⅛ × 12⅜″)	B. 99; I	Rijksmuseum, Amsterdam
148	Old Man Shading His Eyes with His Hand	B. 259; I	Rijksmuseum, Amsterdam
149	Rembrandt Leaning on a Stone Sill	B. 21; I	Rijksmuseum, Amsterdam
150	Student at a Table by Candlelight	B. 148	Rijksmuseum, Amsterdam
151	The Artist Drawing from a Model: Unfinished Plate	B. 192; II	Rijksmuseum, Amsterdam
152	Jan Uytenbogaert, Receiver-General, *also called* The Gold-weigher	B. 281; II	Rijksmuseum, Amsterdam

1640

153	Old Man with Divided Fur Cap	B. 265; I	Rijksmuseum, Amsterdam
154	The Presentation in the Temple: Oblong Plate (8⅜ × 11⅜″)	B. 49; I	British Museum, London
155	The Beheading of John the Baptist	B. 92; I	British Museum, London
156	House and Trees beside a Pool	B. 207	Rijksmuseum, Amsterdam
157	Sleeping Puppy (2½ × 4⅛″; reproduction slightly reduced)	B. 158; I	British Museum, London

1641

158	Cottage with a Large Tree (5 × 12⅝″)	B. 226	Rijksmuseum, Amsterdam
159	View of Amsterdam	B. 210	Rijksmuseum, Amsterdam
160	The Windmill	B. 233	British Museum, London
161	Man at a Desk, Wearing Cross and Chain	B. 261; I	Bibliothèque Nationale, Paris
162	The Card-Player	B. 136; I	Rijksmuseum, Amsterdam
163	Art Student Drawing from a Cast	B. 130; I	Rijksmuseum, Amsterdam
104	The Lion Hunt: Large Plate (8¾ × 15″)	B. 114; I	Fitzwilliam Museum, Cambridge
164	Cottage and Hay-Barn: Oblong Plate (5⅛ × 12⅝″)	B. 225	Rijksmuseum, Amsterdam
165	Woman at a Door Talking to a Man and Children, *also called* The Schoolmaster	B. 128	Rijksmuseum, Amsterdam
166	The Triumph of Mordecai	B. 40	British Museum, London
167	Virgin and Child in the Clouds	B. 61	Rijksmuseum, Amsterdam
168	The Baptism of the Eunuch	B. 98; I	Fitzwilliam Museum, Cambridge
169	The Angel Departing from the Family of Tobias	B. 43; I	Fitzwilliam Museum, Cambridge
170	Saskia Ill, with Large White Headdress	B. 359	Rijksmuseum, Amsterdam
171	Portrait of a Boy in Profile (perhaps William II, Prince of Orange)	B. 310	British Museum, London
172	Christ Crucified between the Two Thieves: Oval Plate	B. 79; II	Rijksmuseum, Amsterdam
173	Cornelis Claesz Anslo, Mennonite Preacher	B. 271; II	Rijksmuseum, Amsterdam
174	Three Oriental Figures (Jacob and Laban?)	B. 118; I	Rijksmuseum, Amsterdam
175	Cottage with a White Paling	B. 232; I	Rijksmuseum, Amsterdam

1642

176	The Spanish Gypsy	B. 120	Rijksmuseum, Amsterdam
177	The Raising of Lazarus: Small Plate	B. 72; I	Rijksmuseum, Amsterdam
178	The Flute-Player	B. 188; I	British Museum, London
179	The Descent from the Cross: A Sketch	B. 82	Bibliothèque Nationale, Paris
180	Man in an Arbor	B. 257	Bibliothèque Nationale, Paris
181	Two Studies: A Tree, and Part of a Head of Rembrandt	B. 372	Rijksmuseum, Amsterdam
182	St. Jerome in a Dark Chamber	B. 105; II	Rijksmuseum, Amsterdam
183	Girl with a Basket	B. 356; II	Rijksmuseum, Amsterdam

1643			
184	The Hog	*B.157; I*	*Rijksmuseum, Amsterdam*
185	The Three Trees *(8¼ x 11")*	*B.212*	*Rijksmuseum, Amsterdam*
1644			
186	The Shepherd and His Family	*B.220*	*Rijksmuseum, Amsterdam*
187	The Sleeping Herdsman	*B.189*	*Rijksmuseum, Amsterdam*
188	The Rest on the Flight to Egypt: A Night Piece	*B.57; III*	*Rijksmuseum, Amsterdam*
1645			
189	The Monk in the Cornfield	*B.187; I*	*Rijksmuseum, Amsterdam*
190	The Rest on the Flight to Egypt: Lightly Etched	*B.58*	*British Museum, London*
191	Farm Buildings, with a Man Sketching	*B.219*	*Rijksmuseum, Amsterdam*
192	Old Man in Meditation (Archimedes?)	*B.147; II*	*Rijksmuseum, Amsterdam*
193	St. Peter in Penitence	*B.96*	*British Museum, London*
194	Christ Carried to the Tomb	*B.84*	*Rijksmuseum, Amsterdam*
195	The Omval	*B.209; II*	*Bibliothèque Nationale, Paris*
196	Abraham and Isaac	*B.34; I*	*Rijksmuseum, Amsterdam*
197	Cottages beside a Canal: A View of Diemen	*B.228; I*	*Rijksmuseum, Amsterdam*
198	The Boat-House	*B.231; I*	*Rijksmuseum, Amsterdam*
199	Six's Bridge	*B.208; I*	*British Museum, London*
1646			
200	Nude Man Seated before a Curtain	*B.193; I*	*Private Collection, London*
201	Het Ledekant *or* Le Lit à la française	*B.186; II*	*Rijksmuseum, Amsterdam*
202	Studies from the Nude: Two Male Figures	*B.194; I*	*Rijksmuseum, Amsterdam*
203	Nude Man Seated on the Ground	*B.196; II*	*Rijksmuseum, Amsterdam*
204	Beggar Woman Leaning on a Stick	*B.170; I*	*British Museum, London*
205	Jan Cornelisz Sylvius, Preacher: Posthumous Portrait	*B.280; I*	*Albertina, Vienna*
1647			
206	Ephraim Bueno, Physician	*B.278; I*	*Rijksmuseum, Amsterdam*
207	Jan Asselyn, Painter	*B.277; I*	*Rijksmuseum, Amsterdam*
208	Jan Six	*B.285; I*	*Rijksmuseum, Amsterdam*
1648			
209	The Synagogue	*B.126; I*	*Rijksmuseum, Amsterdam*
210	St. Jerome beside a Pollard Willow	*B.103; I*	*Bibliothèque Nationale, Paris*
211	Beggars Receiving Alms at a Door	*B.176; I*	*Rijksmuseum, Amsterdam*
212	Rembrandt Drawing at a Window	*B.22; I*	*Rijksmuseum, Amsterdam*
213	Rembrandt Drawing at a Window	*B.22; II*	*Rijksmuseum, Amsterdam*
214	The Bull	*B.253*	*Rijksmuseum, Amsterdam*
215	The Marriage of Jason and Creusa *(illustration for Jan Six's verse tragedy* Medea, *Amsterdam, 1648)*	*B.112; III*	*Rijksmuseum, Amsterdam*
1649			
216	The Hundred Guilder Print *(11⅛ x 15½")*	*B.74; I*	*Rijksmuseum, Amsterdam*
1650			
217	The Shell	*B.159; II*	*Rijksmuseum, Amsterdam*
218	Landscape with a Cow Drinking	*B.237; I*	*Rijksmuseum, Amsterdam*
219	Landscape with a Milkman	*B.213; I*	*Rijksmuseum, Amsterdam*
220	Landscape with an Obelisk	*B.227; I*	*The Art Institute, Chicago*
221	Landscape with a Square Tower	*B.218; I*	*Rijksmuseum, Amsterdam*
222	Canal with an Angler and Two Swans	*B.235; II*	*Rijksmuseum, Amsterdam*
223	Canal with a Large Boat and a Bridge	*B.236; II*	*Rijksmuseum, Amsterdam*

1651

224	The Star of the Kings: A Night Piece	*B. 113*	*Rijksmuseum, Amsterdam*
225	The Flight into Egypt: A Night Piece	*B. 53; I*	*Rijksmuseum, Amsterdam*
226	Three Gabled Cottages beside a Road	*B. 217; I*	*British Museum, London*
227	Clement de Jonghe, Print Dealer	*B. 272; II*	*Rijksmuseum, Amsterdam*
228	The Bathers	*B. 195*	*Rijksmuseum, Amsterdam*
229	Studies, with a Head of Rembrandt	*B. 370*	*Rijksmuseum, Amsterdam*
230	Trees, Farm Buildings, and a Tower *(4⅞ × 12⅝")*	*B. 223; I*	*Bibliothèque Nationale, Paris*
231	The Saxenburg Estate and the Bleaching Fields near Haarlem, *also called* The Goldweigher's Field *(4⅝ × 12⅝")*	*B. 234*	*The Art Institute, Chicago*
232	The Blindness of Tobit: Large Plate	*B. 42; I*	*Albertina, Vienna*

1652

233	Peasant Family on the Tramp	*B. 131*	*Rijksmuseum, Amsterdam*
234	The Adoration of the Shepherds: A Night Piece	*B. 46; V*	*Rijksmuseum, Amsterdam*
235	Faust in His Study	*B. 270; I*	*Rijksmuseum, Amsterdam*
236	David in Prayer	*B. 41; I*	*British Museum, London*
237	Christ Preaching, *called* La Petite Tombe	*B. 67*	*Rijksmuseum, Amsterdam*
238	The Virgin with the Instruments of the Passion	*B. 85*	*Bibliothèque Nationale, Paris*
239	Christ Disputing with the Doctors: A Sketch	*B. 65; I*	*British Museum, London*
240	Hay-Barn and a Flock of Sheep	*B. 224; I*	*Bibliothèque Nationale, Paris*
241	Road beside a Canal	*B. 221*	*Rijksmuseum, Amsterdam*
242	Clump of Trees with a Vista	*B. 222; II*	*British Museum, London*

1653

243	Landscape with Sportsman and Dogs	*B. 211; I*	*Rijksmuseum, Amsterdam*
244	The Three Crosses *(15¼ × 17¾")*	*B. 78; I*	*Rijksmuseum, Amsterdam*
245	The Three Crosses *(15¼ × 17¾")*	*B. 78; IV*	*Rijksmuseum, Amsterdam*
246	The Flight into Egypt *(altered from a plate by Hercules Seghers; 8¾ × 11¼")*	*B. 56; IV*	*Rijksmuseum, Amsterdam*
247	St. Jerome Reading, in an Italian Landscape	*B. 104; I*	*Rijksmuseum, Amsterdam*
248	St. Jerome Reading, in an Italian Landscape: Detail	*B. 104; II*	*Rijksmuseum, Amsterdam*

1654

249	The Golf-Player	*B. 125; I*	*Rijksmuseum, Amsterdam*
250	The Adoration of the Shepherds: With Lamp	*B. 45; I*	*Rijksmuseum, Amsterdam*
251	The Circumcision in the Stable	*B. 47; I*	*Rijksmuseum, Amsterdam*
252	The Virgin and Child with the Cat	*B. 63; I*	*Rijksmuseum, Amsterdam*
253	The Flight into Egypt: Crossing a Brook	*B. 55¦*	*Rijksmuseum, Amsterdam*
254	Christ Seated Disputing with the Doctors	*B. 64*	*Bibliothèque Nationale, Paris*
255	Christ between His Parents, Returning from the Temple	*B. 60*	*State Museums, Berlin (West)*
256	Christ at Emmaus: Large Plate	*B. 87; I*	*Rijksmuseum, Amsterdam*
257	The Descent from the Cross: By Torchlight	*B. 83*	*Rijksmuseum, Amsterdam*
258	The Presentation in the Temple: In the Dark Manner, with a Surface Tint	*B. 50*	*Rijksmuseum, Amsterdam*
259	The Entombment: In Pure Line	*B. 86; I*	*Rijksmuseum, Amsterdam*
260	The Entombment: With a Surface Tint	*B. 86; IV*	*Rijksmuseum, Amsterdam*

1655

261	Ecce Homo: Early State, *also called* Christ Presented to the People *(15⅛ × 18")*	*B. 76; I*	*Bibliothèque Nationale, Paris*
262	Ecce Homo: Later State *(14⅛ × 17¾")*	*B. 76; VII*	*Rijksmuseum, Amsterdam*
263	Abraham's Sacrifice	*B. 35*	*Albertina, Vienna*
264	Four Illustrations for the *Piedra Gloriosa* of Samuel Menasseh ben Israel *(The Image Seen by Nebuchadnezzar, Daniel's Vision of the Four Beasts, Jacob's Ladder, David and Goliath)*	*B. 36; III*	*Rijksmuseum, Amsterdam*

| 265 | The Goldsmith | B. 123; I | Rijksmuseum, Amsterdam |
| 266 | Jacob Thomasz Haaring, Solicitor | B. 275; I | British Museum, London |

1656

267	Abraham Entertaining the Angels	B. 29	Rijksmuseum, Amsterdam
268	Christ Revealed to the Disciples	B. 89	British Museum, London
269	Titus van Rijn, Rembrandt's Son	B. 11	Rijksmuseum, Amsterdam
270	Jan Lutma the Elder, Goldsmith	B. 276; I	Rijksmuseum, Amsterdam
271	Arnold Tholinx, Inspector of the Collegium Medicum	B. 284; I	Private Collection
272	Thomas Jacobsz Haaring, Warden	B. 274; II	Rijksmuseum, Amsterdam

1657

273	Christ and the Woman of Samaria: Arched Print	B. 70; II	Rijksmuseum, Amsterdam
274	St. Francis beneath a Tree, Praying	B. 107; I	Albertina, Vienna
275	The Agony in the Garden	B. 75	Rijksmuseum, Amsterdam
276	Abraham Francen, Apothecary	B. 273; II	Rijksmuseum, Amsterdam

1658

277	Woman at the Bath, with a Hat beside Her	B. 199; I	Rijksmuseum, Amsterdam
278	Woman Sitting Half-Dressed beside a Stove	B. 197; III	Rijksmuseum, Amsterdam
279	Woman Bathing Her Feet	B. 200	Rijksmuseum, Amsterdam
280	Negress Lying Down	B. 205; II	Rijksmuseum, Amsterdam
281	Lieven Willemsz van Coppenol, Writing-Master: Large Plate (13⅜ × 11⅜″)	B. 283; III	Bibliothèque Nationale, Paris
282	Lieven Willemsz van Coppenol, Writing-Master: Small Plate	B. 282; IV	Rijksmuseum, Amsterdam
283	The Phoenix: An Allegory	B. 110	Rijksmuseum, Amsterdam

1659

| 284 | Peter and John at the Temple Gate | B. 94; II | Rijksmuseum, Amsterdam |
| 285 | Jupiter and Antiope: Large Plate | B. 203; I | Rijksmuseum, Amsterdam |

1661

| 286 | The Woman with the Arrow | B. 202; I | Rijksmuseum, Amsterdam |

1665

| 287 | Jan Antonides van der Linden, Physician | B. 264; I | Rijksmuseum, Amsterdam |